WEDDINGS OF STYLE

© 2004 Assouline Publishing
601 West 26th Street, 18th Floor
New York, NY 10001 USA
Tel.: 212 989-6810 Fax: 212 647-0005
www.assouline.com

ISBN: 2 84323 609 6

Color separation: Gravor (Switzerland)
Printed by Grafiche Milani (Italy)

KALLIOPE KARELLA

WEDDINGS OF STYLE

A GUIDE TO THE ULTIMATE WEDDING

ASSOULINE

*To my son, Brando, who has taught me
infinite patience and unconditional love,
and is the source of my endless happiness.*

CONTENTS

INTRODUCTION

Most little girls around the world have a pretty good idea of what their wedding will be like, what their wedding dress will look like, and even who their husband could be. Although their true prince most often appears in a four-door sedan instead of on a white charger, girls continue to dream, unaffected by the changes in cultural mores.

The weddings featured in this book are these girlhood fantasies come to life. Taking place in the most romantic of settings, executed in the greatest of style, and evoking all the glamour that such a special day requires, these weddings are true fairytales.

Truth be told, I was definitely a "late bloomer" in my interest in the world of weddings, having somehow skipped the young girl's fancy that beset my female contemporaries. But when the wedding bug hit me, I was immediately under its spell, plunging into the subject wholeheartedly with such abandon, enthusiasm, and gusto that in short order I earned the title "chairman of the wedding brigade" for being ready at a moment's notice to fly off to yet another incredible celebration.

Of course, most of us could not imagine coming close to the flamboyant character of these weddings or even being able to replicate anything vaguely resembling any part of them. (In fact, my own wedding was a spur of the moment affair, occurring just ten days after the engagement—the bride wore a simple pink cotton dress and the groom white jeans.) But this shouldn't prevent us from being inspired by them: how each bride chose her own unique setting, theme, décor, and style of dress. We should feel free to dream, fantasize, and use our imagination—and perhaps even be motivated to create a fabulous production of our very own.

Each wedding in this book has a story, and each story—from courtship to nuptials—provides ideas for planning, as well as methods for dealing with the mishaps that inevitably occur. As diverse and unique as they may be, all the weddings have one thing in common: the goal of achieving a truly memorable event.

To that end, each and every bride—not only those included in this book—will give one hundred percent of her energy and the best of herself to guarantee that each guest will have the best time possible. She will look after the smallest detail and orchestrate the ensembles of the wedding party (and sometimes beyond!) to make sure that everything is just right. This is the great production of her life, her own wedding day, and she will do her utmost to ensure that when the day arrives she will be able to not only remember it but also (quite selfishly) to enjoy every moment, basking in the hopefulness of a new chapter, the beginning of her married life.

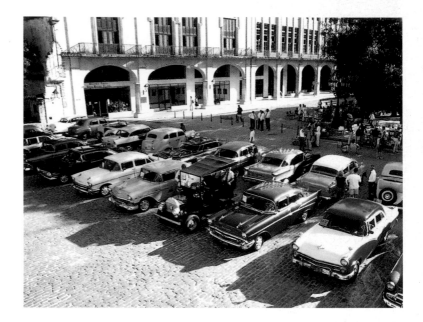

HAVANA
CUBA

SALLY TADAYON & LORD RUFUS ALBEMARLE, MAY 5, 2001

THE ROMANCE

When Sally met Rufus there were fireworks, both in the sky and between them. They locked eyes in Mexico on the buffet line of a cocktail party celebrating the wedding of another happy couple—Karina and Filippo Brignone. As they exchanged pleasantries, they soon discovered that not only did they have a mutual attraction but they also had much in common. Knowing that she fancied him, Sally then went out of her way to avoid him, and a game of hot pursuit ensued. Their casual flirtation rapidly developed into full-blown romance, and by the end of the weekend, the couple was inseparable.

Alas, the magical celebration soon drew to a close, and the cold reality of their lives manifested itself. Sally, a sculptor, lived in London, while Rufus, an industrial designer, lived in New York. Undaunted and thoroughly smitten, Rufus drove Sally the three bumpy hours to the Puerto Vallarta airport to make her flight—even though it was more than eight hours before his.

After an emotional exchange of telephone numbers and e-mail addresses, there soon passed a lively courtship of e-love messages, long distance phone calls, transatlantic trips, and countless letters,

ABOVE: *Vintage American cars waiting in front of the Hotel Santa Isabel to take guests to the Habana Riviera Hotel.*

OPPOSITE: *The couple exiting the Basilica Menor de San Francisco de Asis.*

8

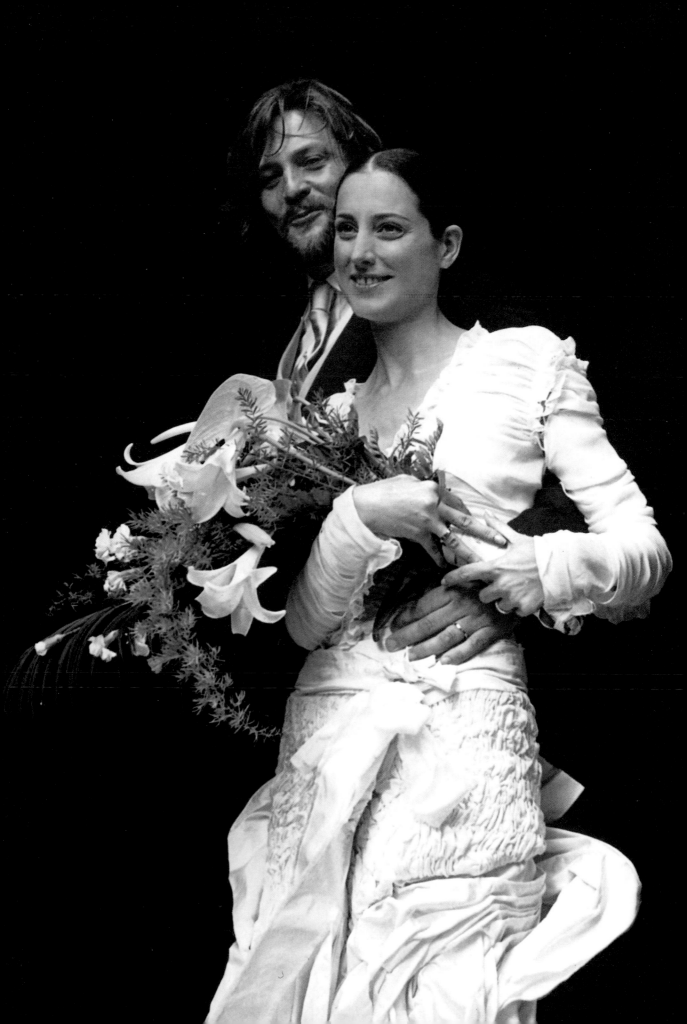

limericks, and puzzles. A few weeks later, in June, Sally was introduced to his mother and sister, and that summer, Rufus invited her to his vacation house in Porto Ercole, Italy, for a romantic weekend. "Everything happened very quickly and very naturally," says Sally. "And he always took the initiative."

On a cold day in November of 2000, about a year after they met, Rufus proposed. Sally, who was in New York for her first major sculpture exhibition, had been anticipating the proposal since their Italian vacation. But Rufus, ever the gentleman, had reason to wait: he simply had not been able to find the right ring, and wouldn't consider proposing without one. Now armed with a fifteen-carat Kenny Lane custom "diamond," he dropped to his knees and said: "I cannot imagine spending my life without you; please, will you marry me?" Sally was so shocked that she started laughing and crying at the same time.

THE RING

Though Rufus had finally found a gorgeous ring to propose with, the couple still wanted something special for their proper engagement ring. With the help of a friend, jewelry designer Francesca Visconti, Rufus and Sally decided to design a ring that would represent them as a couple. Inspired by ring designs from a file that Rufus had meticulously prepared, the pair created their dream ring. In the center of a square band of white gold were four square stones: a diamond, a sapphire, an emerald, and a ruby. These stones have a dual meaning for the couple, as they represent both the four cardinal points and the four elements of nature. The diamond is the North Star; the ruby, the sun; the emerald, the trees; and the sapphire, the ocean. (Rufus has a great Naval tradition in his family.) Rufus and Sally then created a wedding band to complement this ring, with his name

LEFT: *A young guest admiring the bride.*
RIGHT: *Beach club of the "Nomenclatura," the top Communist officials.*

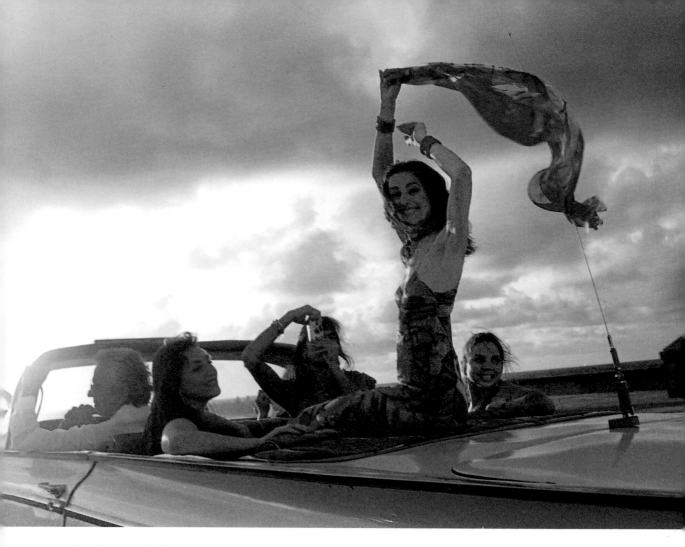

Sally on her way to her birthday celebration at the Habana Riviera Hotel, sitting on the top of a vintage convertible...

inscribed on hers, and her name on his. Inspired by the aesthetic and emotional pleasure of this creative effort, they also designed another small ring to fit between the two, which would be inscribed with the names of their future children.

THE SETTING

Sally had the romantic dream of getting married in Cuba, because of the rich significance the island has for the Albemarle family. In the eighteenth century, George Keppel, Rufus's ancestor and the third Earl of Albemarle, with his legendary brothers, Augustus and William, led the British Fleet in the successful conquest of the island between 1762 and 1763. Due to his family's legacy in Cuba, Rufus still had cultural connections there, and had been in contact with the city historian, Dr. Eusebio Leal Spengler. When Sally

flew to Cuba to scout for locations, she immediately fell under the spell of old Havana, and was determined to make her dream come true.

THE PLANNING

Dr. Spengler and his office were as enthusiastic as the couple about an Albemarle wedding in Havana, and instrumental in arranging the affair. Dr. Spengler granted special permission for the couple to be married in the Basilica Menor de San Francisco de Asis. The Basilica had been confiscated from the Spanish Catholics by the British for the worship of the Protestant faith, and subsequently ceased being used as a house of worship. (Under Castro, it has been used as a warehouse, a museum, and a lecture hall.) Rufus and Sally's union would be the first wedding held there since 1763—a prospect that thrilled Cuba's Anglican bishop.

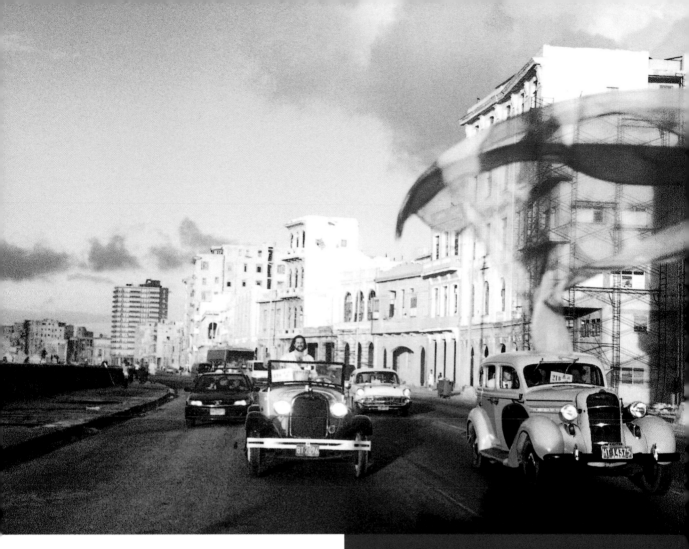

...with Rufus following in another vintage convertible.

THE DRESS

When Tom Ford, an old friend of Rufus's from his Milan days, received the couple's wedding invitation, he insisted on offering a wedding dress as a present. Though Sally had already bought a beautiful dress from Dior, she and Rufus could not refuse such a generous gift—especially since the designer's last collection had been full of vivid Hispanic influences that would be perfect for their Cuban wedding. Tom told Sally to choose whatever she liked from his look-books, and he and his team would create the perfect hybrid for her wedding dress.

After making her choices, Sally flew to Paris to try on what Tom had created. After she left, Tom elaborated on his original design, and the result was breathtaking: an ivory-colored, mousseline blouse paired with a ruffled

66 'I cannot imagine spending my life without you; please, will you marry me?' Sally was so shocked that she started laughing and crying at the same time. 99

Sally had no wedding planner because she wanted her wedding experience to be as personal as possible. Says Sally to any bride who would also like to be in charge of the most important event in her life: "Consider the planning of your wedding as a full-time job. You will be doing nothing else but that," she said. Sally, like most brides, can be very demanding of herself. "Be as meticulous, be as obsessive about details as you and your organizers can, as long as the day

silk organza skirt, with a Spanish train in the back. Sally couldn't have been happier—it was the perfect dress for her, and miraculously, after only one fitting, it fit like a glove.

THE WEEKEND

When the guests arrived Thursday night, there was an informal dinner at El Patio restaurant at the Plaza de la Catedral, to welcome everyone to Cuba. An all-male dancing group arrived to mourn Sally's last moments as a single gal, and ended up lifting Sally on their shoulders and parading her.

The second evening a party for Sally's birthday was held at the legendary Habana Riviera Hotel. The guests were driven to the hotel by a fleet of thirty beautiful vintage American convertibles in pastel colors. Once there, guests were treated to a dinner of sumptuous local delicacies and birthday cake, washed down by countless Cuba Libres, Piña Coladas, and Rum Collinses, accompanied by Cuban music by the "Copa Room Riviera Band," followed by dancing to tunes spun by a local DJ.

THE CEREMONY

The ceremony took place on Saturday evening at the Basilica. The eclectic service opened with "An Ode to Love," by Persian poet Jalal Al-Din Rumi. The ceremony was in Spanish, which English-speaking guests could follow using the translation printed in their programs. When the couple exchanged their vows, Sally and Rufus both said *sí* with perfect Spanish accents.

THE ATTENDANTS

As a gesture of gratitude to the city historian for making her dream wedding possible, Sally had the children of people who worked at his office as her flower girls and pageboys. She bought plain white pants and dresses at Bonpoint, which she paired with pale burgundy silk cummerbunds made by a friend. To complete the outfits, she added big velvet flowers to tuck into the sashes.

> 66 Sally had the children of people who worked at the historian's office as her flower girls and pageboys.99

THE RECEPTION

The reception was held at La Casa de la Obra Pia, an historic building in Old Havana. Sally relied on the baroque architecture of the Casa to create the elegant atmosphere she desired. Each table was named after ships commanded by Rufus's ancestors during the invasion of Cuba, such as the Valiant, the Defiant, and the Intrepid.

There was a surprise musical interlude on the way from the ceremony to cocktails, next door at the Basilica's cloisters: Three guests (Kirat Bindo Young, H.S.H. The Prince d'Arenberg, and the Honorable Peregrine Moncreiffe of that Ilk) encountered a French naval officer on one of Havana's streets. Upon noting the Scottish Peregrine's kilt, the officer confessed to a dexterity on the bagpipes. This gave Prince d'Arenberg an idea: providing his own car and driver, the Prince sent the officer to fetch his bagpipe. The officer arrived at the cloisters, bagpipe in hand, just in time to greet Sally, Rufus, and their guests with "The Scottish Highland Reel."

THE DRESS

Sally's wedding dress was created by Tom Ford (for Yves Saint-Laurent) and consisted of an ivory-colored mousseline blouse paired with a ruffled silk organza skirt with a Spanish train. She carried a bouquet of one palm frond with anthuriums, madonna lilies, gardenias, and asparagus fern.

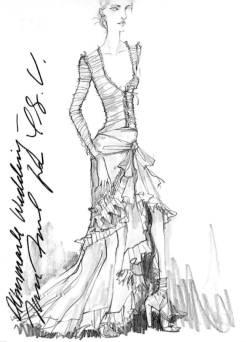

THE COCKTAILS

Mojitos—the typical Cuban drink made with (a lethal combination of) rum, sugar, lime juice, and fresh mint—were served during the welcoming dinner at Restaurante El Patio, at the Plaza de la Catedral. Cuba Libres (rum and Coke), Rum Collinses (a combination of rum, soda, and lemon juice, finished with an orange slice), and Piña Coladas (rum, pineapple juice, and coconut) were served at the party thrown for Sally's birthday at the Habana Riviera Hotel.

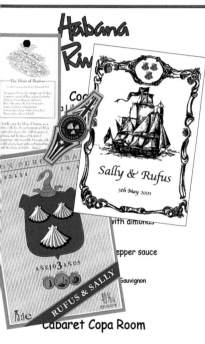

THE MENU

FIRST COURSE
Lobster Salad

MAIN COURSE
Suckling Pig
Christians and Moors
(black beans and rice)

Cuban Cheese with a guava coulis

DESSERT
Wedding Cake

THE FAVORS

Guests were greeted upon arrival at the hotel by a bottle of Cuban rum, and—of course—Cuban cigars. The rum bottles had a special gold and red label, sporting three seashells, which are part of the Albemarle coat of arms. On the back was written: "May their lives together be filled with the spirit of Cuba, with passion, harmony, and delight." The cigars had a "Rufus y Sally" label, with the English flag on one side and the Cuban flag on the other, a blue medallion with the three shells in gold, and the couple's names and the date.

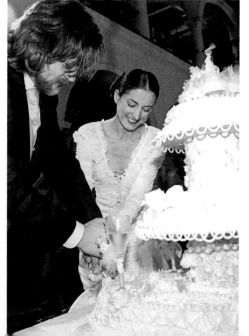

THE CAKE

In the words of the bride it was "a true homage to Cuban patisserie." The cake had an intricate scalloped border that resembled Spanish lace. In keeping with Cuban tradition, the cake was intensely sweet in order to ensure good luck to the couple. At the top, it had effigies of the bride and groom in plastic, which Sally brought back as a souvenir. Sally and Rufus cut their wedding cake after the nuptial dinner at La Casa de la Obra Pia.

CASA DE CAMPO
DOMINICAN REPUBLIC
EMILIA FANJUL & BRIAN PFEIFLER, MARCH 23, 2002

THE ROMANCE

They met downtown in New York's Chelsea, at a party in 1997. Emilia was dating her high-school sweetheart at the time and paid no attention to the handsome 31-year-old bachelor. But after Brian's persistent pursuit, she fell under his spell, broke up with her boyfriend, and started dating him. A month later, they met each other's parents, and shortly thereafter, they were inseparable.

From the start, Emilia's friends warned her not to set her hopes on her new boyfriend. Playboys like him don't know the meaning of the word "betrothed," they told her. But Emilia was in no hurry to get married. At 24, with a promising career in public relations ahead, vows and nuptials were the last thing on her mind. Adjusting to the uptown-downtown commute between her and Brian's apartment was hard enough for now.

Over time, Emilia's cool, level-headed approach to their relationship increasingly endeared her to Brian, and ultimately, she proved her friends wrong. Four years after they had labeled Brian as a "lost cause," the former playboy got down on one knee and presented Emilia with a nineteenth-century, Tiffany-cut diamond ring. He proposed on his birthday—which is one day before hers.

ABOVE: *The Church of Saint Stanislaus, in Altos de Chavon, where the wedding was held.*

OPPOSITE: *Emilia wearing her Carolina Herrera Haute Couture wedding dress, clearly enjoying her special day to the hilt.*

THE PLANNING

Setting the date was tricky. Emilia always wanted to be married at Casa de Campo, her family's compound in the Dominican Republic. But summers there are too hot and early fall is the hurricane season. At the same time, she didn't want to wait another year. "Who wants to be married after a year of talking about it? The enthusiasm definitely wanes!" says Emilia. So a March date was set—a mere four months away. Luckily, Emilia's parents had been organizing the wedding since the night Brian proposed. Her family was used to giving large parties, and knew exactly which florist, caterer, and musician they wanted. Emilia's mother went to the Dominican Republic as the family emissary during the planning phase, where she worked nonstop until March with a local crew to orchestrate the grand affair. By January, 450 friends and family members had received a beautiful, information-packed brochure featuring photographs of the breathtaking estate, details on charter plane schedules, hotel and restaurant suggestions, and an agenda of all the activities planned for the wedding weekend.

THE DRESS

When Emilia first walked into Carolina Herrera's studio in December, she was envisioning a "bohemian, sexy, island look." But Herrera, who is a close friend of the bride's family, quickly put that vision to rest, and suggested a more classic style. The result was a strapless, white organza dress, hand-beaded with a small paisley pattern. The tiny beads started randomly at the top of the bodice, and gradually grew more intense and clustered as they flowed down the dress. To create some exotic glamour, Herrera added a two-inch, transparent, pleated organza flounce border at the hem. When Emilia gathered her train, it

LEFT: *The ring bearer bringing the wedding bands to the altar.*
RIGHT: *The altar of Saint Stanislaus Church in the Dominican Republic.*

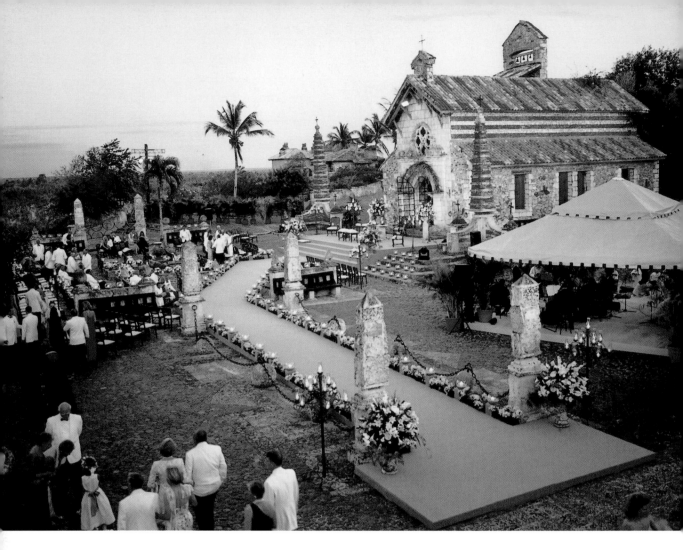

Guests of Brian and Emilia approaching the Church of Saint Stanislaus in Altos de Chavon, where the ceremony is about to take place.

was full, lusciously Latin, and light as a feather, allowing her to dance with abandon.

Emilia's flowing, white organza veil was held by a diamond tiara that had been made from a 1940s Van Cleef and Arpels necklace. The necklace, which had belonged to her paternal grandmother, had to be rewired for this purpose, and Emilia still aches at the thought of the diamond diadem that held her veil: "I had bruises on either side of my head for weeks after the wedding."

THE ATTENDANTS

Emilia decided early on not to have bridesmaids. The thought of coordinating all those schedules and organizing their hair, jewelry, makeup, dresses, and shoes, on top of everything else, sounded like a nightmare to her. Her only atten-

dant was her sister-in-law, Lourdes, who wore a powder-blue "bluebell" dress, also by Herrera. The three little flower girls were dressed in white taffeta dresses with light blue silk sashes at their waists, and held wicker flower baskets with white silk ribbons on either side.

THE WEEKEND

The guests started to arrive on Thursday evening. By late Friday morning, the American Airlines charter flight from JFK had landed and approximately 300 of the couple's friends and family—who had been having cocktails since 8 a.m.—paraded out into the Dominican sun with big straw hats, huge grins, and a passionate desire to continue the party.

The evening's events began with an inventive game of "donkey polo." This was a variation on

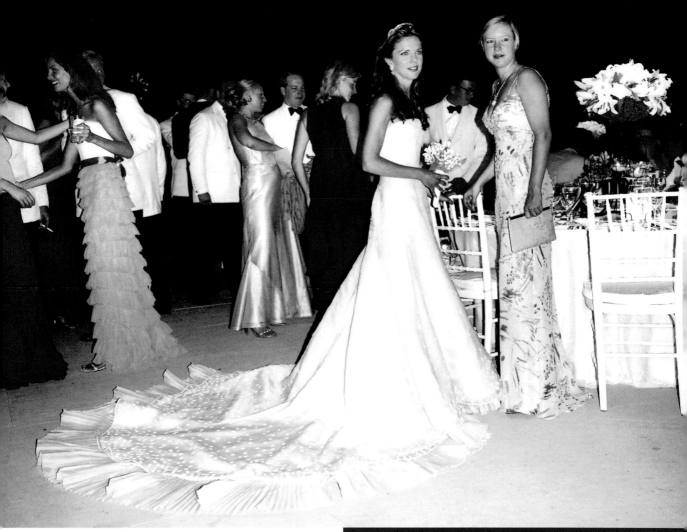

Emilia immediately after the ceremony, greeting her friends.

Argentine polo and consisted of two teams mounted on Dominican *burros* (donkeys), instead of the usual Argentine polo ponies. Donkey polo uses the same ball accessories as the original game—but brooms instead of mallets! Winning consists of the grand achievement of hitting the ball—with the broom and while on the donkey—through the goal post of the opposing team.

At the rehearsal dinner on the private beach of Minitas that night, the dress code was "barefoot on the sand." (Guests were greeted by a "shoe check" as they arrived.) Men wore casual pants with light cotton or white linen *guayaberas* (Cuban dress shirts). The ladies wore light sundresses, and Emilia led the way in a colorful Emilio Pucci design.

The tables were set on the sand and decorated

Bird's-eye view of the construction of the tent on the front lawn of Emilia's house, which was over 25 feet high and completely transparent.

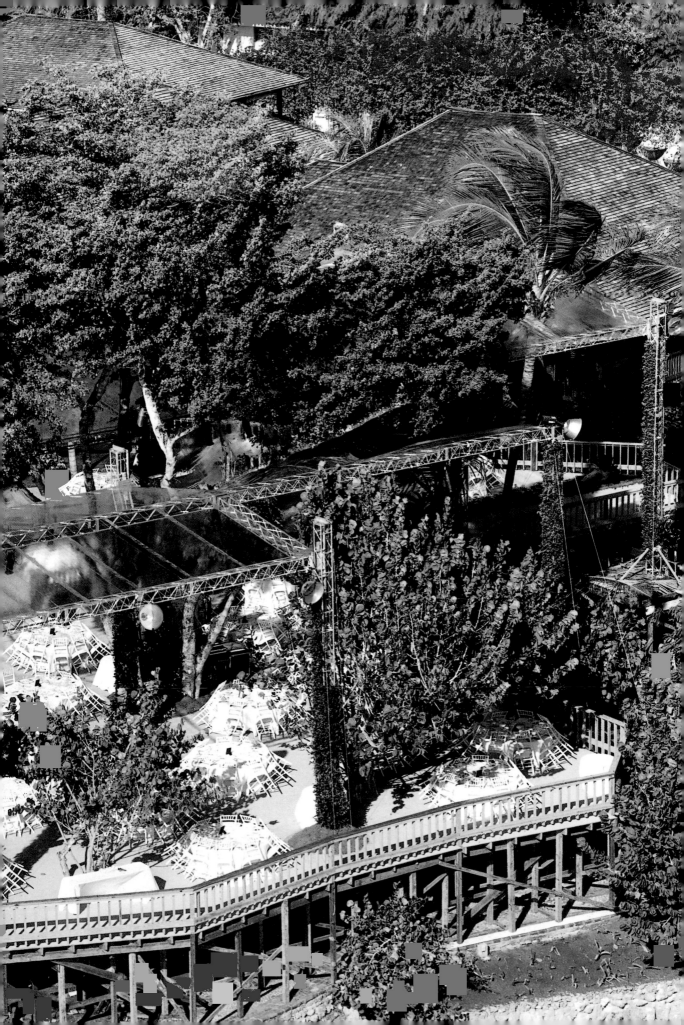

with pale pink linens, while white votive candles resting on centerpieces of mixed shells and sea stars. A typical Dominican buffet was served, with suckling pig, grilled lobster tails, plantains, black rice, hearts of palm salad, and exotic fruits, with *dulce de leche* ice cream for dessert. Dominican cigar rollers were on hand for guests to indulge in, and guests danced on the sand all night to the music of a salsa band.

THE MISHAP

Emilia woke up on her wedding day to a slight panic around the house: Father Pat O'Neil—the priest who married her grandparents, her parents, and all her aunts and uncles, and had also baptized each of their children—had suffered a heart attack after partying with the guests the night before. Thankfully, he was alive, but since he was in the hospital, he had to be immediately replaced by a local priest. Finding a priest on such short notice was only part of the hurdle—the community's strict clergy were reluctant to perform the marriage of a couple they had never met. Fortunately, a priest agreed to marry them because Emilia's parents were such an integral part of the community. The fact that he spoke no English was the least of their worries—Emilia simply asked him to shorten the service and to forgo a speech. The wedding could go on. With the priest situation under control, Emilia could enjoy the afternoon on the beach with her friends. At 4:30, her mother reminded her that it was time to prepare for the big night. As she wore her hair down, as she always does, and very

little makeup, she was still able, with the help of a local stylist, to make her seven o'clock wedding.

THE CEREMONY

The candlelit ceremony was held in a beautiful piazza surrounded by six pillars in front of Saint Stanislaus Church. The local ladies who arranged the seating had decorated the pews with a bevy of local flowers—white orchids, Casablanca lilies, white roses, hyacinths, phaleonopsis, and agapanthus. An angelic boys' choir heralded the beginning of the ceremony. The new priest overcame the language barrier with great charm, and the short service was peppered with Spanish jokes that kept the audience entertained. As they exchanged their vows, a light breeze blew through Emilia's veil, giving an ethereal quality to the image of her and Brian kneeling in front of the altar, under the stars.

> 66 As they exchanged their vows, a light breeze blew through Emilia's veil, giving an ethereal image of her and Brian kneeling. 99

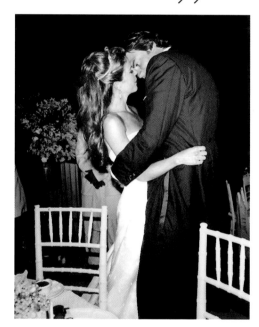

THE FAVORS

As Emilia and Brian sailed away on a private yacht for their idyllic honeymoon in the British Virgin Islands, some of the guests prepared for their journey back home, while others extended their stay into an Easter vacation. When their friends and family members left the island, they each received a set of bright red wooden plates, that were hand-painted by a local artisan named Bibi Leon. The women received a set depicting hummingbirds, a symbol of love and eternal happiness, while the men's plates featured frogs, good omens in many Latin and European countries—beautiful and symbolic souvenirs of the magical affair.

THE CAKE

The five-tier wedding cake by Paola Sturla was composed of four individual layers, each 6 inches high, with the first base 40 inches in diameter. The creation measured over 3 feet tall. It was decorated with natural flowers, including pink and white freesias, roses, and hydrangeas.

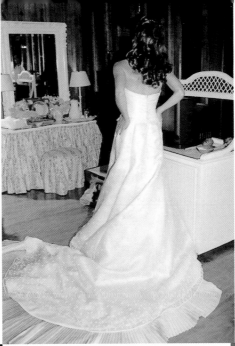

THE DRESS

Although Emilia wanted a more casual and carefree look for her island wedding dress, her couturier and family friend Carolina Herrera gently discouraged her impulses and instead directed her toward a look that would remain classic throughout the years. This strapless organza dress had a tiny hand-beaded paisley pattern at the hem and a two-inch transparent flounced border that became wider toward the back. Although it had a long train, Emilia's wedding dress remained light as a feather when she wanted to join her friends on the dance floor.

THE MENU

FIRST COURSE
Fonduta di Ravioli with tallegio, robiola and fontina cheese
Chilean Sea Bass with wild mushrooms, asparagus tips, galette of potato with herbs and porcini jus
Louis Latour 1999

MAIN COURSE
Roast tenderloin of Beef with tomato provençal, roast carrots, confit of shallots, haricots verts, and a Perigourdine sauce
Château Meyney, St. Estephe 1998

DESSERTS
Mini crème brûlées, Petits fours
Wedding Cake

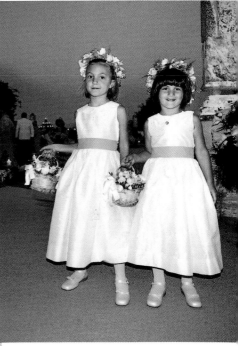

THE GAME

Before the rehearsal dinner on Minitas beach, Emilia and Brian organized a mock "donkey polo" game with players using brooms instead of mallets. Straw hats befitting the occasion were distributed to shield faces from the fierce Dominican sun.

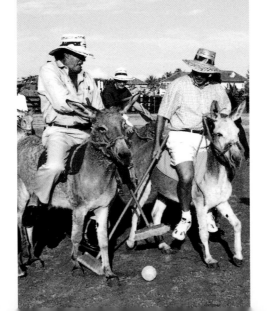

THE FLOWER GIRLS

The little flower girls, dressed in white taffeta dresses with light blue silk sashes, held wicker baskets overflowing with flowers. They wore garlands of white and yellow flowers in their hair. The girls were accompanied by a ring bearer, who wore white bermuda shorts, a short sleeved shirt, and had a light blue silk sash around his waist.

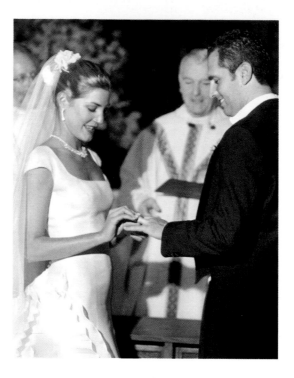

NEW YORK
NEW YORK

MARISA NOEL & MATTHEW BROWN, OCTOBER 26, 2002

THE ROMANCE

Matthew Brown had it all planned out. The dashing 33-year-old investment manager had been on a quest for the past two years for a tall, exotic beauty named Marisa Noel. When she finally broke up with her boyfriend in July of 2000, Matt began to secretly plot his conquest of the 25-year-old, hot-blooded Brazilian.

He chose a fund-raising dinner over Labor Day weekend for the scene of the seduction. After hearing that Marisa would be at this event, Matt called to RSVP, and charmed the PR rep into giving him a seat next to "the lovely Marisa Noel." At the party, Matt brought out his wit and banter to keep Marisa engaged and entertained all night long. A proper first date (to see the musical *Cabaret*) soon followed, and shortly thereafter, they were inseparable. But Matt's conquest was not over yet. After an incredible year of dinners, long jogs in Central Park, and trips to places like Capri, Botswana, and Mustique, Matthew took Marisa and a few of their friends to his brother Chris's villa called Casa Parasol ("umbrella house") in Careyes, Mexico, for the Thanksgiving holiday. He had a plan up his sleeve and an emerald-cut diamond ring—which he had designed himself—in his pocket.

ABOVE: *Mr. and Mrs. Matthew Crawford Brown exchanging their vows at the Church of Saint Vincent Ferrer.*

OPPOSITE: *Marisa, hours before the ceremony, in her family's apartment.*

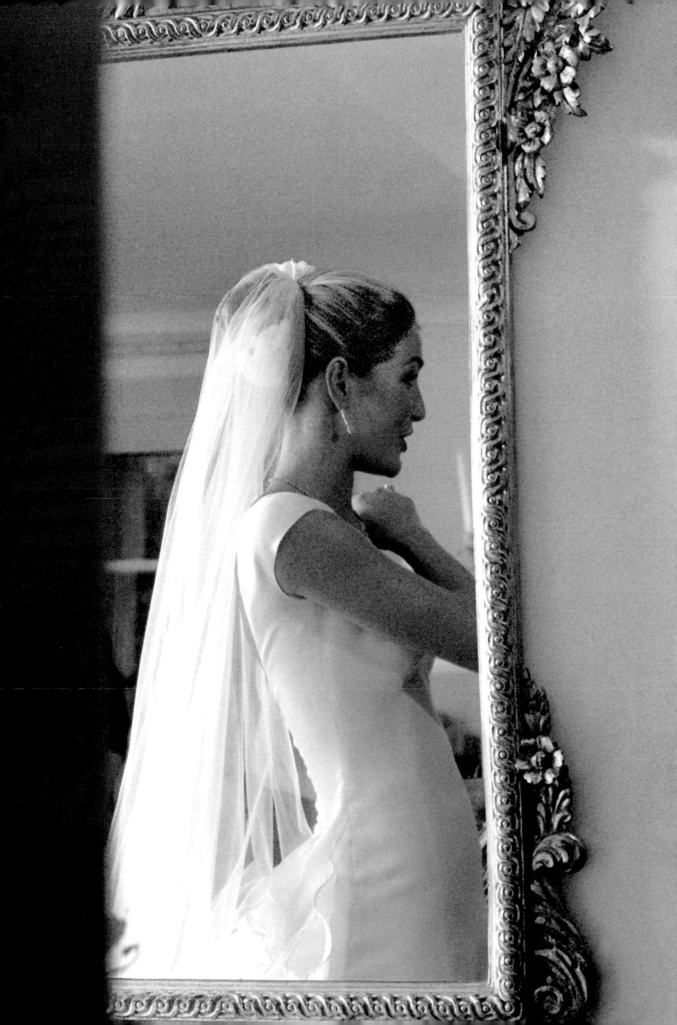

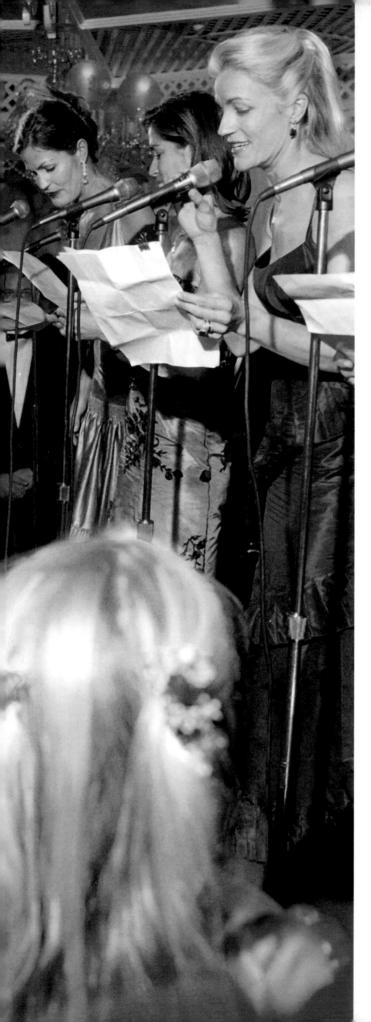

On their first day there Matt, concocting an elaborate story about a "lunch date" that they must attend, whisked Marisa away from the others for a private lunch on the beach. Other girls might have become suspicious upon seeing the canvas tent and the chilled champagne, and hearing Matt's "confession" about just wanting "our own moment together," but Marisa just thought it was Matt. "He is such a romantic," she says. "He would just do that kind of thing."

An hour later, Marisa was basking in the Mexican sun with her head in Matt's lap, when out of the blue he said, "Sweetie, I have to ask you something." Marisa felt him reach into his beach bag, out of which he produced an unmistakable little black box. "Will you make me the happiest man in the world?" he asked. "Will you marry me?" As they hugged and kissed, barely able to contain their joy, Marisa spotted a man on horseback coming toward them, leading two horses on reins. It was like a scene out of a classic Hollywood romance: The couple jumped on the horses and galloped up and down the beach with total abandon. Matt's conquest was finally over.

THE PLANNING

Marisa's mother Monica is a renowned hostess in Greenwich, Connecticut; Mustique; and New York, and was a veteran wedding planner, having gone through the process with Marisa's four older sisters. So she and Marisa already had a good idea of what they wanted: Studio 54 legend Chris Ford to DJ; The Starlight Orchestra as the band; Dutch flower expert Remco Van Vliet as the florist and decorator; and an overriding autumn theme. The catering would be done by Tavern on the Green, where the wedding was being held, and they chose the fabric, style,

LEFT: *Marisa's sisters, Ariane, Corina, Lisina, and Alix (not shown), singing a song they wrote for their youngest sister.*
RIGHT: *Matt and Marisa showing off their Fred and Ginger moves at Tavern on the Green.*

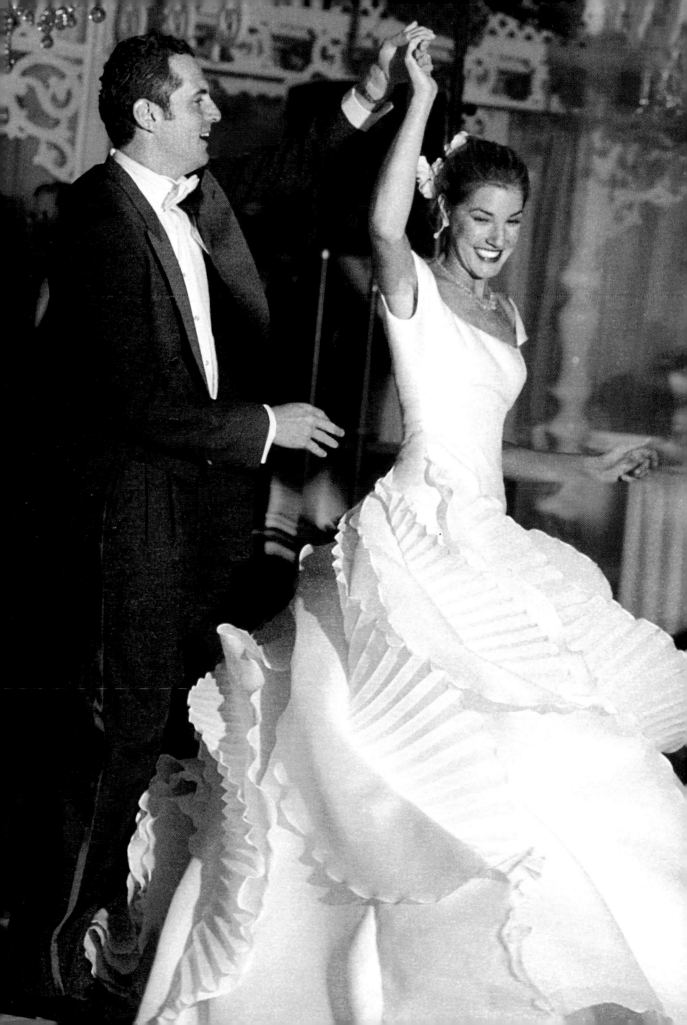

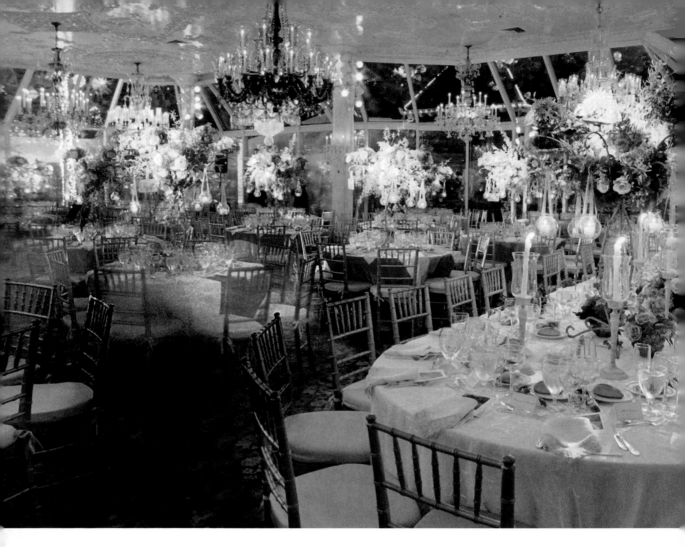

The interior of Tavern on the Green, decorated by Remco Van Vliet.

and color of the tablecloths themselves. What they needed was someone to pull it all together. That someone turned out to be Simone Martel, a veteran wedding planner. Simone arrived toward the end of the wedding process to orchestrate a smooth production, and to shield the bride from last-minute worries. When the couple found out a week before the wedding that there would be a Bar Mitzvah celebration at Tavern on the Green until just hours before their party was supposed to start, Simone took charge of the potential crisis. She made sure that the more than sixty tables were set, the flower arrangements were flawless, and all of the name cards were in the appropriate place. Thanks to Simone, Marisa could be confident that everything would go as planned and focus on her most important task—looking her most beautiful.

THE DRESS

Marisa's favorite part of the whole wedding planning was the creation of her dress. "I was very focused on my dress—I really wanted something that I had created or at least I was a big factor in the creation." Though she did not have a specific vision of her dream dress, she did know exactly what she didn't want.

The first thing she did was go to Kleinfeld's, the famous bridal emporium in Brooklyn. There, she tried on dresses of all different styles and cuts to figure out what kinds of necklines, waistlines, fabrics, and looks she liked (and suited her)—something that she advises all brides to do. She then made appointments with all the usual bridal designers: Vera Wang, Carolina Herrera, and Badgley Mischka. But when a friend told her about a Venezuelan designer named Angel

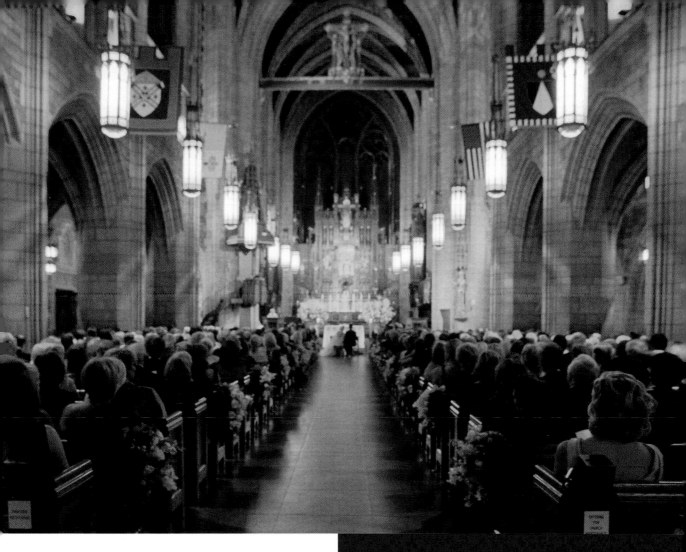

The Church of Saint Vincent Ferrer.

Sanchez, she was intrigued. After checking to see if she liked his designs at Bergdorf's, she made an appointment to visit his showroom. Marisa knew from the minute she walked in that she had found her man. Angel's warmth and Latin exuberance instantly drew her in, and the precise lines of his clothes—owing to his architectural training—was exactly what she wanted. "I wanted a structured and beautiful dress in its form and in its lines. I knew I wouldn't be able to pull off something with lots of lace or intricate design. I wanted something bold and strong, and this is exactly what my dress ultimately looked like."

THE CEREMONY

The ceremony was held in the Church of Saint Vincent Ferrer, an ornate and majestic church

with gorgeous architectural details. Since Marisa and her mother had concentrated their efforts on the decorative and aesthetic aspects of the wedding, Matt was left in charge of the religious ceremony. "I pretty much gave him free rein with the church, to choose the priest, and let him decide how the service would be structured, because he comes from a very Catholic family."

The one thing she and her mother were concerned about was the length of the mass. Marisa, who is half-Brazilian, was worried that her exuberant Latino guests—who don't like to wait for a party to start—wouldn't be able to sit through the service while all 650 guests received communion. But Matt insisted on having the proper wedding mass and he was right to do so: all the guests commented on how beautiful the ceremony was, what a warm familial feeling it evoked, and how it touched everyone's hearts, regardless of faith or nationality.

THE ATTENDANTS

Marisa did have definite opinions on who should take part in the ceremony, and where they should be situated. She wanted to include all of her family and all of Matt's in the wedding party, so she could show everyone how very special they all were to her. First came her sisters: one was her witness, and the other three walked down the aisle with their spouses and the babies that were too young to be flower children. Next came the bridesmaids and groomsmen (seven each), walking in pairs. Marisa had each bridesmaid choose her outfit because "I wanted them each to look different and unique, but still

"Anything you can do differently adds to the special quality of these occasions, making them so much more interesting."

be recognized as being a special element in the wedding." Her only request was that they not look too "spring-like," and she gave the final approval on each of their choices.

Preceding the bride were eighteen girls and boys, ranging in age from 2 to 10, wearing outfits designed by Monica Noel. The toddler girls wore traditional smock dresses with very puffy sleeves, a huge sash, and a big bow. The older girls wore a version with less puffy sleeves, a smaller petticoat, and a drop waist. They all wore Mary Janes. The boys wore chocolate velvet knickers and white silk "Lord Fauntleroy" shirts.

THE FLOWERS

Marisa was very concerned about keeping her floral arrangements tasteful, especially in the church. Using tawny colors inspired by the autumn theme, she had Remco Van Vliet create four huge bouquets in stunning combinations of ivory, tangerine, apricot, and chartreuse, which were placed in oversized urns. Bouquets of similar colors, tied with an apricot-colored ribbon, adorned every third pew.

THE DECOR

For inside the tent that encompassed the entire outdoor area of the restaurant, Van Vliet used a magnificent palette of apricot, tangerine, gold, buttery yellow, and mocha. To create a starry effect throughout the room, he draped the entire ceiling with a shimmering beige fabric, and tied the votive candles from the arms of the centerpiece candelabras, by an amber-colored organza ribbon.

THE FLOWER
GIRLS & PAGEBOYS

Since both Matt and Marisa come from large families (they are both the youngest of five siblings), their nieces and nephews made up their eighteen flower girls and pageboys. The girls wore burnt orange dresses and the boys wore "Lord Fauntleroy" shirts and chocolate brown velvet knickers designed by Marisa's mother, Monica.

THE DRESS

"I loved my dress because it had a lot of drama, umph, and chutzpah. Angel Sanchez created a dress that was totally me! Sometimes dresses get trendy, you see the same style again and again that indeed might be beautiful, but it is important to chose a style that is suited to you." Marisa reveled in her stunning white silk gazar dress throughout the evening.

THE MENU

FIRST COURSE
Timbale of Maine Lobster
Copperidge Chardonnay, 2000

MAIN COURSE
Rack of Veal
Ragout of wild mushrooms
Green pea Risotto
Baby carrots and asparagus spears
Copperidge Cabernet Sauvignon, 2000

DESSERT
Mesa di Doces
(Viennese dessert buffet)
Wedding Cake
Champagne

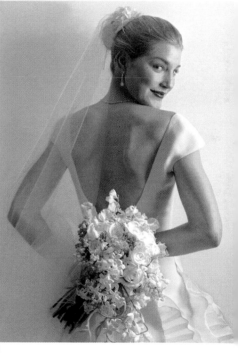

THE CAKE

The five-tiered cake by Tavern on the Green had an all-white filling and pastel-colored flowers. Following Brazilian custom, in addition to the cake, Marisa and Matt had an elaborate dessert buffet called "Mesa di Doces."

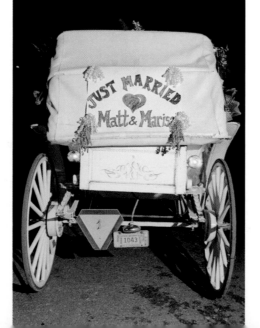

THE HONEYMOON

Marisa's favorite moment of the entire wedding was when she walked out of her party at five in the morning and got into a car waiting outside the restaurant, having no idea where she was going next. It turned out that she did not have far to go. Matt had booked a room at the Ritz Carlton on Central Park South for the night. The next evening, after a day of relaxation and massages, the happy couple boarded a plane for their real honeymoon in Rajasthan. Despite having fractured her foot horseback riding, Marisa managed to have a wonderful time in India.

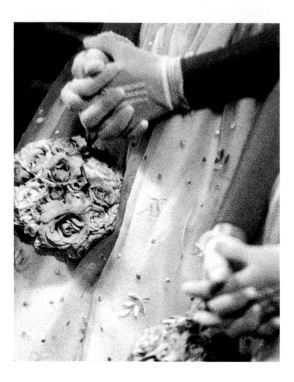

CARACAS
VENEZUELA
CLAUDIA CISNEROS & JAVIER MACAYA, NOVEMBER 15, 1997

ABOVE: *Flower girls wearing white lace gloves, and holding a bouquet of roses.*

OPPOSITE: *Claudia in her John Galliano (for Christian Dior) Haute Couture dress, and the veil that her sister Mariella had worn at her own wedding.*

THE ROMANCE

Theirs was a romance born out of rivalry, nurtured in the unlikeliest of environments: a business deal. When Venezualan businessman Oswaldo Cisneros hired Javier Macaya to represent his family's interests in an important deal, he was instantly dazzled by the young investment banker's business acumen. Mr. Cisneros began to sing his praises unceasingly to his daughters, much to the chagrin of his youngest, Claudia, who worked in the family business. As it became clear that Javier, whose family traveled in the same circles as Mr. Cisneros, was becoming the son her father never had, Claudia's jealousy and curiosity bubbled over. She decided that she just had to meet the person who had upstaged her in her father's affections.

Claudia flew to New York for her father's next business meeting in order to meet this character face to face. Though at first she didn't think much of the baby-faced Spaniard, as the meeting progressed, she became more and more impressed by the way he spoke, how he expressed himself, and his sexy self-confidence. Javier, however, paid absolutely no attention to her—which infuriated her even more. "I liked him, I didn't like him; I loved him, I hated him. He

36

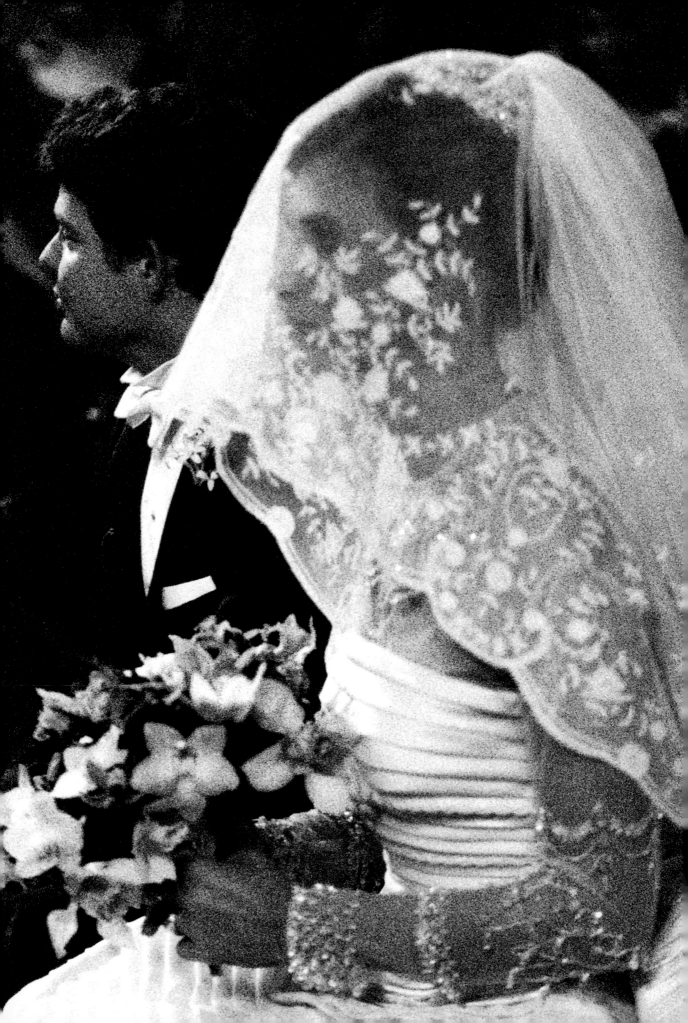

became a sort of challenge for me. I wanted to get him and dump him, to make him suffer." After the meeting, Claudia realized that when the business deal went through, she'd have no excuse to see Javier to exact her revenge. So she devised a plan to get him on her home turf, inviting him down to Caracas for a press conference that didn't actually require his presence. Little did she know that her feigned animosity was about to take an amorous turn. At a lunch to celebrate the closing of the deal, chemistry took the reins, and their rivalry was transformed into an irresistible attraction. After the long, intimate meal, Javier grabbed Claudia in the middle of a nineteenth-century cobblestone piazza and gave her an intense, romantic kiss. By the end of the week, they knew they were meant for each other. He missed his plane to go back to New York so he could stay with her, and then, after hearing of Claudia's desire to visit Provence for the first time, whisked her away for an impromptu trip. "Those were the most romantic ten days, and the most wonderful trip I could ever imagine," Claudia recalls. "In a way, this trip was a pre-honeymoon, and we got to really know each other. It confirmed just how very compatible we were." Six months later, Javier proposed in New York.

THE PLANNING

Claudia wanted to get married quickly because she was worried that "if I had too much time to think about it, I probably wouldn't go ahead with it." So a November date was decided on—less than four months away. With so little time to plan a wedding for 700, and with guests traveling to Caracas from destinations all over the U.S., Europe, and Latin America, Claudia knew that she would have to be very organized. First, in planning the guest list, she used the rule "if I can't remember them, they shouldn't be at my wedding." She wrote down the names of

LEFT: *The white orchids and tall glass candelabra that were centerpieces on the table.*
RIGHT: *Claudia changed into an Angel Sanchez party dress later that night.*

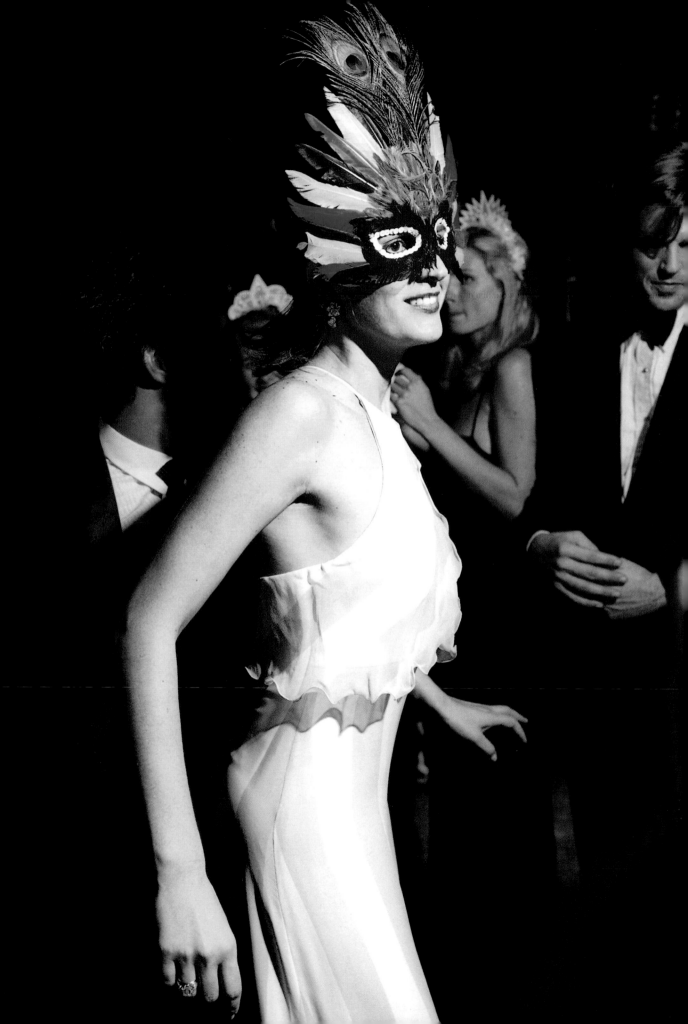

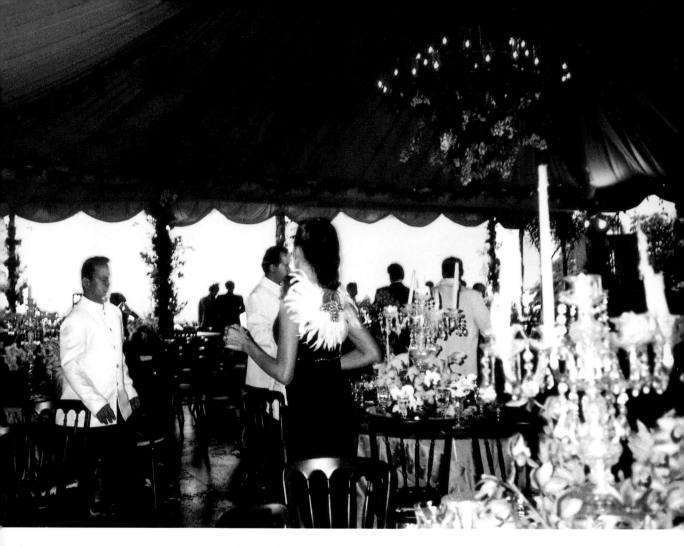

The decor under the pavilion for the wedding celebration.

the friends she could recall, and instructed Javier and her family to do the same. Then, to avoid duplication of names, she installed special software on her computer that tracked the list. She then set up an RSVP fax number and an e-mail address for guests to respond around the clock, no matter what time zone they were in. On the first night, Claudia's uncle was to give a dinner for the couple, the next day would be the wedding, and then on Sunday a brunch at the bride's house.

THE DRESS

Though nervous about the wedding itself (she admits that she and Javier almost eloped a few months earlier in St. Tropez), Claudia had no doubts about the dress. Her dream dress was the one Grace Kelly wore on her wedding day, and ever since she was a little girl, "I always wanted to

have a Dior dress for my wedding." With those two guiding inspirations, she and her mother went to Paris to try on some of John Galliano's couture evening dresses. Claudia fell in love with the first one she tried on.

Because the strapless dress would be considered too revealing for church, a delicately embroidered "body suit" was added. This was a slip-on bodice of incredibly delicate tulle, with long sleeves and very elaborate embroidery of tiny pearls and diamonds around the neckline and the cuffs.

Claudia also requested two different sized trains—a long one for the church ceremony and a shorter version to dance in at the party. These were attached by different zippers, and were easy to add and remove. Claudia wore her mother's earrings from when she got married, and borrowed her sister Mariella's veil.

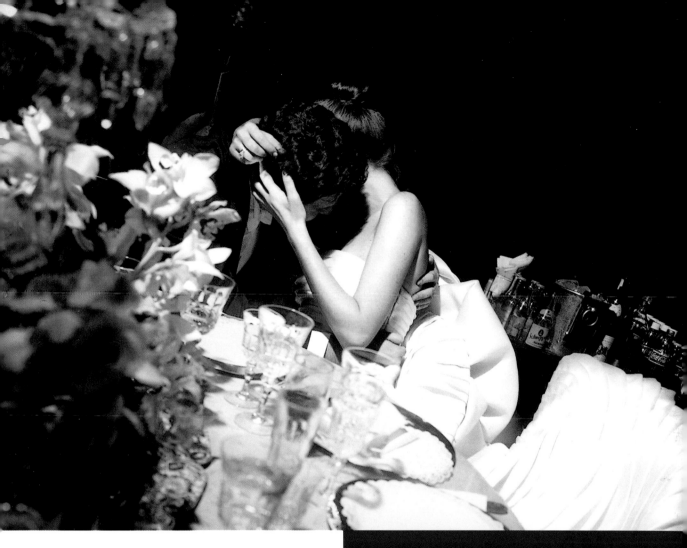

Claudia and Javier in an intimate embrace at the reception.

THE ATTENDANTS

Her flower girls were dressed in pink silk taffeta with round collars and puffy sleeves trimmed in lace. A pink bow from the same fabric was neatly tied in the back, with pink bows at either side of their heads. The skirt had an overlay of tulle embossed with white flowers.

THE CEREMONIES

On Friday night, Javier and Claudia had an intimate civil ceremony at the house of Claudia's uncle, Ricardo Cisneros. The setting was magical: an Indian gazebo surrounded by orchids and tropical flowers. Claudia wore an Asian-inspired purple silk dress that her mother had worn at her christening. No worries about overshadowing the bride here: Javier's sisters, who were serving as the two

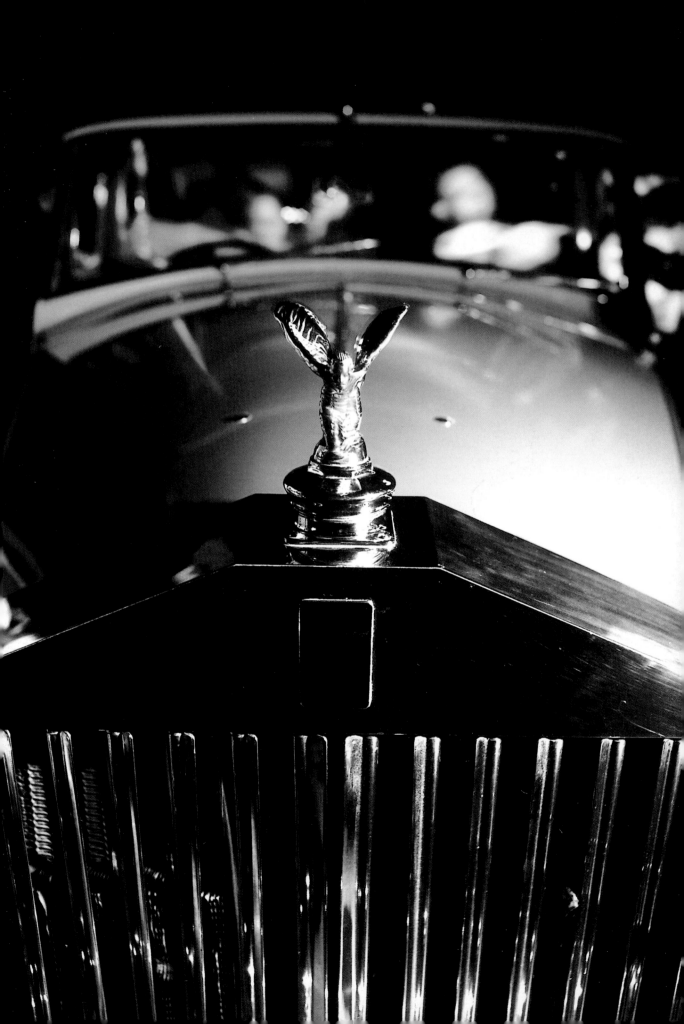

The father of the bride, Mr. Oswaldo
Cisneros, in the back seat...

OPPOSITE:
...in the Rolls Royce that was to take
Claudia to her wedding.

witnesses, had lost track of time and had to be dragged out of the shower to sign the civil documents in their bathrobes.

On the day of her wedding, halfway to the church, the elegant vintage Rolls Royce that Claudia and her father were riding in gave a gasping sound and died, leaving the two no choice but to take Mr. Oswaldo Cisneros's less stately but more reliable Jeep Wrangler, which was quickly summoned from the bride's home. Despite the commotion, they made it to the church safe and sound, stopping a few feet away from the waiting photographers to save Claudia the embarrassment of such an unglamorous arrival.

Inside, the church was filled with white and pale pink roses, gladiolis, and lilies mixed with baby's breath in tall silver vases. Claudia, who loves orchids, held a bouquet of white and pale green cymbidiums.

Claudia thought that she would be nervous walking down the aisle but to her surprise, she felt very present in the moment. "I was so nervous for so many months, but this was my moment of peace. I was thinking of how I wanted to be a good mother, a good wife. It is every girl's dream, the moment when she walks down that aisle, all the eyes on her. You are marrying the man of your dreams and starting a new life. It was a truly spiritual moment for me."

> " I was so nervous for so many months that this was my moment of peace. It is every girl's dream. You feel as if you owned the world. "

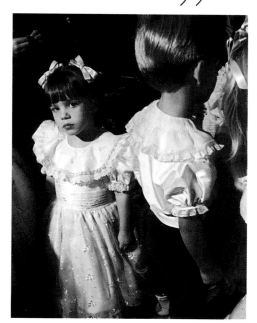

THE RECEPTION

Although Claudia wanted a great big party for her wedding day, not a quiet family celebration, she still wanted to be able to spend time talking with the friends she rarely had the chance to see. She felt that this was the last time that she would have so many of her friends around her. She wanted to create a traditional Venezuelan decor that blended their two cultures: Javier's Spanish background and her Latin American roots. The reception was held on the grounds of Claudia's house in Caracas, called Quinta Los Cisnes, under a big pavilion constructed for the event.

The marathon evening started with a typical Venezuelan buffet dinner, followed by dessert and dancing. There were small bars scattered around the room, and waiters passing hors d'oeuvres and trays of wine, champagne, and still water around.

Colorful masks were distributed in big baskets, and following the wild rhythms of the Brazilian samba dancers, guests made a Conga line all around the tent wearing their masks. After the samba, a DJ took over playing a variety of the latest hits and Latin music.

THE HONEYMOON

Claudia has one firm piece of advice for the honeymoon: "Don't do what we did!" After four days of non-stop activities and partying, she and Javier jumped on a plane the very next day for the 36-hour trip to Bali. "I wish I had stayed home and taken a couple of days to recover by the sea, or up on a mountain lodge—somewhere peaceful and quiet!" After having gone through a marathon of parties preceding the wedding, Javier became sick with a high fever the first day of his honeymoon, leaving Claudia no other option but to shop till she dropped—and shop she did!

THE CAKE

Claudia and Javier chose a three-tiered cake that was all white inside. According to custom, they saved one piece to eat on their first wedding anniversary. The taste of the cake rekindles fond memories of their wedding day and brings back the happiness they felt that day. Instead of throwing the bouquet, Claudia embraced the Venezuelan custom of having her friends pull on silk strings coming out of the cake in order to find a prize of a gold heart-shaped pendant hidden inside. The lucky girl who found the necklace is supposed to be the next to walk down the aisle.

THE DRESS

Claudia always dreamt of having a Dior dress for her wedding. For her, the ultimate in style would be the dress worn by Grace Kelly to her wedding. "It was simple and elegant." Claudia's dress was made of organza, lace, and tulle. There was additional tulle in between the horizontal layers of organza that were wider around the edge of the dress and became narrower at the waist. For the church ceremony she wore a tulle bodice to cover her arms and shoulders, which had an intricate pearl and crystal embroidery around her neck and wrists.

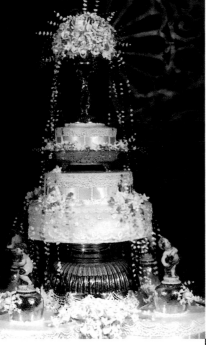

THE MENU

FIRST COURSE
Langosta Cribiche
(Lobster in its shell)
Foie de Canard Frais en su Salsa de Uva
(Fresh Duck liver in its grape sauce)
Langostinos Jumbo con Salsas Vanadas
(Jumbo Crayfish with its sauces)

MAIN COURSE
Ceviche de Mero Servido en Calabazas
(Red Snapper served in pumpkins)
Assado de Carne
(Variety of Meats with rice, plantains, and yucca)

DESSERTS
Chocolate cake,
meringue with strawberries and chantilly sauce,
guava pie, passion fruit mousse,
and small bite-size cupcakes with coconut
and dulce de leche

THE DECOR

Claudia loves orchids and chose for her wedding a mixture of pink, white, and yellow phaleonopsis, and cymbidiums to surround the cut crystal candelabra that were in the center of her tables. Tall candles reflecting off the dusty-pink silk damask tablecloths added to the glamour of the setting.

THE AFTER-PARTY

At about 2 a.m., the party switched gears, and the elegant wedding celebration gave way to a wild party. Omelets, salads, and sausages were brought out, and the band was replaced by an ensemble of Afro-Brazilian bongo dancers. Then, at about 4 a.m., the breakfast buffet was laid with croissants, arepas (corn fritters), and churros (fried dough with cinnamon) accompanied by hot chocolate, coffee, tea, and fruit juices. Throughout the night there were small bars stationed around the room, and waiters constantly passing out hors d'œuvres, wine, champagne, and still water to keep the guests' energy high.

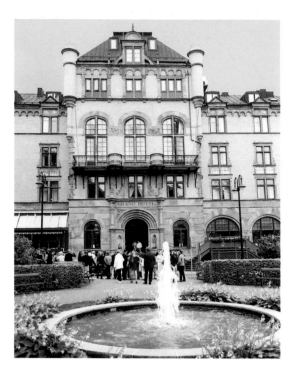

LUND
SWEDEN

ULRICA BOMAN & ALESSANDRO LANARO, JULY 25, 1998

THE ROMANCE

Once upon a time, a dashing young Italian named Alessandro Lanaro showed up in the quaint seaside village of Southampton, Long Island. This knight in a shining Range Rover was taken in by a group of Swedish stunners, who were out on the island escaping the treacheries of the New York summer. He quickly won their hearts, wining and dining them, lending them his car, and defending them from lecherous men. All of which earned him the nickname "Carl Gustav," after the famous Swedish king, who was known for his fun-loving and charming personality.

Amidst the blonde-haired, blue-eyed beauties, there was a certain feisty brunette who caught Alessandro's eye, and made his heartbeat quicken: the lovely Ulrica Boman. One day, he plucked up his courage (for even the most valiant get nervous when it comes to love!) and asked her out on a date. She accepted his offer, and allowed him to whisk her into the city for a dinner at Cipriani in SoHo. The evening was a success: by the end of the dinner they knew they were meant for each other. As the summer progressed, they fell more deeply in love, and by September, they were living together.

ABOVE: *The Grand Hotel in Lund where guests stayed and convened for a welcoming cocktail.*

OPPOSITE: *Sipping champagne, the newly-weds arrived at Svaneholm Castle in a tiny rowboat sprinkled with white daisies, green ivy, and blue wildflowers, over a shimmering pond.*

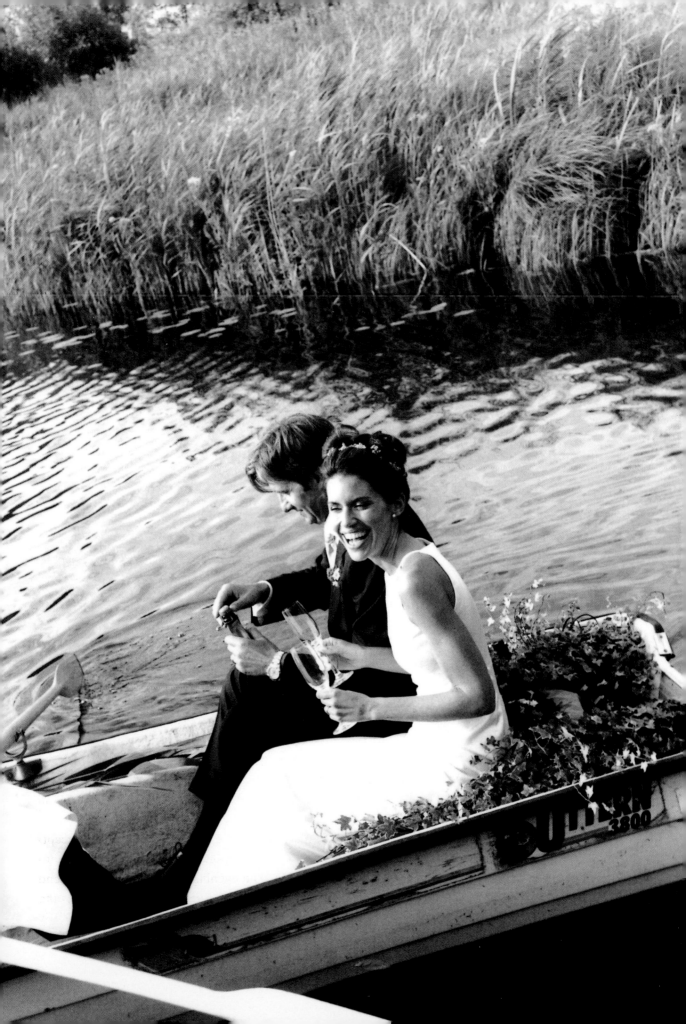

Alas, the happy couple would all too soon be challenged by the evil forces of circumstance. Ulrica's job at an advertising firm was coming to an end, and she was soon to be sent back to Stockholm. She managed to postpone her departure for a few months, "but never did I think of not leaving."

Bravely, Alessandro decided to take matters into his own hands, and confront adversity head on. He organized a romantic Thanksgiving getaway to Saint Bart's, where they stayed at a quaint hotel up in the hills of Gustavia. There, on the big terrace overlooking the ocean from their bungalow, in the soft light of the sun setting behind the palm trees, Alessandro went down on his knees in his white terry cloth bathrobe and proposed, with a custom-made Stuart Moore platinum diamond ring.

Ulrica was overwhelmed with joy and amazement: after only four months together, she had found true love. "I don't commit to things so easily; I am more of a skeptical person. This was so unlike me! But I felt comfortable with him," she says.

THE PLANNING

Setting the wedding date was a difficult and emotional challenge. Ulrica's father had recently been diagnosed with lung cancer, and the doctors had given him only a few months to live. Though she desperately wanted to honor her father's wishes to marry right away, the naturally cautious Ulrica didn't feel that she could rush into a wedding so quickly, especially with someone she had known for so short a time. "I wanted to go into this marriage knowing exactly what I was getting into, with no illusions," she says. "I wanted the wedding to be a celebration of finding each other forever." The wedding was set for July 25th of the following year.

LEFT: *Two flower girls in traditional Tyrolean dress, in honor of Alessandro, who is from Cortina in the Italian Alps.*
RIGHT: *Ulrica's bridesmaids, Sandra, Charlotte, and Monica.*

The couple at their wedding reception under the traditional Swedish "bjork," made of white daisies, birch leaves, and blue cornflowers.

THE SETTING

That summer, Ulrica flew home to Stockholm to start the preparations. She had envisioned a typical urban wedding, but at her father's suggestion, she began to consider Lund, in southern Sweden. It is a part of Sweden very few tourists get to see, and would be different and exciting for their guests. Most important, Lund is where her father's family comes from, and where Ulrica had spent all her childhood summers.

When she got there, she immediately fell under the spell of the pristine countryside. She found the most beautiful and romantic location imaginable for the service, the Church of Dalby, the oldest stone church in Northern Scandinavia. Dating from 1150, it sits on a hilltop overlooking a beautiful valley. Inside, the church is medieval in style, with ornate altar decorations, sculptures,

and colorful window paneling. For the reception, Ulrica decided on the magical setting of the sixteenth-century Svaneholm Castle. Built in the 1500s, the Renaissance castle is on an islet on the Svaneholm Lake, for which it is named. (The lake itself gets its name from the swans that fill it.) The castle is said to be home to the ghost of a "White Lady," who walks around the lake at midnight.

THE DRESS

Ulrica knew she wanted something simple for her wedding dress, without any fluff and puffiness. "I am a tomboy, and that princess look really doesn't suit me," she says. She checked all the bridal stores in Manhattan, but found only one dress that she felt was "her": a sleek white silk dress from Vera Wang. Instead of a veil, she had a Swedish flower called *hund kex* braided in

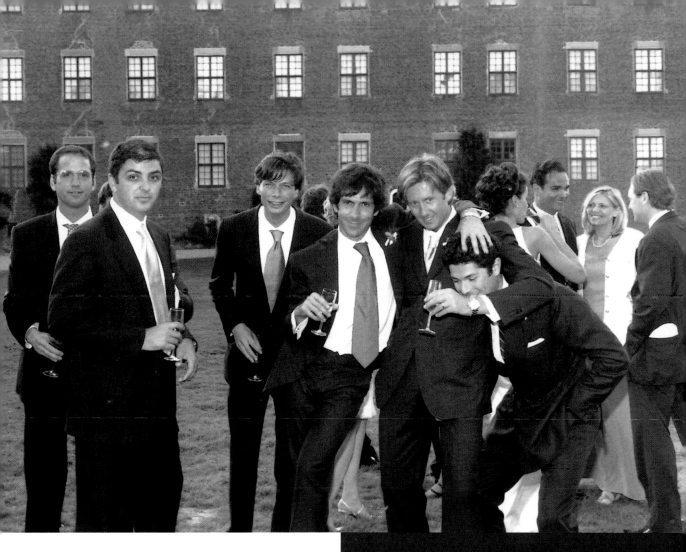

The bridegroom surrounded by his best men.

her hair, as all Swedish summer brides do. Her bouquet consisted of yellow baby roses, white daisies, and blue cornflowers, tied with a silk ribbon.

THE ATTENDANTS

Ulrica decided to have her three bridesmaids wear knee-length versions of her dress, in pale baby blue silk. "They are such beautiful girls—I wanted everyone to admire them. I didn't want them to be in my shadow." And they weren't. According to the bride herself, "they were real knockouts."

THE CEREMONY

Ulrica had always dreamt of a traditional church wedding and spent a lot of time planning the simple, 45-minute service. She asked a

Ulrica and Alessandro enjoying pre-dinner drinks with their guests on the grounds of Svaneholm Castle.

friend of theirs, a renowned flutist, to play a song, a trumpeter friend to play "Morning Has Broken," and another friend to sing "Ave Maria." However, despite Ulrica's intentions, there were a couple of amusing moments that set the traditional service apart from other weddings. First, as Alessandro knelt down in front of the altar, everyone burst out laughing—written in chalk on the soles of both of his shoes was the word "Help!" (The culprit: His best man.) Then, after the ceremony, the music took a sudden turn to the unfamiliar, forcing Ulrica to miss her cue to walk out of the church. Unbeknownst to her, the flutist had composed a special tune for the couple. The bridesmaids, flower girls, and Alessandro all looked at each other, not knowing what to do. The ever-practical Ulrica made her own cue, however, and started walking out while the flutist continued playing the special tune.

The most poignant moment of the ceremony, however, came when Ulrica was escorted down the aisle by her father. Against all odds, her father had stayed alive long enough to give his daughter away to the man he believed would take excellent care of her forever.

THE RECEPTION

Sipping champagne, the newlyweds arrived at the castle in a tiny rowboat sprinkled with white daisies, green ivy, and blue wildflowers. In Sweden during the summer months the sun doesn't set until well into the night, which created a magical mood that befitted the couple's fairytale romance.

"Against all odds, her father had stayed alive long enough to give his daughter away to the man he believed would take excellent care of her forever."

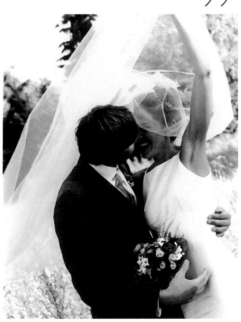

At Swedish weddings, it is customary to break couples up for the seating, which Ulrica and Alessandro hoped would encourage mixing between their two cultures. With the help of a lethal local drink called *aqua it*, this arrangement worked beautifully—though a few of the Italian wives were less than thrilled to see their husbands seated next to svelte Swedish blondes.

There was trailing ivy strewn on the tables, and the centerpieces were purposely low, so that people could talk to each other. Behind the married couple was the traditional Swedish arch, called a *bjork*, made of white daisies, birch leaves, and blue cornflowers. There wasn't a dry eye in the room when the ailing Mr. Boman gave a heartbreaking and beautiful speech to his daughter: "1969 was a very remarkable year. It was the year that Neil Armstrong took the first step on the moon, but more importantly for me, it was the birth of my only daughter, Ulrica."

THE HONEYMOON

After the wedding, the couple left for Australia and Bali. They were so exhausted from the festivities that they only woke up when their flight reached Singapore. First, they spent time on a secluded resort off Australia's famous Great Barrier Reef. They enjoyed lobster and champagne picnics on private beaches and underwater trips to view the mesmerizing colors of the diverse marine life that lives on the reef. Then, they went to Bali and trekked through the vast green rice fields of that exotic island.

THE CAR

After the ceremony, the bride and groom were whisked away in a vintage Model T, decorated with yellow and pale blue ribbons (the colors of the Swedish flag). In the rear, there was a heart made of birch surrounded by yellow daisies, blue cornflowers, and roses, with "Just Married" written inside.

THE FLOWER GIRLS

The flower girls, Charlotte, Susanna, Giada, and Lisa, were dressed in traditional Tyrolean outfits, in honor of their uncle, Alessandro Lanaro, who is from Cortina in the Italian Alps. They wore wreaths of blue cornflowers, yellow daisies, and roses in their hair. Not only did they precede Ulrica and Alessandro down the aisle, but they also had the honor of being the ring bearers.

THE MENU

FIRST COURSE
Dill and fennel marinated Salmon with caviar sauce, salmon tartar, and egg of quail

MAIN COURSE
Skåne Duckling with roasted hazelnuts, with marinated cherries, potatoes, vegetables, and port wine sauce

DESSERT
Grand dessert à la Ulrica and Alessandro Wedding Cake, Coffee

DRINKS
Swedish lemon vodka, Red wine White wine, Liquors

THE SEATING

The tables were arranged in an "E" shape, with the bride and groom and their families seated on the long side, the bridesmaids and groomsmen in the middle, and everyone else in long tables coming out from the main one. This arrangement ensured that there were no "good" or "bad" tables, and everyone was included in the action.

THE REHEARSAL DINNER

Ulrica wanted the rehearsal dinner to be very traditionally Swedish and simple. She found a beautiful spot by the lake where guests had to walk through thick clusters of trees in order to reach their destination, making it very mysterious and romantic. She wanted the event to be able to stand on its own without being overshadowed by the drama of the next day's wedding. They had one long table under the tent with elegant candelabras casting a flattering glow on the faces of Ulrica's guests.

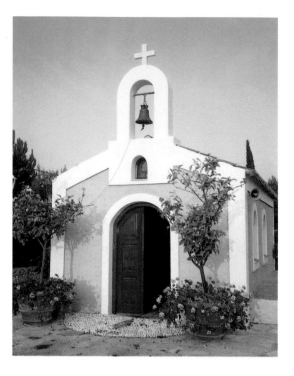

GREECE &
NEW YORK

NATASHA COVAS & RYAN KNEISS, AUGUST 25, 2000

THE ROMANCE

It all started in January 1996, on a ski trip Natasha and Ryan took to Vermont during winter break of their sophomore year at Harvard. Natasha's roommate had her eye on Ryan's roommate, and asked if the two girls could share a log cabin with them. The weather was foul—it was raining, foggy, and miserable—and no one else dared to go out skiing except for Ryan and Natasha. Their shared passion for extreme skiing fostered an instant attraction—though the long, chilly rides up the chairlifts together probably didn't hurt either. From that weekend on, the two daredevils were inseparable.

A year after their graduation, the happy couple was presented with a more logistical obstacle. Natasha had to move to Athens to work for her family's business there, while Ryan had to remain in the U.S. for law school. It wouldn't be easy keeping a relationship going over a 10,000-mile distance and a seven-hour time difference, but the brave couple faced this challenge with the same resolve they brought to the ski slopes. They set firm rules to overcome the great physical distance between them, and maintained constant contact via mobile phones. Natasha fortunately

ABOVE: *The private chapel of Saint George, in Elies, Greece, where Ryan proposed to Natasha and where the couple was married.*

OPPOSITE: *Ryan and Natasha during their Greek Orthodox wedding ceremony.*

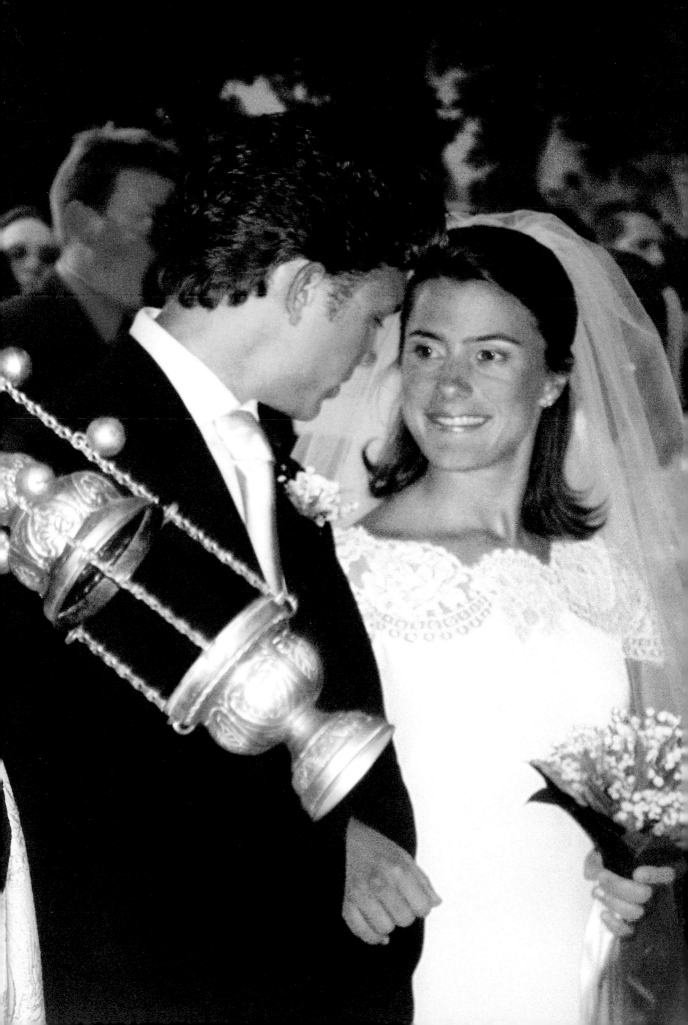

A view through the guest house at Elies, Peloponnesus Greece.

had business meetings in New York fairly often, and both made sure that they always had a plan for the next reunion. "Whenever I visited him in New York, or he visited me in Greece, we already had a ticket in our pocket for the next visit. These visits gave us strength to look forward to a happy reunion, instead of commiserating about how lousy our situation was," Natasha recalls.

Thanks to their determination and commitment to each other, they overcame this trial, and instead of allowing distance to weaken their ties, their love grew stronger. In the summer of 1997, Ryan proposed to Natasha at her parents' seaside vacation villa, called Elies, in the Peloponnesus. He took her up on the hill to the small private chapel of St. George, fell to his knees, and popped the question. "I was

extremely emotional; it was a bit unexpected," recalls Natasha. "We had talked about marriage, but I didn't expect the proposal so soon. We still had three long years of separation between us." The wedding date was set for August 2000, right after Ryan would graduate from law school and would have taken his bar exam.

THE PLANNING

For Natasha, the most daunting task of the entire planning process was putting together the guest list. "The lists were endless, mainly because my mother knows everybody on the planet!" At this point, Natasha decided to take a step back. "I made a conscious effort to pick my battles. With so many guests, it wasn't going to make a difference if my mother wanted to invite fifty more or fifty less." To accommodate their

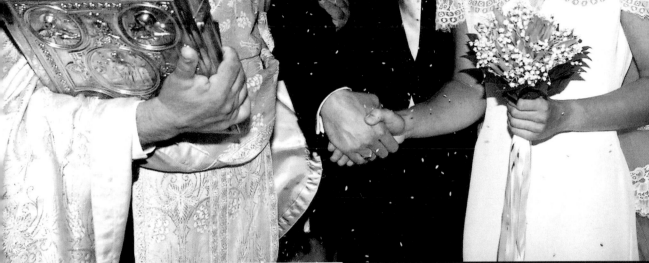

The bride and groom under a shower of rice, thrown for "prosperity."

international guests and make the festivities more manageable, they decided to break the celebration into three separate events. The first was the actual wedding ceremony and reception at Elies on August 25, for 400 of their close family and friends. Ten days later, there would be a dinner party at the Ekali Club in Athens for 200 business associates. Finally, on October 7th there would be a reception at Cipriani 42nd Street in New York for another 400 of the couple's American and international friends and family.

THE DRESS

Unlike most brides, Natasha dreaded choosing the dress. "I knew it would be so difficult to please both my mother and myself. She has very high standards, and we have very different

tastes. She wanted couture and I didn't mind picking something off the rack."

Natasha's mother brought her to Milan to visit the usual list of couture designers. Nothing they saw appealed to the bride-to-be. "I was very disappointed. The dresses I saw were definitely not my style, too ornate and vastly overdone. I was looking for something simple, that wouldn't look out of character on me, that I would feel comfortable wearing." She also had a few specific parameters: She wanted something that was conservative in the front, but low-cut in the back (a request of Ryan's), and she didn't want to reveal her shoulders in church. She finally got lucky at Gianfranco Ferré. The designer and his assistants immediately understood what she wanted, and her dream dress materialized after only two fittings.

THE CEREMONY

A Greek Orthodox ceremony is wonderful to watch—it is full of pomp and ritual—but few words are spoken. Even vows are not exchanged; instead, a priest takes the couple by the hand and leads them around the altar three times. This is called "Isaac's dance," and it symbolizes the couple's first steps together as husband and wife. Then the couple, each wearing a round flower wreath on their head, holds hands as they are symbolically bound together by a silk ribbon uniting the two wreaths. At the end, rice is thrown at the couple for prosperity.

THE ELIES RECEPTION

The reception was held under a tent on the grounds at Elies. Natasha settled on a green-and-white color scheme for this party, as Elies (which means "olives" in Greek) is surrounded by olive groves. Baby's breath, Natasha's favorite flower, was used throughout, from the

LEFT: *The couple starting their first dance in Elies.*
RIGHT: *Mrs. Iro Covas, the mother of the bride, in a seductive pose on the dance floor at Cipriani 42ⁿᵈ Street.*

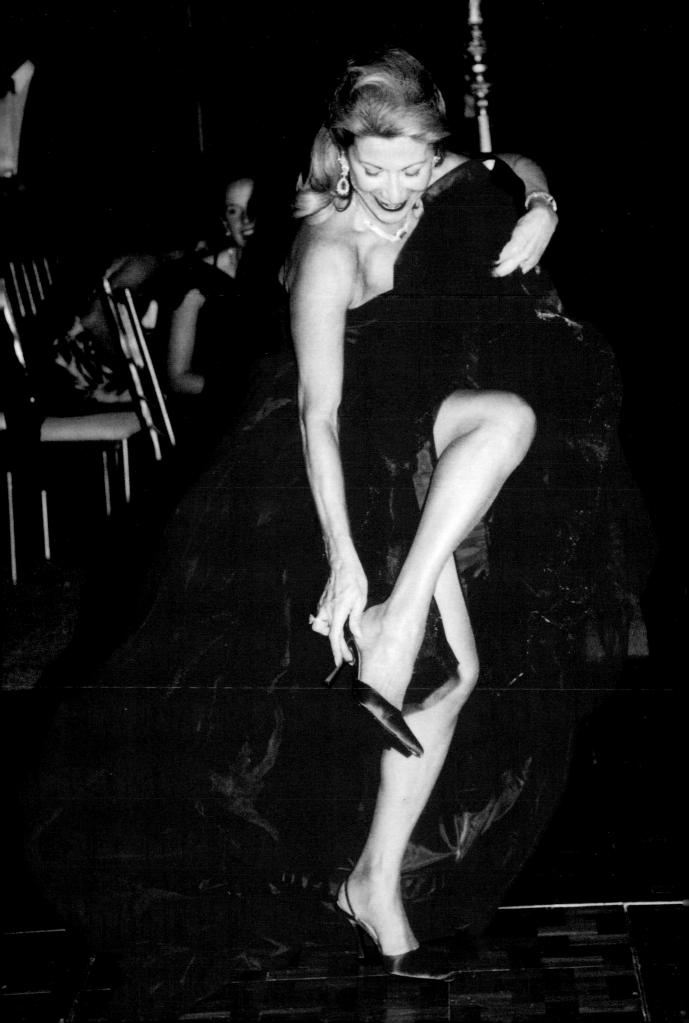

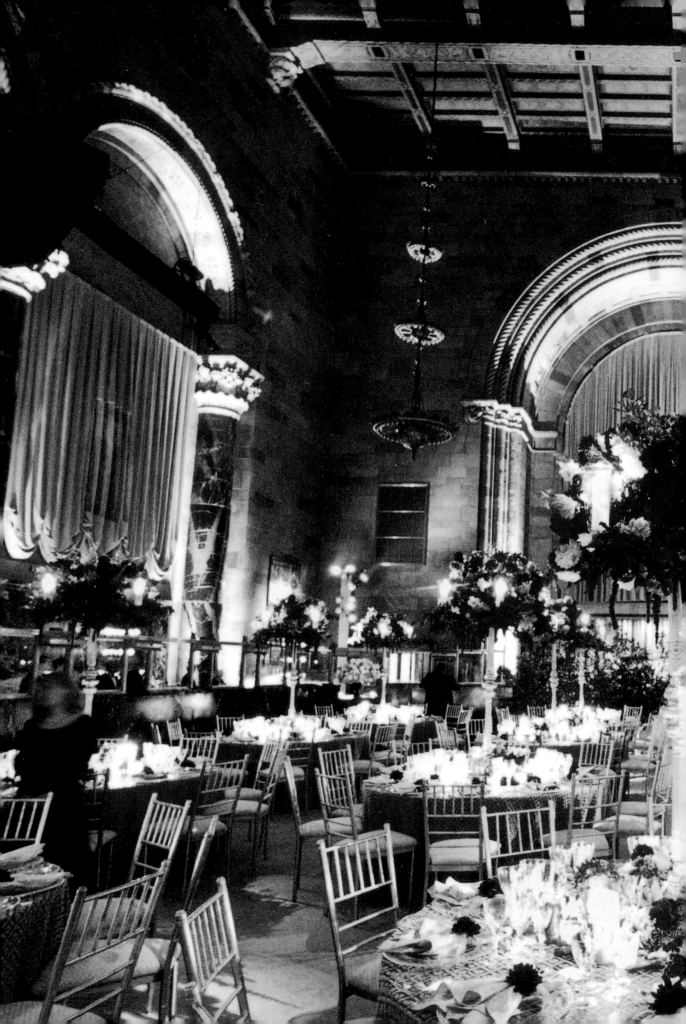

The cavernous Cipriani 42nd Street was transformed into a warm autumnal refuge by the sumptuous decor of Avi Adler and lighting by Bentley Meeker.

centerpieces on the tables, to the decorations on the tent, the custom-made chandeliers inside, and even on the golf carts that ferried the guests to and from the church.

On each of the round tables under the tent were five clay pots with topiary plants of different heights made out of baby's breath. The table-cloths were a light olive color with scalloped place mats in a darker shade on top. Each chair had cotton covers in the same dark olive, with pale green piping and a knot at the back. The wrought iron, baby's breath-swathed chandeliers were suspended by three thick metal chains; votive candles were scattered all around, giving the entire area a romantic, ecclesiastical feel.

In front of each place setting there was a minia-ture silver pot filled with sugar-coated almonds, called bonbonnieres, that is a traditional gift after a wedding and is intended to share the sweetness and happiness that the couple feels with their guests.

THE NEW YORK RECEPTION

In a lovely contrast to the serene, olive-themed reception at Elies, the cavernous Cipriani 42nd

> **"A Greek Orthodox ceremony is wonderful to watch—it is full of pomp and circumstance—but few words are spoken."**

The altar of Saint George Chapel, swathed in baby's breath, awaiting the bride and groom.

Street was transformed into a warm autumnal refuge, thanks to the harmonious collaboration of renowned floral designer Avi Adler and the talented lighting crew of Bentley Meeker. As guests entered the vast space, they were greeted with what Adler described as "a glowing tapestry of golden russets." Tall trees made of softly hued oak and maple branches, and antique garden urns overflowed with luscious dahlias in fall colors. The light in the room ranged from pale peach to soft amber, creating the most intimate and inviting atmosphere.

To the left of the entrance, in the annex, where the cocktail hour was held, there was a spec-tacular arrangement of flowering clover branches, opulent hydrangeas, dahlias, and golden roses surging from another antique garden urn. On either side of the stationary bar, there were similar, slightly smaller arrangements. Different versions of these bou-quets were also on the cocktail tables, sur-rounded by votive candles giving off their shimmering light.

The aesthetic excitement continued in the main dining room. The huge ballroom glowed in the romantic air of candlelight, and the opulent red-and-gold damask tablecloths on each of the fifty dining tables spread the warmth of golden reds throughout the room.

The centerpieces were particularly breathtak-ing. On top of each table was a four-foot-tall antique gold candelabra with majestic pillar candles. Lush floral decorations of garden roses, dahlias, fall berries, hanging amaranthus, scelosia, and a variety of orchids mingled with fresh apples and pears, cascading down from the top of the candelabras.

THE HONEYMOON

The active couple had an appropriately jet-set honeymoon, starting first in the Maldives, then traveling to Bali, and finally ending up in Australia, where they joined Natasha's family at the summer Olympics in Sydney.

THE NUPTIALS

In Greek Orthodoxy no vows are exchanged, instead a priest takes the couple by the hand and leads them around the altar three times. This is called "Isaac's dance," and symbolizes the couple's first steps together as husband and wife. The bride and groom are bound by two floral wreaths united by a silk ribbon. Afterward, rice is thrown for good luck, health, and prosperous life by the guests.

THE CAKE

The six-tier wedding cake, created by Cheryl Kleinman, was softly draped in tones of ivory, cream, and white, with rolled fondant icing and flowers made of sugar. With a luscious chocolate filling made of mocha and ganache, it was as delicious as it was beautiful—a pleasant and irresistible surprise for all of the guests.

THE MENU

FIRST COURSE
Medallions of Maine lobster tail
in vinaigrette with haricots verts
de Ladoucette, Baron 1994

MAIN COURSE
Rack of Lamb alla Veneziana
and risotto primavera
Château Lynch Bages 1994.

DESSERT
Cipriani Dolci Buffet
(Cipriani's signature dessert buffet)

Möet Chandon Brut

After midnight, a sushi bar and a vodka station were set up to refuel the party.

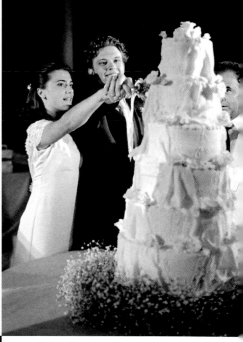

THE DECOR

The theme of the evening was green and white since Elies means "olives" in Greek. On each of the round tables under the tent, were five clay pots with topiary plants of different heights made out of baby's breath. (Baby's breath is Natasha's favorite flower, and has the added advantage of being able to be set up the night before without spoiling.) All of the fabrics used were in different shades of green giving a fresh, crisp look to the tent.

THE FLOWER GIRLS

The Flower Girls—Atalanta, the bride's god-daughter, Daphne, and Myrto—wore ankle-length cotton and lace dresses and traditional baby's breath wreaths. They ranged in age from 3 to 5, and in order to keep them from misbehaving their mothers devised a game where they would count the flowers on Natasha's wedding dress. Natasha herself was the flower girl at Atalanta's parent's wedding.

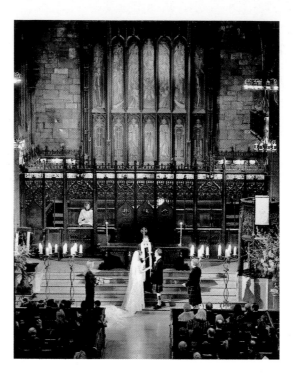

NEW YORK
NEW YORK

ROLLA BATNIJI *&* **LLOYD GRANT GORDON, FEBRUARY 3, 2001**

THE ROMANCE

Their backgrounds are as different as can be. She is a native of Jordan, and spent her summers in the Gulf of Aqaba by the Dead Sea, listening to Arabic music and belly dancing barefoot on the sand. He is a wild Scotsman from the Highlands, the heart of whiskey country. He grew up in a castle, surrounded by moors and hills reminiscent of the romantic terrain made famous in Emily Brontë's novel *Wuthering Heights*, wearing his kilts and dancing to bagpipes.

They knew of one another during college, and afterward, they occasionally ran into each other at social events. Nothing developed between them until one night in New York, at a French restaurant called Le Charlot, where Rolla was celebrating her birthday. Lloyd happened to drop by for a drink and noticed her group of friends in the corner. He asked the maitre d' to let him bring the birthday cake to her. "They dimmed the lights, the candles were flickering," Rolla recalls. "The whole restaurant was singing 'Happy Birthday' and there came Lloyd with his sparkling bright green-blue eyes and a huge grin on his face, looking as cute as can be. He presented me with my birthday cake and sat right

ABOVE: *Interior of the First Presbyterian Church of Scotland on Fifth Avenue and 12ᵗʰ Street.*

OPPOSITE: *Rolla and Lloyd leaving the church.*

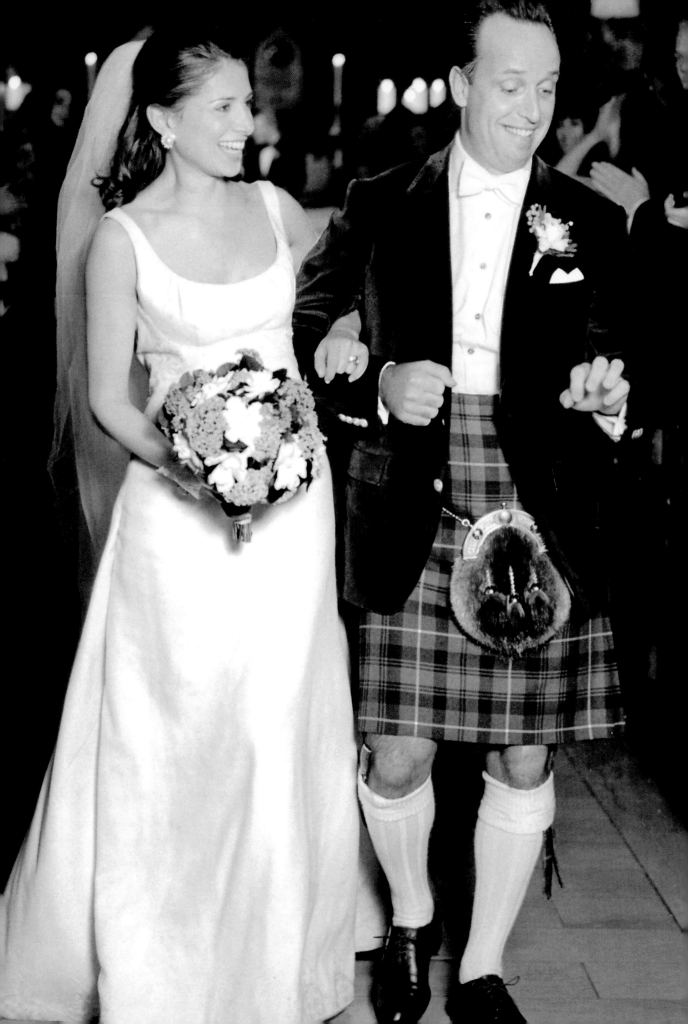

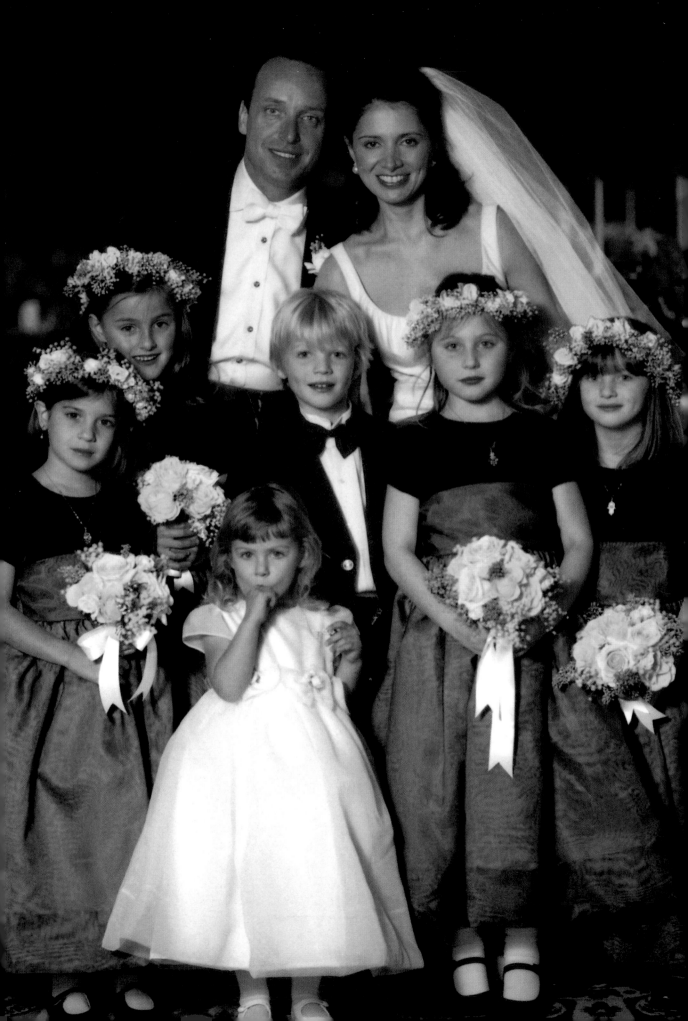

across the table from me." Even though she had seen him so many times before, "For me it was the first moment I *really* saw him." In that moment, there was an instantaneous connection between them, and they both had a feeling that they would be together for a long time. However, that first year of their courtship was very difficult, due to Rolla's very demanding work schedule.

Eventually, Rolla quit her job to start her own consulting business, and the couple took a month-long holiday in Europe. In Geneva, they stayed at La Bellote, a charming bed and breakfast on the lake near Cologny. It is there that in the midst of a romantic giggling episode, Lloyd asked Rolla if she would be his wife. Incredulous, she had him repeat the question—thinking he might have had one drink too many.

THE PLANNING

The couple planned to have a traditional Muslim ceremony and celebration in January 2001, in California, where Rolla's parents live, with belly dancers and an Arabic theme and menu. In addition, they wanted to do something that blended both of their cultures, so they planned another wedding celebration in New York for that February 3rd. This ceremony would take place at the First Presbyterian Church of Scotland (where Lloyd was a member).

Finding a location for the reception was more difficult. It would have to be large enough to accommodate their 300 guests, and have a dance floor in the same room. They finally settled for the Regent Hotel on Wall Street, whose ball room has its own private entrance, and offers the catering and service of the hotel, without the inconvenience of walking through the hotel's lobby to get to the event.

LEFT: *Flower girls Sofia, Kasmira, Olivia, Clio, and Blue, and young Constanin in outfits by the Spring Flowers boutique, with the bride and groom.*
RIGHT: *The pageboys wore custom-made kilts with the customary Scottish accessories. They were Rex (shown), Nicolas, and Sebastian.*

The groom with his groomsmen clad in Scottish tartan kilts.

THE INVITATIONS

Lloyd didn't want a typical wedding invitation—instead he wanted something special that would represent their coming together as a couple. So, inspired by the good luck charm that Rolla wears around her neck, they came up with a personal motif to adorn their invitations. A little Fatima's hand (an inverted open hand with a dot representing the evil eye in the middle) was framed by a Celtic pattern. Rolla's father had written their names in Arabic characters inside the Fatima's hand. This motif not only adorned their invitations, but also served as a central symbol for the entire wedding, appearing on all the menus for the rehearsal dinner, on the décor at the reception, and even on the embroidery trimming Rolla's dress.

THE ATTENDANTS

Rolla's five flower girls wore dark green velvet short-sleeved dresses from the Spring Flowers boutique, in New York, which were designed by Joan Calabrese. They had high-waisted pistachio-green silk taffeta skirts, tied with a cummerbund, with a large bow in the back. They wore flower headbands of pale pink and yellow serena roses, intertwined with yellow mimosas and some greens. They held little bouquets of flowers all of the same color, which were tied with a four-inch-wide silk ribbon in white. They wore white socks and black patent side-buckled Mary Jane shoes. The pageboys wore custom-made kilts with the customary Scottish accessories. The children's easy laughter before the ceremony helped to calm Rolla's pre-wedding jitters.

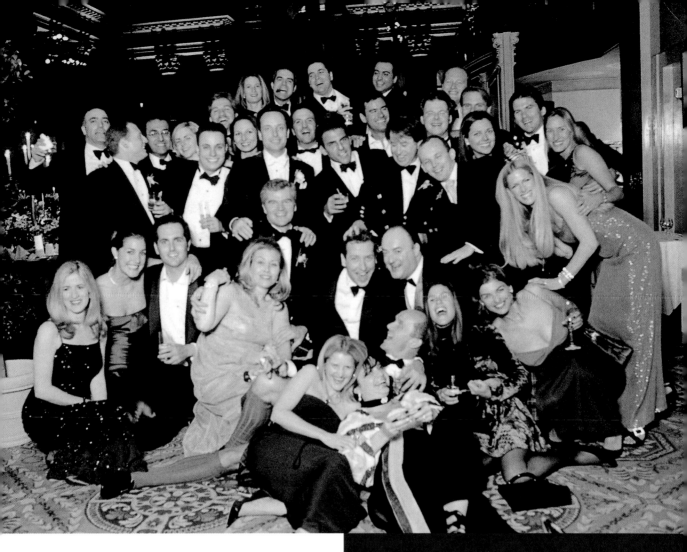

Guests at the Oriental-themed after-dinner party.

THE CEREMONY

The guests were greeted by a band of kilt-wearing bagpipers, all members of the New York Police Department, that Rolla had found by chance walking down Fifth Avenue one day. In the church, Lloyd wore the Gordon kilt with his family colors of yellow, green, and blue. His witnesses and all the ushers wore tartan kilts as well. The flowers around the church were in large urns of the same color palette as the flower girls: white, yellow, and various shades of dark green. There were four six-foot floor candelabra on either side of the altar.

THE DECOR

The main decorating challenge for Rolla, her florist, Ron Wendt, and the lighting specialist Bentley Meeker, was transforming the huge,

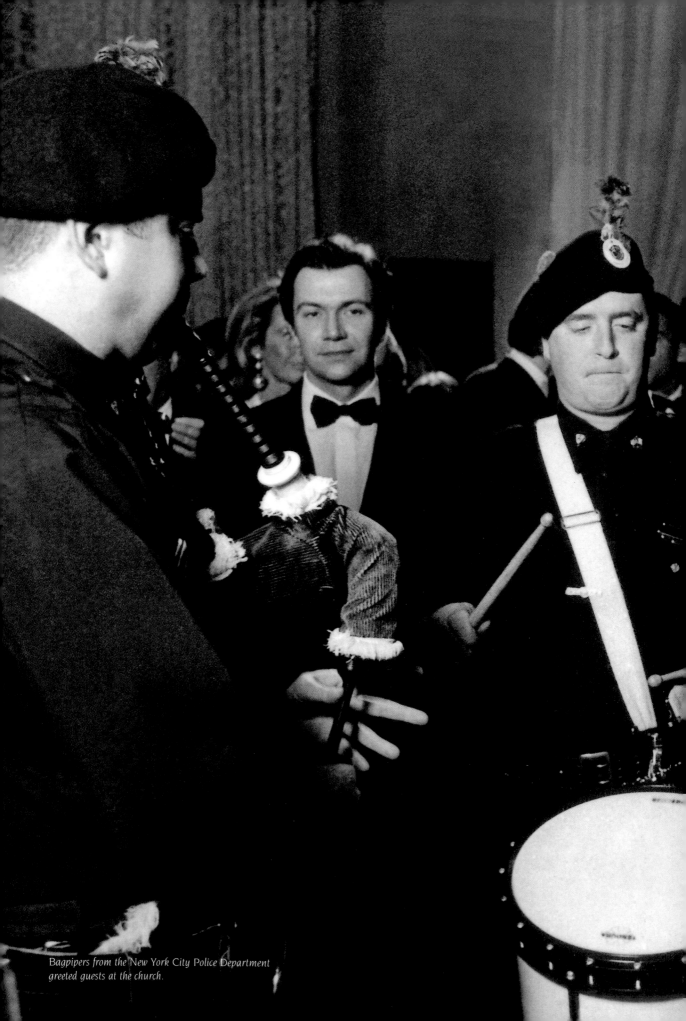

Bagpipers from the New York City Police Department greeted guests at the church.

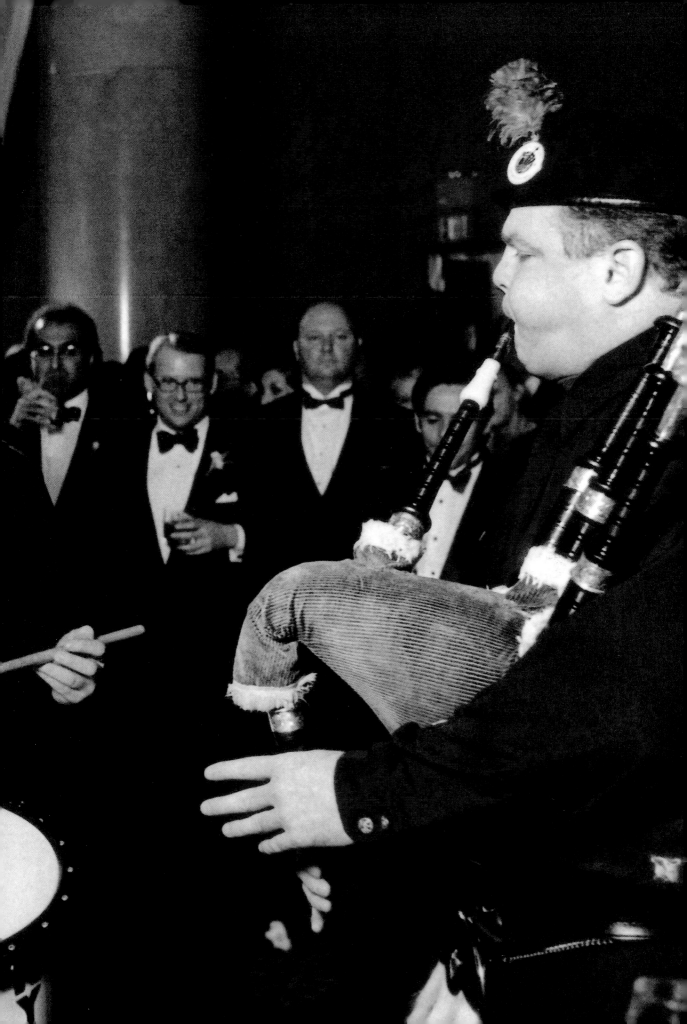

cold space of the Regent's ballroom into something more cozy and inviting. Sixteen partitions were brought in to enclose the party area, with three singular-pillar candelabra in front of each of them. Twelve five-pillar candelabra were also placed around the dance floor, and sixteen triple-ball topiary plants (approximately seven-and-a-half-feet tall each) were placed around the perimeter to enhance the sense of enclosure. The couple's motif was projected on either side of the balcony onto two sheer panels.

Lloyd had requested a "classic but simple approach to the decoration of the tables," while Rolla wanted "a more homey and spontaneous look." To satisfy both Rolla and Lloyd's ideas for the décor, the couple had a variety of shapes and sizes of tables in burgundy damask table-cloths, named after famous Scottish destinations.

Picking the color theme for the evening was also tricky. February is a funny month for a wedding: After Christmas-time but not quite spring. As with her tables, Rolla didn't want to be too homogeneous with her floral arrangements.

She sent Ron cutouts from magazines of flowers, fabrics, and colors she liked, and ultimately did a combination of three different table settings, with celadon greens and different tones of orange, red, yellow, and dark green. One of the centerpieces featured gold Corinthian candelabra with tall white candles on top. Another was comprised of three low pedestal urns in different sizes. For the third setting on the bridal table, Ron filled tri-level *étagères* with a medley of rust-toned roses and mango callas, contrasting the sharp greens of cymbidium orchids and viburnum with gold anemones and a variety of citrus and berries.

THE RECEPTION

As they entered the Regent's two-tiered ballroom, guests were greeted by the band of bagpipers from the New York City Police Department, and whisked up the staircase for cocktails. These bagpipers later announced that dinner was served with full musical gusto.

After dinner, in keeping with the Middle Eastern theme, Ron transformed the upper level into "Ali Baba's cave," with *kilim* pillows lying on exotic Oriental carpets, low brass tables, teapots, and sheer voile panels floating between each column, creating a mysterious and sensual look. At midnight, tortellini carbonara and penne with tomato and fresh basil were brought out, along with tuxedo-dipped strawberries and brownies to give the guests extra energy for the after-party. Tea, coffee, and typical Oriental delights were also offered. The fragrance of the rose petals strewn all around the room transported everyone to a faraway land. The bar stayed open until 3 a.m., and DJ Pat Caramel put the guests in a great party mood.

> 66 **Rolla and Lloyd took off the next evening for Memba Island, off the coast of Tanzania.** 99

THE HONEYMOON

Rolla and Lloyd took off the next evening for Memba Island, off the coast of Tanzania. Next, the couple took an African tented safari to look for what Rolla is fascinated with most—elephants! They ended their honeymoon at Hotel Bristol in Paris, a gentle re-entry into civilization.

THE DRESS

In an appropriate touch for her winter wedding, Rolla wore a Velasco Anderson white cashmere dress. The bride picked elements from a variety of designs seeking a dress that was light and simple in terms of line, and yet detailed in design without being too fussy. She decided to incorporate their signature motif as an embroidery around the hem and added tiny blue beads to field off against the evil eyes of envious onlookers (a Arabic folkloric tradition).

THE DECOR

Rolla sent Ron Wendt, her florist, cutouts from magazines of flowers, fabrics, and colors she liked, and ultimately did a combination of three different table settings, with celadon greens and different tones of orange, red, yellow and dark green. For the bridal table, Ron filled tri-level étagères with a medley of rust-toned roses and mango callas, contrasting the sharp greens of cymbidium orchids and viburnum with gold anemones and a variety of citrus and berries.

THE MENU

FIRST COURSE
Maple-cured applewood smoked Salmon
Frisée Salad with mustard dill dressing.
Cascina Chicco Roero Arneis 1999 (Piedmont)

MAIN COURSE
Pomerol-roasted Rack of Lamb with rosemary crust,
with pomme gratin, haricots verts,
and roasted tomato with rosemary jus.
Château de Fleur Petrus 1997

DESSERTS
Poached Pear with blue cheese and brie
Quinta do Noval (20-year-old Tawny port
from Portugal), Chocolate Decadence Cake
Tuile of Pineapple sorbet with Fresh Berries
Zabaglione wedding cake (by Cipriani)
Assortment of fine single-malt scotches
from the Grant family's distilleries

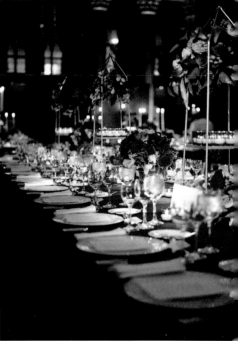

THE MOTIF

To fuse both of their backgrounds, Rolla and Lloyd incorporated both an Islamic and a Celtic element for their invitations, which were designed by Bernard Maisner. The Fatima's hand in the center, which wards off the evil eye and ensures good luck, framed by an intricate Celtic pattern that was interlinked—as the couple would be from now on.

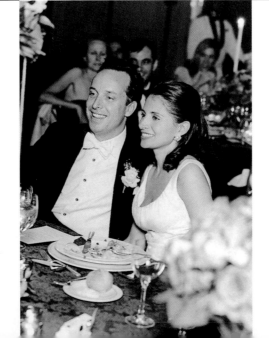

THE DINNER

Lloyd and Rolla listened to the speech made by their best man, surrounded by friends and family in the midst of the opulent décor and centerpieces created by Ron Wendt. Soon the dancing would start, and there would be a conga line around the dance floor—to the sound of the bagpipes! Pat Caramel, the DJ, took over from New York's finest bagpipers and put the party into high gear.

ISTANBUL
TURKEY

JOANA KRUTTKE *&* HENRIK SCHLIEMANN, SEPTEMBER 3, 1998

THE ROMANCE

Joana Kruttke and Henrik Schliemann first met in their hometown of Munich, when she was 15 and he 18, and started dating in high school. Joana's parents liked him from the beginning: he had a mature "man of the world" look about him, and seemed always to be in charge. Plus, according to Joana, "he was a great mother-pleaser." But fate intervened, and four years later they broke up when Henrik left Munich for London.

For the next eight years, as they each explored the world on their own, they spoke sporadically on the telephone and saw each other during the holidays. During those years, Joana enjoyed a gypsy-like existence, living in Buenos Aires, Hong Kong, Paris, and Los Angeles, and working in a variety of fields. Though she found herself missing him, it hadn't yet occurred to her that they were meant to be together.

Henrik, however, always knew that she was "the one," and always had a master plan to win her back—it was just a matter of when. One day, when Joana was still working in New York, Henrik called from London to say that he would be visiting. As soon as he arrived, he told her: "Pack your bags. We are going on a trip." This

ABOVE: *The invitation to the Kruttke-Schliemann wedding, designed by Alec Cobbe and David Mees.*

OPPOSITE: *Joana and Henrik exiting the Church of Saint Esprit, of the Silesian Order, in Istanbul.*

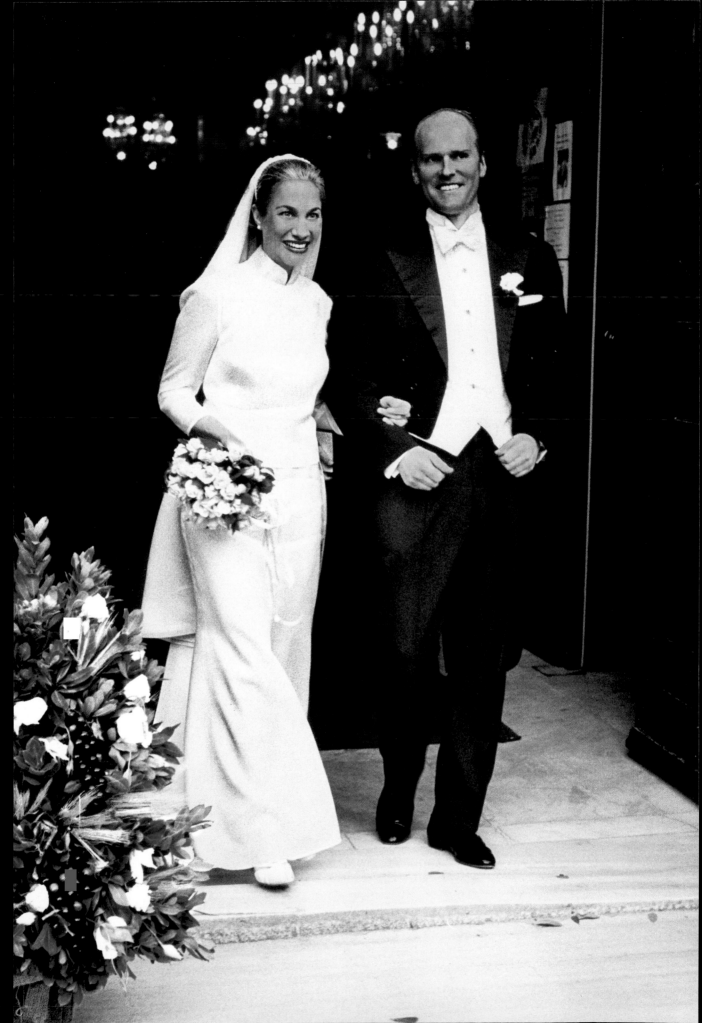

was a sure way of intriguing Joana—a self-described lover of the "impulsive, unplanned, spontaneous, and unknown."

The destination was Lebanon—Lebanon, Vermont, that is. They were off to Twin Farms, a most romantic place of understated luxury, with little cottages right out of a Ralph Lauren catalogue. At the end of this surprising weekend, Joana called her mother: "Mommy, I think this is it. I am crazy to still look around, because the man I want to spend the rest of my life with is right here next to me." By March, she had moved in with Henrik in his London flat.

THE PROPOSAL

Over Easter weekend of the following year, Henrik "kidnapped" his beloved once again, and took her to Istanbul. It was the first visit for both of them, and they fell in love with the city. On one drizzly day, while they were visiting the ancient city of Troy, Henrik said to Joana: "Now you go and find your treasure in Troy." After searching for twenty minutes, she found the little blue velvet pouch that Henrik had hidden in a crack in the ruins. Inside the pouch was an antique Victorian ring with a Burmese ruby in the center, surrounded by diamonds. Joana was as impressed by the ring's beauty as she was by the romantic way she'd received it.

THE PLANNING

After this special proposal, Istanbul seemed to be a perfect setting for their wedding. And the city formerly known as Constantinople actually has another sentimental and historic significance for the couple. Henrik's great-great-great-grandfather, the archeologist Henrik Schliemann, a man passionate about (and obsessed with) the fabled cities of Homer, discovered Troy, as well as the ancient village of Mycenae in Greece. A

LEFT: *Fez-wearing waiters offering cocktails before dinner.*
RIGHT: *Festively dressed guests flanking an Ottoman guard, in front of the Yildiz Palace before the Ottoman Ball.*

On the Tashkent, the boat taking the guests to Çubuklu 29, on the Asian shore of the Bosphorus Strait, for dinner and dancing.

smart, successful businessman and a true Renaissance man, Schliemann was much admired by Henrik (the younger), who wanted to honor his fascinating ancestor's legacy by getting married in his beloved land of the Sultans. Joana chose designers Alec Cobbe and David Mees to create an invitation that would evoke the Ottoman theme of the wedding. The invitation depicted Saint Sophia in the center, flanked by traditionally dressed Ottoman guards in a style reminiscent of Turkish miniatures. Bordering the invitation was a traditional Ottoman engraving of lotus flowers and tulips.

THE SETTING

For the ceremony, which would take place on Thursday night, Henrik and Joana chose the Cathedral of Saint Esprit, an elaborate, archi-

tecturally detailed church of the Silesian order. And for Saturday night's big Oriental Ball, Joana found the Silahane Armory of the Yildiz Palace, an old palace surrounded by a beautiful park with gorgeous trees and lush gardens. Securing the Yildiz Palace was difficult, but Joana has never been known to back down from a challenge. The palace had never been used for an event of this size before (they were expecting 250 people), and there were a couple of regulation issues (like a ban on smoking, a 10 p.m. curfew, and a rule that guests had to wear slippers inside) that had to be dealt with by Joana's party organizer.

THE CEREMONY

Only around sixty guests were invited to the ceremony. Presiding were Henrik's Protestant

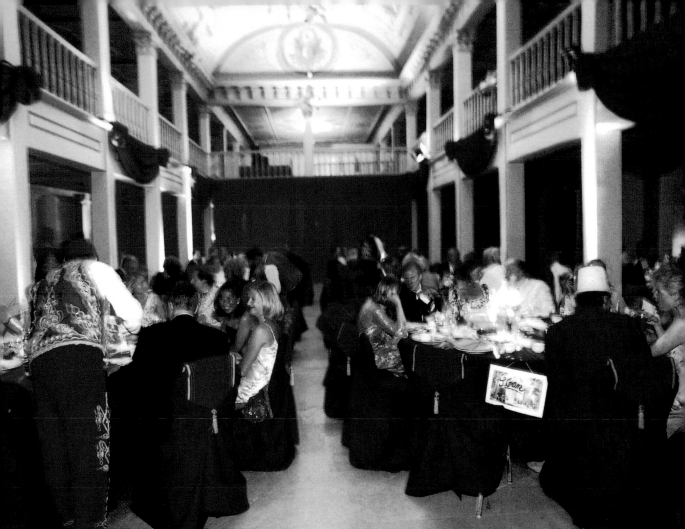

At the Silahane, tables were named after Ottoman rulers.

minister from Norway, who had also confirmed him, and a Catholic priest of the Silesian order. The Silesian philosophy of borderless and non-discriminatory religion appealed to Joana, a humanitarian and a believer in Asian concepts of universal love.

Joana chose to have a soprano sing Handel's "Hallelujah Chorus" and the "Ave Maria" during her ceremony. Some very close friends read from the Bible. Joana wore a very Zen-like dress by Morgane Le Fay in silk chiffon with straight, simple lines, and a camisole with a Mao collar on top.

Immediately following the ceremony, there was a dinner in the only room from the original Çiragan Palace, a magnificent nine-teenth-century marble and limestone edifice on the banks of the Bosphorus Strait. The

" Go for your dreams and don't hold back! Whether it's a shack on a mountaintop with goats or an elegant ball, don't ever give up the 500 family members who will never the

The façade of the 19th-century Çiragan Palace,
on the banks of the Bosphorus Strait.

breathtaking room with its ornate diamond-patterned parquet floors, intricate wall stenciling, and huge multi-armed chandelier, created a seductive environment of magic and mystery for the evening. Large double doors opened the terrace, which looked straight into the Bosphorus Strait. Cocktails were served in the palace's white marble *hammam* (Turkish bathhouse).

THE RECEPTION

The dress code for the Oriental Ball at Yildiz Palace was, not surprisingly, "Ottoman." Joana wore a silver Galliano dress from his "Sultan Collection," with intricate lace and draped silk décolleté, and an equally impressive choker with an Ottoman medallion of a *pasha* (Ottoman potentate) in the middle. Guests were greeted by Ottoman guards dressed in traditional costumes, with a multicolored sash on their waists, bejeweled swords hanging through them, and headdresses that looked like bishop's miters, with thick gold trimming all around. The waiters wore typical red, gold, and white Ottoman attire with a red fez on their heads.

The theme of the party was red and gold, and in order to set the mood the interior of the Silahane was draped with crimson velvet fabric on every other balcony, which overlooked the stone-floored room. The round tables were decorated with the same red fabric, with a runner with gold- and yellow-trimmed edges and a tassel of

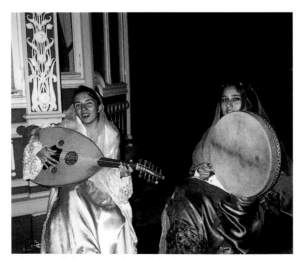

Classic Turkish music in front of the kiosk in the Palace gardens.

the same color added on either end. There were pink and white rose petals strewn all around the table and typical Oriental lanterns bought from the bazaar a few weeks before. The chairs were draped in a similar red silk fabric as the tablecloth runner. Each table had a watercolor gouache of a different view of Istanbul, and each was named for a different Ottoman sultan (such as Süleyman, Abdul Medjid, Sultan Ahmet). The menus on top of each plate had the same motif as the invitation. The party favor was a silver metal napkin ring with a big colored gem in the center, with the initials of the bride and groom engraved on either side—which most of the women converted into a bracelet.

As guests entered the palace, they were serenaded by an all-female ensemble playing traditional Turkish music in a kiosk in the garden outside. During dinner there was a harp player, and after dinner the whole outside courtyard was laid out in carpets, oversized pillows, and low stools. Tea, traditional sweets, and coffee were passed around on huge brass trays. The whole garden from the entrance to the courtyard was illuminated by candlelight. Afterward, DJ Claude Challe (from the Buddha Bar in Paris) kept the music going until dawn.

THE WEEKEND

In addition to the party at the Yildiz Palace, the couple planned several events to help their guests take advantage of the exotic setting. On Friday evening, there was a cruise on the Bosphorus Strait in the motorboat "Tashkent," which took the guests across the Asian shore to Çubuclu 29, a hip spot where there was dinner and dancing. Finally, there was a send-off brunch on Sunday at the Bebek Balikçi Locanta, an eatery on the Bosphorus Strait. Joana created a weekend her guests wouldn't forget. However, she had another concern: Henrik refused to tell her the destination of their honeymoon. She only found out that he was taking her to Rajasthan, in India, when their plane was about to take off.

THE DRESS

Joana wanted a wedding dress that reflected her affinity for Asian art, religion, and culture. She found a dress at the New York boutique of Morgane Le Fay that was simple in look, but quite intricate in its composition. It was a very Zen-like chiffon slip dress with simple lines and a silk camisole overlay on top.

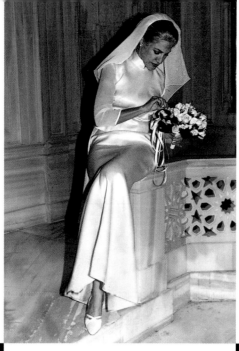

THE MUSIC

As guests entered the Yildiz Palace, they were serenaded by an all-female ensemble playing traditional Turkish music adjacent to a kiosk in the garden outside. During dinner there was a harp player, and after dinner the whole outside courtyard was laid out in carpets, oversized pillows, and low stools. For Joana, music is one of the most important elements of a successful party. Claude Challe, from the Buddha Bar in Paris, certainly was well aware of his role and changed the tunes to suit the mood of the party.

THE MENU

FIRST COURSE
Selection of Anatolian Mezze

MAIN COURSE
Chicken Sultan Süleyman
stuffed with Spinach
and Pistachios in Morel Sauce
Oriental Rice and Julienne Vegetables

DESSERTS
Bazaar of Ottoman Delights

Coffee and Cognac

THE DECOR

Gold and crimson were the dominant colors for the Oriental Evening. Joana found Turkish lanterns in the Bazaar and placed them in the center of silk and velvet tablecloths with a tassled red runner in the middle. Pink and white rose petals were strewn on the tablecloth to add more color and a touch of decadence. The tables were named after Ottoman sultans, and the menus echoed the oriental border and motif of the invitations.

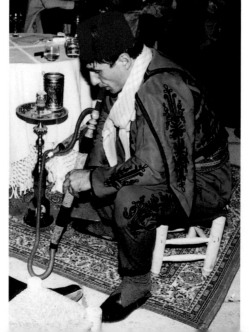

THE DRESS CODE

Guests, inspired by the Ottoman dress code for the Oriental Evening, rummaged through the cavernous alleys of the covered Bazaar or Kapali Çarsi in order to come up with appropriate accessories such as fezes, medallions, and caftans. Pants and tunics worn by courtesans, belonging to the Harem, were sought out by the adventurous female guests.

VENICE
ITALY

LINA BOTERO & RODRIGO SANCHEZ Y VALS, JULY 7, 2001

THE ROMANCE

Lina Botero met Rodrigo Sanchez y Vals at a wedding that both were attending in Ibiza, Spain. They were introduced by a mutual friend, who mentioned that Rodrigo had a son. Lina, who has two children of her own, immediately felt a connection with him. They started to talk and didn't separate for a single moment that whole weekend.

After the wedding, Lina left to visit her father (the artist Fernando Botero) in Pietrasanta, Italy. Rodrigo called every day to ask her to come back and visit him in Seville before she returned to her home in Mexico. Finally, she acquiesced.

She was very nervous on the flight back to Spain. But her doubts and fears evaporated the moment she saw him waiting for her at the airport. He then proceeded to take her all around Andalusia. One evening under the August stars, at an unpretentious seaside restaurant in Porto Santa Marina, Rodrigo fell to his knees in the middle of the dance floor and, with his arms outstretched, yelled at the top of his lungs: *"Casa ti con migo, quiero que te casas con migo*!" ("Marry me, I would like you to marry me!") She started to cry and fell into his arms saying,

ABOVE: *Venetian gondolieri awaiting the guests by the Grand Canal to take them to the reception.*

OPPOSITE: *Lina enjoying a moment during her wedding celebration on the balcony of the Palazzo Pisani Moretta, overlooking the Grand Canal.*

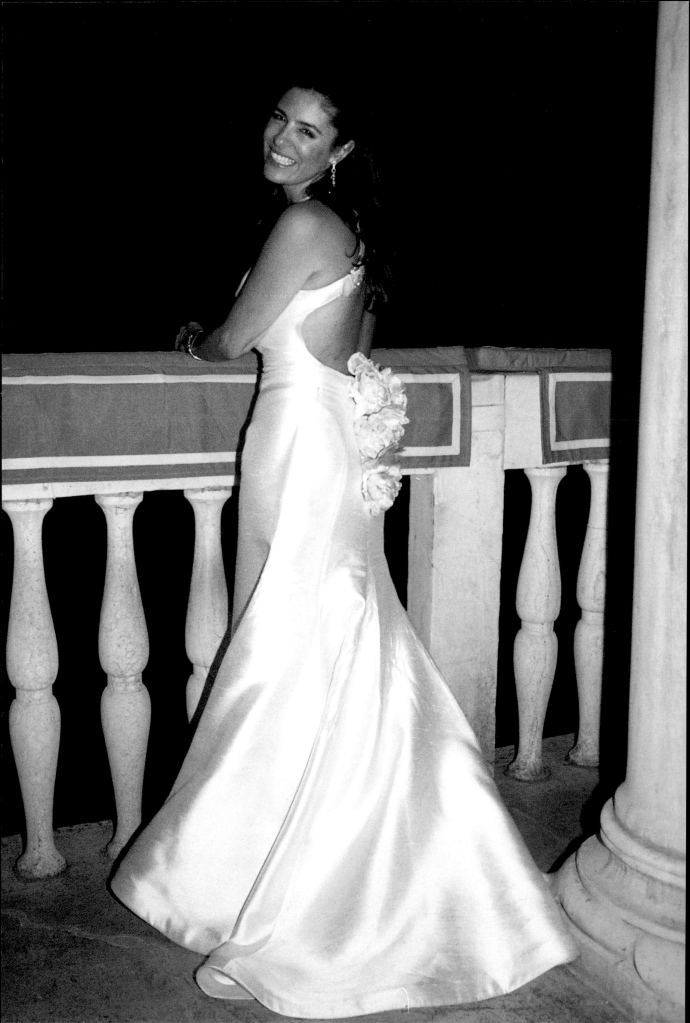

"This is crazy, but yes I will!" It was barely one month since they had met.

The following spring, when they both were in Mexico, Rodrigo suggested that they try a "new restaurant" in the penthouse of the Four Seasons Hotel. When they opened the door, Lina saw a room covered in red rose petals, with candles all around. Classical music was playing in the background. A table for two with crisp linens, silver candlesticks, and a champagne bucket nearby was set up for them on the terrace overlooking Mexico City. Rodrigo gave her an exquisite antique ring, of an emerald surrounded by diamonds. (The emerald is the indigenous stone of Colombia, Lina's native country.)

THE PLANNING

The date was easy to set—July 7, 2001, exactly a year after they met. Finding an appropriate location was a bit harder. The obvious choice was Colombia, but providing security for all the guests would have created havoc. And Spain, where Rodrigo is from, posed logistical obstacles. Since Lina's father had a house in Italy a few hours away from Venice, and she had spent her summers there with her family, Venice seemed like a good solution.

Lina was fortunate to find the Marchessa Barbara Berlingieri to help her organize her wedding from afar. The Venetian event planner's organizational skills are well respected, and she came highly recommended by the American charity Venetian Heritage. Still, planning a wedding on such short notice over a six-hour time difference (not to mention the two-hour Italian lunch break) "was quite a challenge." But Lina was fortunate to fall into the right hands, and although she was only able to make two trips to Venice before her wedding, thanks to the Marchessa it was a success.

LEFT: *The bride and groom enjoy a passionate embrace.*
RIGHT: *The sketch from the wedding invitation, by the artist Fernando Botero, the bride's father.*

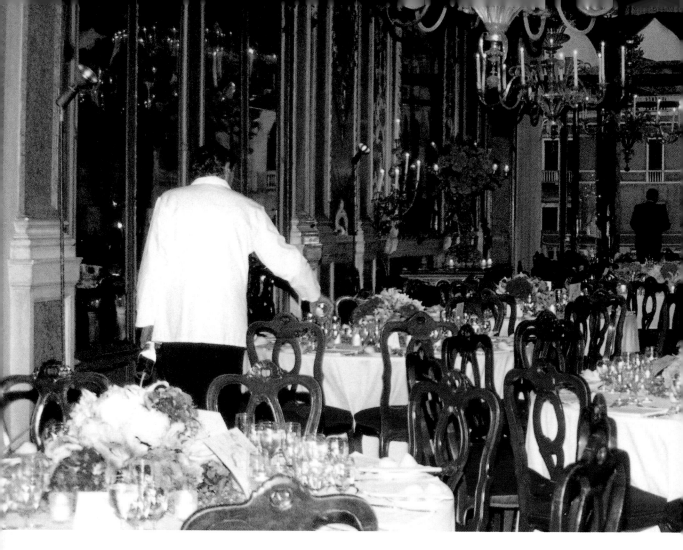

Interior of the Palazzo Pisani Moretta, set and decorated with low bouquets of pale pink and fuchsia peonies for the wedding celebration.

Fortunately, Venice proved to be the perfect host city for the event. Friends and family kept bumping into each other in the narrow streets, creating the intimate atmosphere Lina wanted. Venice, "La Serenissima," as the locals refer to the city, has evoked a seductive and mysterious quality that lingered throughout the weekend.

THE INVITATIONS

Neither Lina nor Rodrigo wanted invitations of the typical embossed white or ecru paper variety. Instead, Lina asked her father to create something that would "spark people's imagination." The result was a whimsical drawing of two rather plump figures entwined in an embrace, just about to begin a tango or *paso doble*. Behind them is the Cathedral of San Marco and the Lion of Venice. Instead of the traditional

pompous wording, the card simply read: "Lina and Rodrigo invite you to dinner on the occasion of their wedding at the Palazzo Pisani Moretta, in Venice, July 7, 2001." (On the lower left there was also a recommendation that guests arrive at the Palazzo by gondola.)

THE CEREMONY

The civil ceremony took place during the day, followed by a lunch at a nearby *ristorante*. Lina had only included her closest friends and family and recalls reveling in the moment, thoroughly enjoying being surrounded by all of the people that she loves, laughing, chatting, and dripping in sweat in the oppressively humid afternoon. Around 5, as the guests were heading back to the Gritti Palace, where they were staying, everyone got caught in a torrential

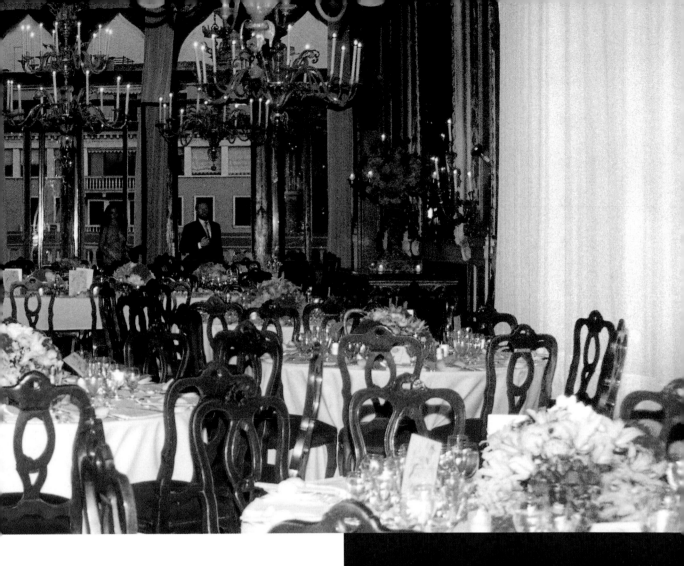

rainstorm. Fortunately, the skies were clear by sunset and the humidity had completely disappeared.

THE MISHAPS

The rainstorm was not the only dramatic event of the day. There had been a major strike at all the Italian airports, leaving many guests stranded at various airports all over Europe. "One plane even flew to Venice and was sent back to Paris with ten of my guests aboard. It was a nightmare," Lina recalls. Until the last minute they didn't know who would make it and who wouldn't, which meant that an emergency seating plan revision had to be executed. Thankfully, Sophia Botero, Lina's stepmother, and Rodrigo's sister stepped in to help the busy bride.

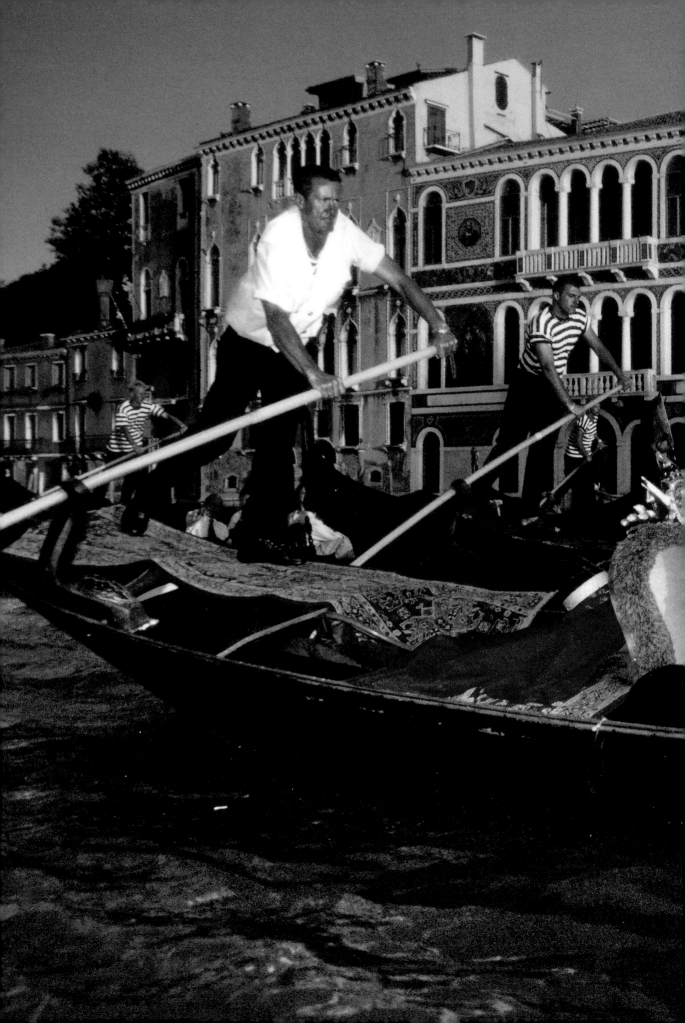

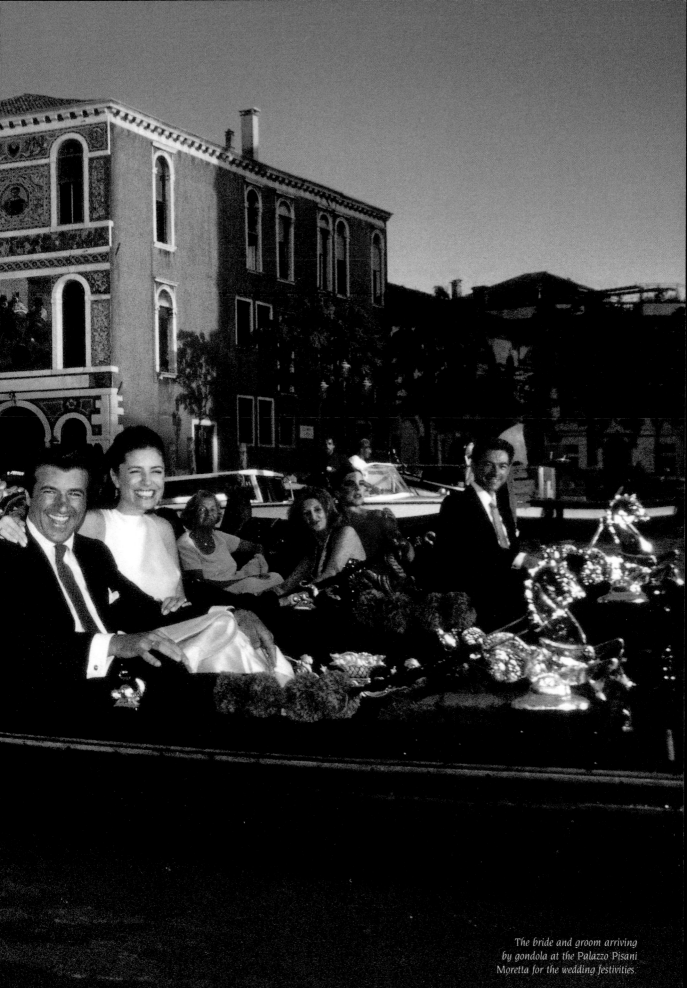

The bride and groom arriving
by gondola at the Palazzo Pisani
Moretta for the wedding festivities.

As they were sitting on the floor of their room in the Gritti trying to sort out the seating mess, they suddenly saw water gushing from under the bathroom door. With all the commotion from the wedding lunch, the rain, and the stress of the strike, Lina had forgotten that she had run a bath! The water had soaked the living room, and began to trickle down the marble stairs of the Gritti Palace, all the way down to the hotel lobby. "Everything went wrong," she says with a smile. "When you marry the first time, your parents organize everything. By the second time, *you* organize everything. I could only come to Venice three days before my wedding. I needed more time."

Upon arriving at the palace that night, Lina encountered yet another tricky situation. The Italians in charge of the seating couldn't handle the double- and triple-barrel names of the Spaniards, and had simply given up on the place cards. Lina was distraught. "I had put a lot of thought into it. I believe that the seating can make or break the party." She immediately grabbed the friends she knew she could count on from each table and told them that they were responsible for "collecting the remainder of the table."

> " When you marry the first time, your parents organize everything. By the second time, *you* organize everything. "

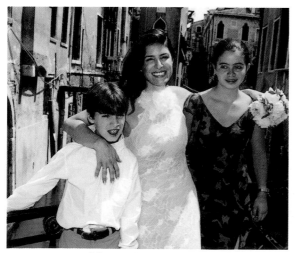

Lina with her two children, Nicolas and Andrea.

THE RECEPTION

With the seating situation under control, Lina could relax and enjoy her party—almost. A few days before she had been told that by law all parties in Venice had to end by 2 a.m.! "I almost had a heart attack. How can this be possible? In Spain, you don't even sit down to dinner before midnight!" But Lina was determined to keep her party going. The police inevitably arrived to inspect the situation, but guests kept offering drinks to them, which prolonged the party for another 45 minutes. The loudspeakers finally had to be turned off, but thanks to the diehard Sevillian party animals, the party kept going until morning, as guests sang, clapped, and danced the flamenco to the drums and guitar.

Somehow, despite all the obstacles, Lina managed to remain cool and enjoy herself. "I kept telling myself that all the effort I put into the organization of this evening would make this a magical and spectacular event and that everything would turn out as I expected. I kept being positive about all of this." It eventually all worked out perfectly. When she left at dawn, about 100 guests were still there singing and dancing. Lina and Rodrigo then went up to their balcony overlooking the Grand Canal. Relaxing in terrycloth bathrobes, they basked in the Venetian morning, watching the hustle and bustle on the Grand Canal as they reveled in their memories of the amazing evening.

THE HONEYMOON

Lina strongly advises that you spend at least one day far away from everyone after your wedding, so "you and your husband can remember every detail. Sometimes the wedding day is just a big blur. You want to enjoy it to its fullest before you let the everyday events come back into your life again." The couple only took a short trip to the South of France before joining their families at Pietrasanta, Lina's father's house in Italy.

THE DECOR

For Lina, the florist is one of the most important elements to a successful party. "Everything comes in through the eyes. He translates your vision into reality." When she walked into the floral studio of Marco Munaretto, Lina's eye caught a very "Boteroesque" arrangement of huge hydrangeas in pale blues climbing toward the sky. "It was very dramatic but not overdone." For the party, Marco used pink peonies, Casablanca lilies, and fragrant tuberoses.

THE DRESS

Lina wanted to wear a white dress for the occasion but "definitely not a wedding dress; I wanted to celebrate the fact that I was being re-married." She decided on a raw silk Valentino gown in off-white, closed up in the front with a low-cut back and a small train. For a little extra flair, she added three big silk ivory and pink roses at the bottom of the back. "It was a beautiful dress, just a step down from a wedding dress." She carried a bouquet of pale pink and white peonies.

THE MENU

FIRST COURSE
Insalata di Crostacei dell Adriatico
(shellfish Adriatic style)

MAIN COURSE
Sampietro alla Carlina con Riso Pilaf
(sea bass with rice pilaf)
Braciole di Vitello alla Salvia, Giardiniera di Legumi
(veal cutlet in sage with garden vegetables)

DESSERT
Torta Nuziale Millefoglie
(Millefeuille Wedding Cake)

Vino Cipriani Cancello della Luna
Vino Cipriani Cancello del Sole
Champagne Louis Roederer

THE CAKE

Since it was her second wedding, Lina did not want a traditional wedding cake. The oversized millefeuille cake, prepared by Harry's Bar, was served instead of the typical multi-tiered confection that is normally featured at weddings. It had little pale pink and fuchsia flowers to blend with the color of the peonies on the table tops.

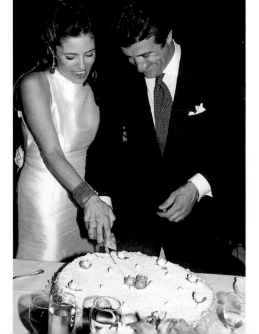

THE ATMOSPHERE

Lina wanted to give her guests the uniquely Venetian experience of leaving the gondolas they had arrived in and walking into a palazzo completely illuminated by candlelight. A Venetian string quartet played in the background as the guests walked up the stairs to dinner. During the meal, Lina didn't want music to be playing so that her guests could talk to each other without being distracted by other sounds. Then, following dinner, the guests descended the marble staircase to dance to the wild sounds of rhumba and flamenco.

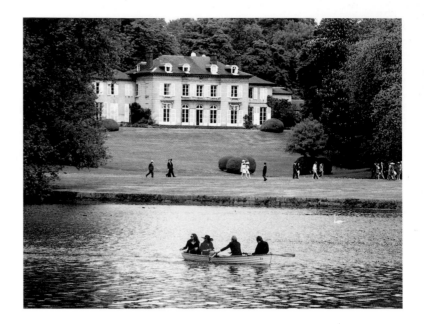

CHANTILLY & MARRAKECH

VALESCA DOST & MATHIAS GUERRAND-HERMES, MAY 12, 1999

THE ROMANCE

Valesca and Mathias have a lot in common. Before they were together, they frequented the same New York social events, and even shared a best friend. They both have a passion for cooking and a knowledge of fine wine, including a special affinity for those of the Bordeaux region of France—especially Petrus. They are both enthusiastic athletes (Mathias is the French polo team's champion player), and share a love of skiing and horseback riding. They also have compatible personalities, and share similar senses of humor, values, and a respect for traditions. To Mathias, it seemed only a matter of time before the Canadian-Danish beauty would succumb to what for him seemed inevitable: sharing their lives.

Yet while for Mathias it was love at first sight, it took Valesca four months to realize what a gem he was. She recalls a certain Sunday morning when she was about to call him to ask him out to brunch. When she realized he was in his house in Warren, Connecticut, she suddenly missed him terribly. As she was about to call, she felt a little nervousness creep over—her heart was racing at 1,000 miles an hour.

ABOVE: *Château de Saint Firmin in Chantilly, France.*

OPPOSITE: *The bride and groom exiting the church under an arch made of polo mallets, held by Mathias's teammates.*

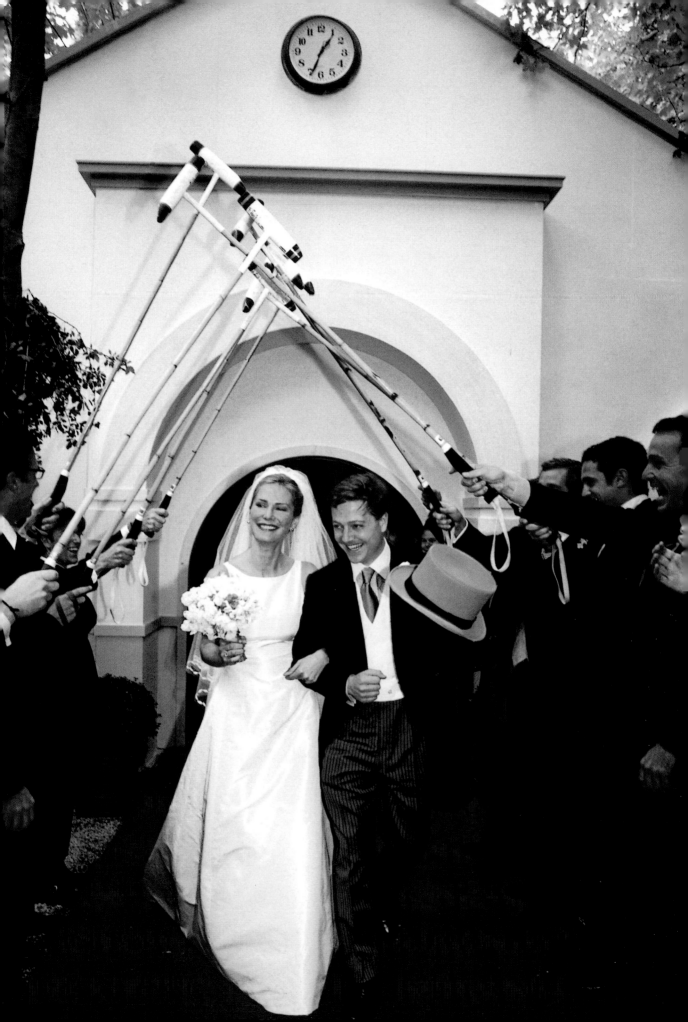

They decided to have supper that evening at Café Luxembourg. This was their first official date—the first time they were actually alone together, not part of a group. On their way out of the restaurant—a few blocks from where they would eventually live as a married couple—Mathias grabbed Valesca and gave her a most romantic kiss. "He had seen the sparkle in my eyes, I looked at him differently that night and he knew the time had come."

THE PROPOSAL

It took another two and a half years, however, before Mathias would propose marriage. One day, he asked her out for a formal dinner date at Jean-Georges Vongerichten. Valesca sensed something was up by the way they were greeted at the restaurant. They ordered champagne at dessert, and after the first sip, Mathias leaned over and gave her the most romantic kiss—packed with a Harry Winston emerald-cut diamond ring. (Thankfully, she didn't swallow it!)

THE PLANNING

Unlike most couples, Mathias and Valesca had no trouble deciding on where or when to have their wedding. There was no question that Mathias's family estate in Chantilly, the famous racehorse town on the outskirts of Paris, would be the ideal location for their nuptials. The festivities would then continue (via chartered planes) at Ain Kassmou, the Guerrand-Hermès family's estate in Marrakech. Nestled in a tropical oasis of colorful gardens and lush vegetation, this Moroccan paradise would be the perfect setting for the four-day weekend celebration. May is the best month, weather-wise, both for Chantilly and Marrakech, and 12 has been Valesca's lucky number forever, so May 12th it was. All together, the celebration would last almost a week.

LEFT: *Mathias winning the horse race before the Red and White evening.*
RIGHT: *Dinner at Dar Mouley Baubker (the tallest house in Marrakech), hosted by Mathias's uncle, Xavier Guerrand-Hermès.*

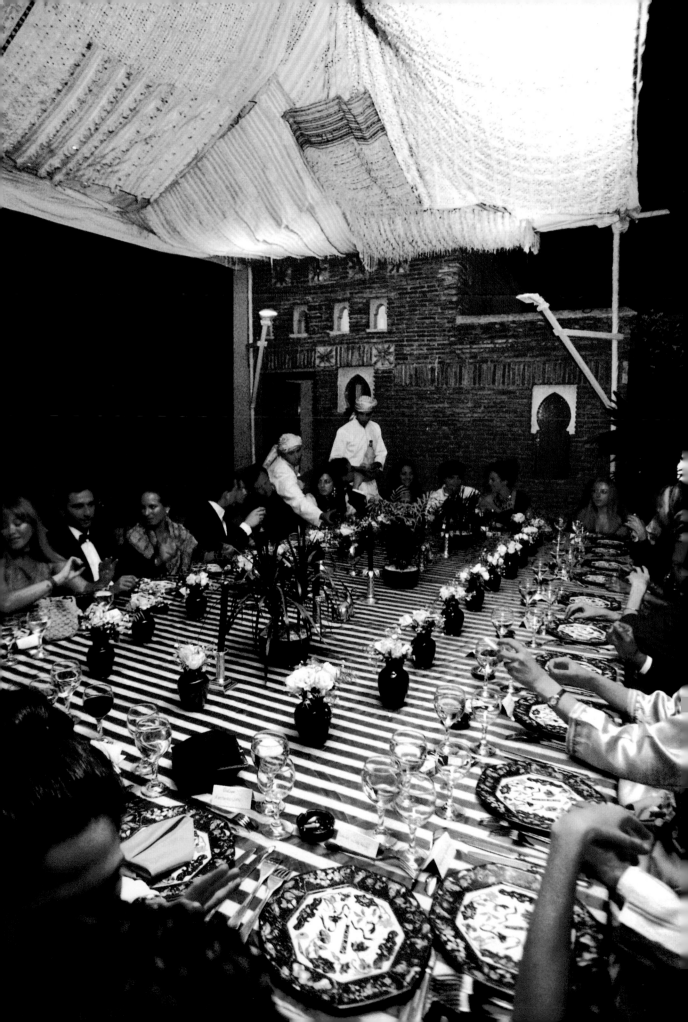

After the alfresco barbecue at Ain Kassmou, guests participated in a camel-back polo game.

A colorful mix of Moroccan tribal singers and dancers dressed in traditional costumes greeted guests at the Red & White Party.

THE KICKOFF

The night before the wedding, Mathias's uncle, Patrick Guerrand-Hermès, hosted a lively tango dinner-dance aboard a *peniche* (a floating barge). Tango lessons were provided, though a performance by two very suave dancers after dinner was a tough act for the novices to follow.

THE CEREMONY

There could not be a more bucolic location for an early spring wedding than the Château St. Firmin, Mathias's family home. The ceremony was held on the grounds, as was the sumptuous lunch for 450 people. A temporary "chapel" was constructed on the lawn, inspired by photographs Valesca and Mathias had taken of their favorite churches in Connecticut. The chapel had a wood façade of great charm and was covered by a tent in the back.

The ceremony was mostly in French. Valesca remembers how emotional she felt throughout, and how she kept reminding herself to walk slowly and to not cry in front of all these people. Mathias's own nervousness was revealed when he tried very hard to push Valesca's ring onto the wrong finger. After that incident they just looked at each other and kissed before the priest even had a chance to give his blessing. As they exited their special chapel, the couple was greeted by all of the groom's polo buddies, who raised their polo mallets in salute, letting them pass underneath. The couple left on a horse-drawn carriage, which was an Hermès family heirloom, with the flower girls, and pageboys (Brooke, Jacqui, Oleg, and Slava) and Valesca's adored grandmother to join their guests at the luncheon pavilion.

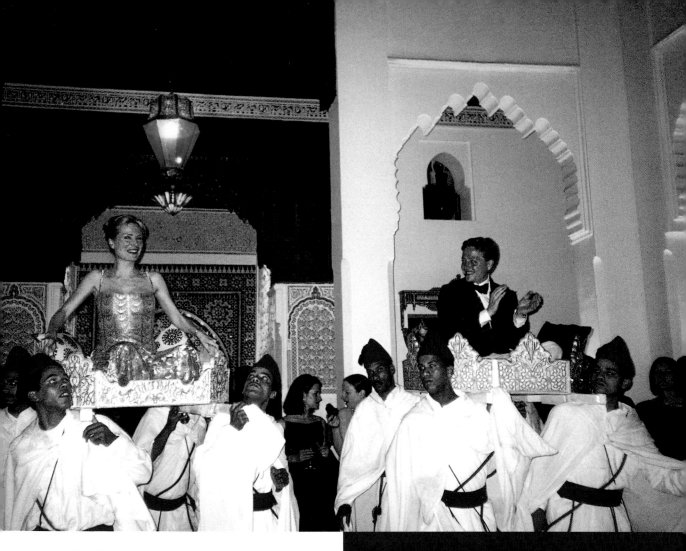

The traditional Moroccan bridal dance.

THE RECEPTION

The reception was held outdoors under an impressive celebratory pavilion in the Guerrand-Hermès family's polo colors. Royal blue and green drapes opened up to reveal a fabulous view of the château. A wooden deck had green tables and blue chairs where guests had drinks and socialized before and after lunch. The tablecloths were white, with yellow, white, and cobalt blue flower arrangements by the famous flower designer Christian Tortu. There were even artworks hung on the temporary pavilion walls to make guests feel more at home. The famous Hermès designer, Folon, designed a symbol of love for Mathias and Valesca that appeared on various decorative elements throughout the wedding festivities. The symbol was of two doves facing each

other in a circle. This emblem appeared in the center of the plates and on Saint Clair's four-tiered wedding cake, and was also embossed on the back of the tent on a blue background, right behind the bride and groom's seats. After lunch, the back of the tent opened for a performance by an all-female meringue band; dressed in white pants and sexy white tops, the entertainers got everyone up on the dance floor. Later on, guests were treated to an extraordinary show of acrobatic horsemanship featuring expert riders jumping off and on their magnificent jet black, gray, and white horses at full gallop, riding sideways, on top, and sometimes even under the horses' bellies!

THE MOROCCAN LUNCH

That night, 250 of the couple's closest friends and relatives reconvened at the Charles de Gaulle airport to board two chartered Air France flights to Marrakech for the four-day Moroccan extravaganza at Ain Kassmou.

The next morning, guests went up into the Atlas Mountains for a typical Moroccan countryside buffet lunch under white umbrellas. Arriving by foot, mule, or donkeys, they were greeted by local women and children singing traditional Moroccan songs. After lunch, there was some clay shooting organized for the men.

THE RED & WHITE PARTY

That evening was the lavish "Red & White Party." With the help of party impresario Gerard Gasquet, Mathias's parents, Patrick and Martine Guerrand-Hermès, transformed the courtyard of their polo barn into yet another elegant pavilion.

THE ORIENTAL EVENING

That night, Mathias's other uncle, Xavier Guerrand-Hermès, hosted a dinner at his home, Dar Moulay Boubker ("the tallest house in Marrakech"). The dress code was "Oriental Outfit or Black Tie," so guests had all stormed the Bazaar that afternoon in search of authentic treasures to sport.

The guests, who were greeted at the courtyard gates by Moroccan horsemen wearing white turbans and holding four-foot rifles, proceeded to the house along a narrow path laid in Berber carpets. Ladies in royal blue *yashmaks* (traditional veils) and head-to-toe *djellabas* (caftans) held torches along the walls of the alley to light the way to the ornate wooden gates of the palace. Inside the expansive courtyard, which had been filled with flowers, was a blue-and-white marble tiled fountain. Inside the house, a visual feast of Oriental décor, the guests were greeted by intricately carved woods and multicolored mosaics. Dinner was held on the top terrace, where there was an ornate red tent with green scalloped edging and the initials M and V in the middle. The bride and groom cut a *croquembouche*, a concoction made of tiny round sweets filled with Crème Chantilly and dipped in caramelized sugar. After they left, the guests felt as though they had just lived through the Scheherazade's *Tales of 1,001 Arabian Nights*.

> "Guests received an exotic water-color invitation for the Oriental Evening, evocative of *Tales of 1,001 Arabian Nights*—and demanding a dress code to match!"

THE CAKE

The five-tiered wedding cake at the Red and White Party was made of pralines and strawberries from the Amlou region, with a sauce of grilled almonds and honey, a specialty of Mogador. When the cake was cut, two white doves hidden inside were released by the bride and groom.

THE DRESS

Valesca wanted something simple, elegant, classic, and beautiful, so she went to the master—Oscar de la Renta. The white silk taffeta dress took just four fittings to come out perfectly. De la Renta also designed the veil himself, which Valesca didn't see until the day of the wedding. Her bouquet was a simple bunch of white freesias tied with a vine. She wore Mathias's birthday present of two gray pearl earrings with diamonds from Asprey.

All the dresses for her subsequent two big parties would also be from Oscar, with the exception of the red-and-white dress by Luca-Luca that she wore at the Red & White Party.

THE MENU

FIRST COURSE
Fondant de fenouil aux herbes de St. Firmin
(fennel with herbs from the property)
Langoustines de Belle-Ile

MAIN COURSE
Mignon de veau aux morilles de Notre Dame
de Vaulx aux légumes du potager
(veal with mushrooms and vegetables
from St. Firmin's own gardens)

DESSERT
Tarte fine à la Fourme d'Ambert
Wedding cake

Chassagne Montrachet 1993, Château
la Lagune 1990, Château Lafite 1993
Château d'Yquem 1991,
and Champagne Réserve Pol Roger

Catered by Saint Clair

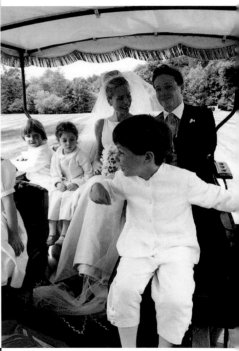

THE RED & WHITE PARTY

Yards of red fabric were draped across the tent, with artwork hanging from the walls and big "balls" of red and white roses hanging from the ceiling. The walls were decorated by the doves designed by Folon in red, and just before dinner, real white doves were released.

THE DEPARTURE

Valesca and Mathias left the ceremony in a horse-drawn carriage to attend the wedding lunch under the pavilion facing Château Saint Firmin. Since the couple is both fond of horses, and it was a country wedding, they decided to incorporate horses as a symbol of their first ride into married life. Mathias's nephews, Oleg and Slava, Valesca's cousin Brooke, a friend's daughter Jacqui, and Valesca's maternal grandmother accompanied them.

CAREYES
MEXICO
KARINA DE BRABANT & FILIPPO BRIGNONE, APRIL 4, 1999

THE ROMANCE

Filippo didn't ask Karina to marry him—he told her that inevitably, she would. The couple, who had met the year before at Karina's "Anna Karenina"-themed birthday party in Gstaad, Switzerland, was strolling down the Champs Elysées one night during a Parisian getaway, when Filippo announced that they were going to be married. Two months later, he called her in London (where she was living) from his flat in Milan to tell her again: "You don't realize it, but we are getting married!" He then proceeded to call all of his and her relatives to announce their wedding. He didn't give her any time to think. Knowing that Karina was indecisive about the big change (which would include a move to Milan), he knew better than to give her an option. It worked: The wedding was set for the next Easter weekend, at Filippo's father's seaside estate in Careyes, Mexico.

THE RING

Not only did Karina not get proposed to—she didn't even have a ring during their engagement! Filippo had been so afraid of disappointing her with a design or stone she wouldn't like, that

ABOVE: *The wedding invitation, created by graphic designer Florine Asch.*

OPPOSITE: *The altar at Filippo's father's seaside estate, called El Tigre del Mar, in Careyes, Mexico.*

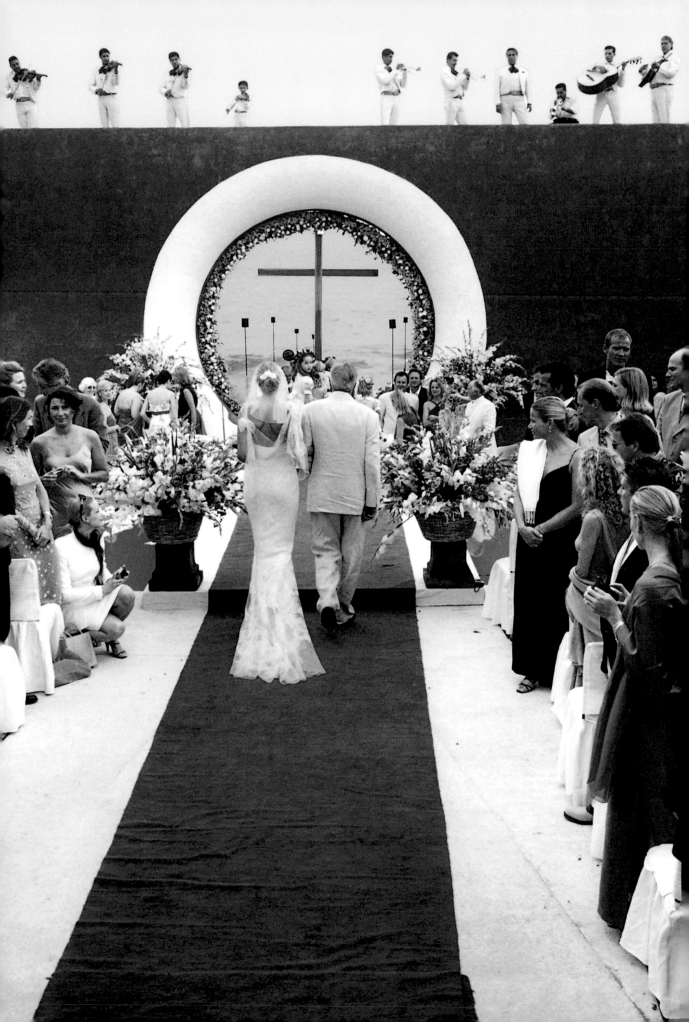

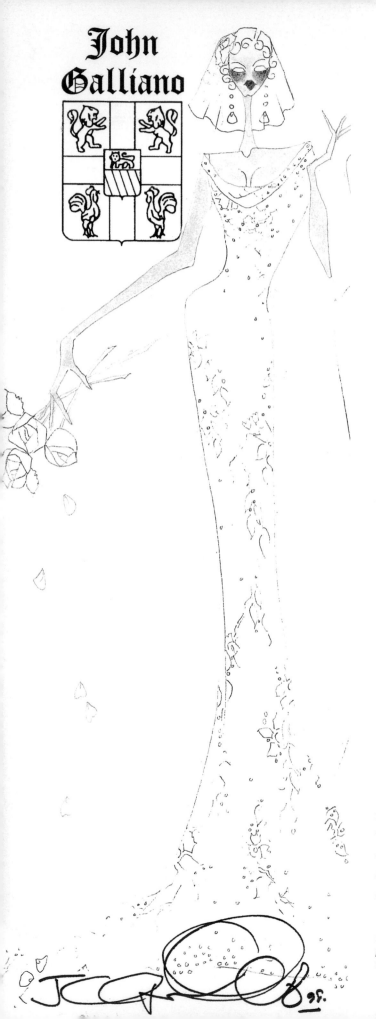

John Galliano

he spent months searching for the perfect ring. She finally got her ring five days before the wedding, while getting ready for one of their "theme" dinners in Mexico. He sighed in relief when she enthusiastically slipped the emerald-cut, diamond-clustered Ceylon sapphire ring on her finger.

THE PLANNING

Karina flew to Mexico twice before her wedding to formulate a master plan for the seaside nuptials. Mr. Brignone's estate, El Tigre del Mar ("The Sea Tiger"), is set on top of a cliff overlooking the ocean, so she decided to have an outdoor service, beyond the pool area. For her walk to the altar, a wooden structure was built on top of the pool, which served to give the illusion of her walking on water.

The reception would take place on the beach below. For this, Karina designed a *palapa* (tent) herself. It had a typical thatched roof structure made of straw, bamboo, and coconut leaves, and measured approximately 3,300 square feet. A crew of 160 workers worked for fourteen days to build it—only to have it collapse five days before the wedding! (It was eventually propped up.) Karina also designed a rock staircase leading from the cliff to the beach, to accommodate the elegant stiletto-heeled ladies—quite a challenge, given how hard and steep the rock was.

Because of the remoteness of the wedding location, Karina had to bring all the catering staff, chefs, and waiters from Mexico City, along with all the necessary supplies and rentals for all the different events. Four chefs worked out of a small kitchen, along with a crew of forty waiters and twelve florists.

So that there would be no misunderstanding on how she wanted things done, Karina

LEFT: *John Galliano's sketch of Karina's dress for Dior Haute Couture.*
RIGHT: *Karina's father leading her to the altar.*

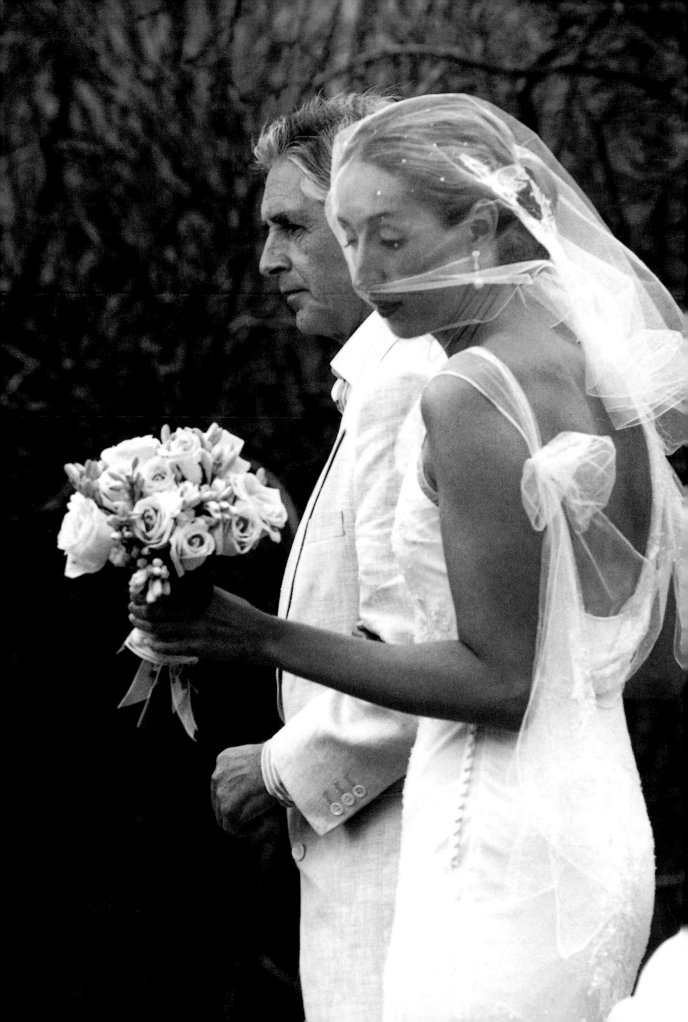

Saturday evening's Mexican-themed party held on "La Playa Rosa" (the pink beach) in the Careyes resort complex.

took photographs of every flower arrangement, table setting, type of menu and the plate presentation that she had made a decision on, and sent them all to the organizers.

THE DRESS

Karina thinks that a wedding dress should fit both the bride's tastes and the wedding's atmosphere, so her big sartorial dilemma was finding a dress that not only looked right on her, but also fit in with the Mexican springtime.

In her quest to find an appropriate dress, she tried on every imaginable shape and type of wedding dress that she could find. Then she visited specific designers that she liked and thought would understand what she wanted. Finally, she went to see John Galliano at Christian Dior, who she felt would most understand her vision.

(The fact that she had brought along photographs of Careyes, and of the actual spot on the beach where the ceremony was being held, also helped.)

The final version was a bias-cut, white silk tulle dress with embroidery on the tulle—white on white—of flowers, leaves, and butterflies with a slip underneath and a small train in the back. On the back of each shoulder was a soft bow tied asymmetrically. The dress had a slightly draped front, and a loose, low-cut back. Tiny little pearls and paillettes were dusted "Cinderella style" with crystals and silver on the randomly embroidered tulle fabric. Miniature fabric-covered buttons ran all along her left side. She wore white suede Manolos, with three tiny little white suede roses in front on the straps.

The five flowergirls dressed in Monica Noel outfits.

The veil was a big issue for her. She never envisioned herself under a huge veil since it would be at odds with the outdoor environment, so Galliano came up with the concept of a silk tulle veil that just touched the shoulders, and covered her whole face. Embroidered on the left of the veil in minute crystals and pearls were overlays of two flowers and a butterfly. This gave the impression that she was wearing a jeweled pin in her hair. The end result was exquisite subtlety and elegance.

THE WEEKEND

To entertain her 250 guests coming from abroad, Karina organized a multitude of events for the weekend. Besides the casual "welcoming buffet" at the resort hotel the first night, there were two other "theme"

View of the intricately carved stone steps leading from El Tigre del Mar down to the tent on the beach. These steps were specially carved out of hard rock for the wedding to accommodate the stiletto heels of the female guests.

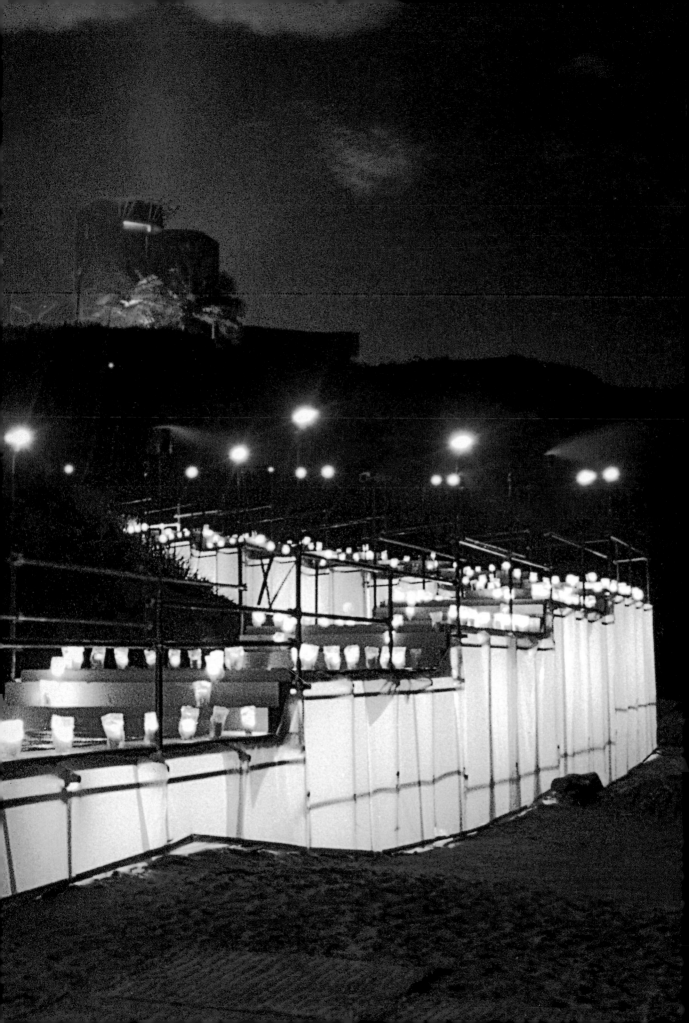

evenings: an Asian one on Friday, and a Mexican one on Saturday. The finale was the wedding party on Sunday night. During the day, there was a polo match in the polo fields and a golf tournament.

THE CEREMONY

The ceremony was to begin at dusk on Sunday. Karina had chosen the part of the beach garden with the distinctive architectural elements and dramatic setting. The blue wall between the beach and the steps had a round white opening in the middle, through which the guests could see the ocean and the waves breaking with a terrific crash on the beach. The space had two levels, creating the feeling of an ampitheater, with some guests witnessing the ceremony from above and some from below, which gave the event the feeling of a ritual in ancient Greece.

A twelve-man mariachi band was lined up on top of the wall, all clad in white with red scarves tied around their necks. The pool that Karina crossed to come to the altar had gardenias and tuberoses floating on the surface. The flower girls sat by it on big white cushions, holding white tulle-covered baskets filled with yellow, pink, and white rose petals. Their headbands were made of bougainvillea strands woven together in shades of fuchsia, pink, and white. Their beige and white smock dresses were embroidered with scallops and shells, and they wore white ballerina shoes on their feet. A wooden cross was placed inside the circle,

> “ I needed something to keep me focused so I would not become too emotional; the smell of the tuberoses in my bouquet kept me grounded. ”

which was surrounded by white gardenias and tuberoses that spread a dizzying fragrance throughout the audience.

Four large wicker baskets surrounded the altar, with white gladiolas, tuberoses, and pink lilies. The bride's bouquet consisted of pink roses and tuberoses.

There were two priests, both wearing robes designed by J. C. de Castelbajac. The designated designer for the Vatican (and a friend of the bride and groom) made the outfits as a wedding gift to the couple. They resembled a rainbow, with blue, red, orange, and yellow stripes.

THE RECEPTION

That evening, the guests walked down the steps to the beach to the temporary *palapa* for the party. Everything was white in the soft candlelight. There was white carpeting on the floor, and tall palm trees around the dance floor. All the tables were round, and as a centerpiece Karina had designed big silver bowls, which were crafted by local Mexican artisans, into which she placed phaleonopsis and cymbidium orchids. Her mother-in-law, who was supposed to have the seating plan for the reception, misplaced it a few hours before the wedding. Thankfully, Karina stayed calm and designated five of her close friends to help her with the seating by creating a table of ten each.

There was a Cuban band from Mexico City followed by DJ Claude Challe, from Paris's Buddha Bar. The guests were also treated to a beautiful display of fireworks on the beach.

THE DECOR

The tables were set with white table-cloths, dark bamboo placemats, white napkins, and black chopsticks. The centerpieces featured birds of paradise placed inside pillar-like bamboo vases. Once the pillar candles were lit, the birds of paradise created a sparkling glow that made the tables look as if columns of flames were rising to the ceiling.

THE POLO GAME

As Careyes is reknowned for its fabulous polo players and polo fields, the bride and groom decided to allow their polo-minded guests to give it a try. The groom's team was headed by the groom's brother, Giorgio, who resides year-round in Careyes. A local Mexican marching band added to the relaxed and festive ambience of that afternoon.

THE MENU

FIRST COURSE
Coconut curry soup
Lobster and Shrimp salad

MAIN COURSE
Pepper Tuna with vegetables

DESSERTS
Fondant of chocolate cake
Wedding Cake composed of individual small cupcakes

THE RECEPTION

After a delicious meal and dancing to the Rosalia Cuban band, guests enjoyed fireworks on the beach before continuing their disco dancing with D.J. Claude Challe of the Buddha Bar in Paris.

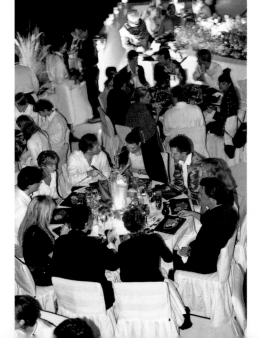

THE BLACK & WHITE NIGHT

The first big theme party, which took place before the wedding, was a black & white night at the villa called "Casa Sol de Oriente." The theme was inspired by the Orient, and an Asian fusion menu was served. Sushi and sashimi were passed for hors d'oeuvres, and black cod was served at the table. The centerpiece consisted of bird of paradise flowers in orange and yellow, inside bamboo vases and surrounded by tall thick candles.

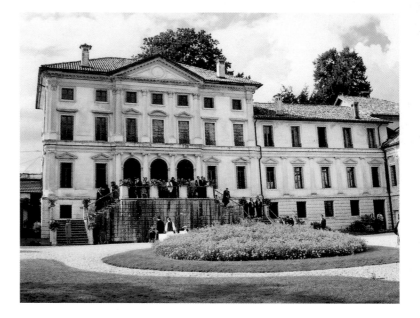

BELLUNO & FLORENCE
ITALY

CHIARA MIARI FULCIS & MASSIMO FERRAGAMO,
SEPTEMBER 11, 1993

THE ROMANCE

Their mothers admit it: "It would never have worked if we had planned it." Not that they didn't try. For Countess Lucrezia Miari Fulcis and Wanda Ferragamo, friends and neighbors in Florence, Italy, having their children, Chiara and Massimo, fall in love and get married seemed like a perfect arrangement—that any independent-minded child would resist. Chiara, in fact, still remembers crumpling the little piece of paper with Massimo's number on it that her mother had given her years ago. An accomplished downhill skier (she has been a member of the Italian national team for eight years), Chiara was traveling to America with friends for a ski trip; afterward she was to stay for a few months in New York, where Massimo lived. She was given her former neighbor's number in the hope that she would contact him during her stay. Instead, she immediately threw the scrap of paper into the wastepaper basket.

Ten years later, destiny intervened, in the form of Chiara's cousin, Duccio Corsini. Duccio invited her and a group of friends to go sailing in Greece; Massimo and his own friends joined them in another boat. Each morning, with the majestic backdrop of the ruins of the

ABOVE: *Villa Modolo, the bride's country home in Belluno.*

OPPOSITE: *The bride and groom in front of the altar with the Choro Agordo singing in the background.*

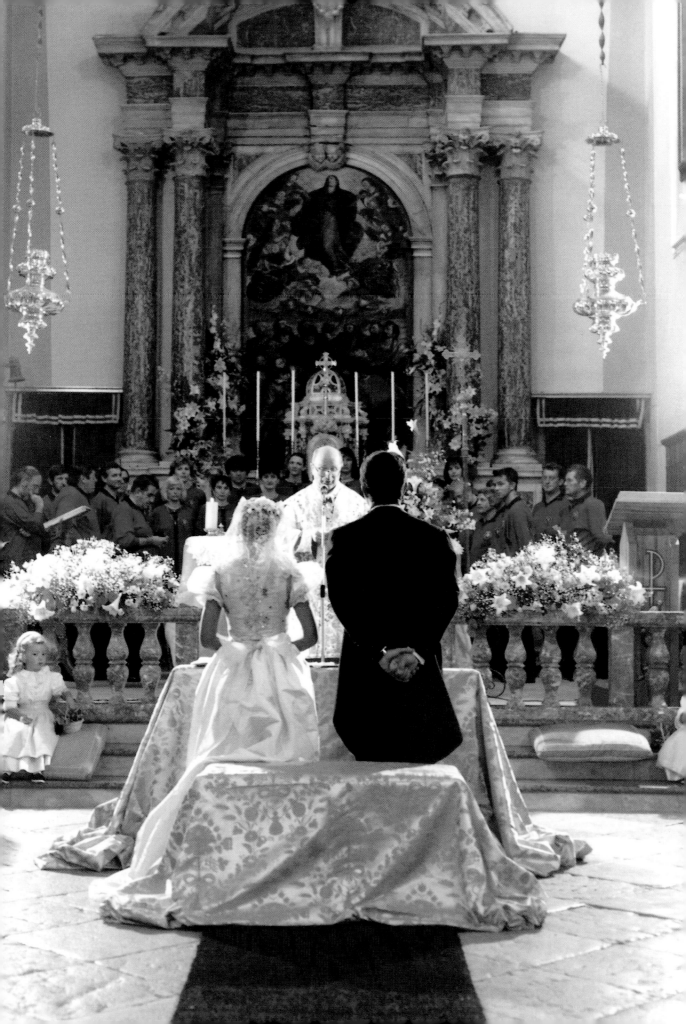

"The traditional dress honored her family's legacy and harmonized with the rustic mountain setting."

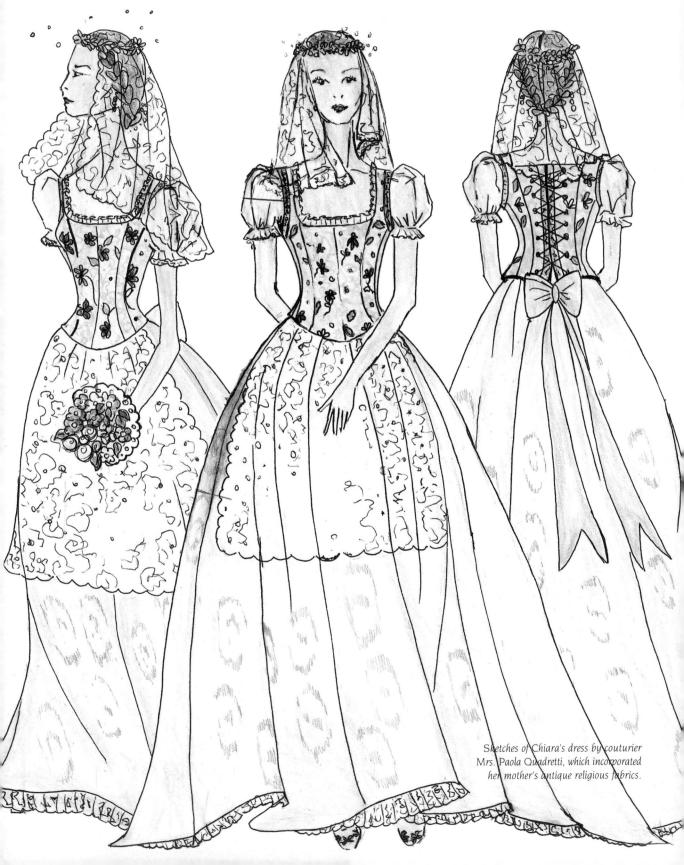

Sketches of Chiara's dress by couturier Mrs. Paola Quadretti, which incorporated her mother's antique religious fabrics.

Temple of Cape Sounion, Chiara would plunge into the clear blue waters of the Aegean Sea for her morning swim. Massimo remembers admiring the bold strokes of her crawl, while she confesses to being taken by his red-hot swimming trunks. For the remainder of the cruise, they used their early morning swimming rituals to chat and get to know each other. On Massimo's next trip back to Florence, he came to pick her up for the sailing group's reunion dinner, and a long-distance romance started soon after. Fearing the certain exuberance of both sets of parents, they kept the budding courtship under wraps. Ever discreet, Massimo never used the "M" word, and didn't formerly propose. Instead, he just asked if Chiara would come and live with him in New York after they went through with the necessary "festivities." This suited the independent and free-spirited Chiara just fine.

Eventually, however, they had to let their parents in on the secret. Massimo announced their wedding plans to his mother before mass one Easter Sunday morning. After church, Wanda called to congratulate Chiara, who had stayed home with an aching throat. She suggested that Chiara follow her old remedy of hot tea with honey and lots of lemon, and soon enough, Massimo brought over a basket of lemons freshly picked from his mother's garden. Chiara told him to leave it on the kitchen sink, but Massimo insisted that she take a better look at these "especially beautiful" lemons. Upon closer inspection, Chiara found hidden amongst them a velvet box with a large sparkling Bulgari diamond ring inside!

THE PLANNING

The two thrilled mothers wanted a huge wedding, but Chiara insisted that she only wanted to invite people that "I like and want to kiss that day." She also wanted to be married in

One of the flower girls, Maria Sole Ferragamo, dressed in the nineteenth-century Veneto style.

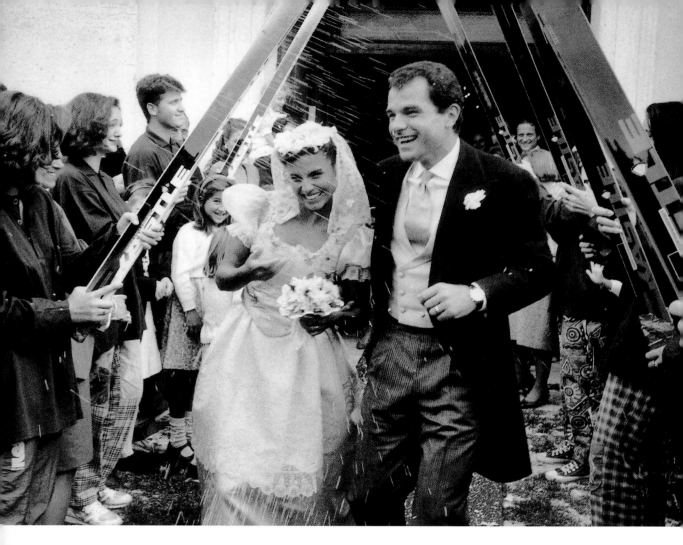

Chiara and Massimo exiting the church under an arch made of skis, held by Chiara's teammates.

Belluno, where she grew up, and whose mountains and church have a special meaning for her. So they decided to compromise with a big reception for 1,500 business relations, friends, and relatives in July, followed by a more intimate event, after the actual wedding ceremony, in Belluno in September.

THE SETTINGS

The large summer celebration would be held just outside of Florence, at the Fulcis family estate called Villa di Maiano. Belonging in the 1800s to Sir Temple Leader, this estate has an illustrious provenance, having hosted royalty and nobles, including Queen Victoria. The estate is best known for providing the location for James Ivory's *A Room with a View*. It now belongs to Chiara's mother. Nestled in the gentle hills of

Fiesole, overlooking the city, the Miari Fulcis family would also host a small September reception at Villa Modolo, an estate built in 1644 that has belonged to the family since the beginning of the nineteenth century. This "small" gathering would be an *al fresco* feast for 450 in the Villa's courtyard and gardens. Since there are over 200 family members just between the Ferragamos and the Miari Fulcis clans, this would be as intimate as it would get!

THE DRESS

Chiara conceived and created her dress as an homage to her maternal ancestors, the Principi Corsini. An important part of Italian history, this illustrious clan has included numerous priests, bishops, and even a Pope. Through the family, Chiara's mother had in her possession

*Chiara with her brother and sister and the bride's niece,
Anna Miari Fulcis.*

antique religious garments of extreme beauty
and craftsmanship. Chiara used these garments
not only as inspiration but also literally as mate-
rial to create a traditional gown. This would
honor her family's legacy, harmonize with the
rustic mountain setting of her wedding, and
accord with the informal character of the recep-
tion that would follow. Besides being a truly
unique wedding dress with its precious antique
fabrics and elegant and classical style, it also
suited the bride's personality perfectly. The
resulting creation consisted of a bodice made
of an eighteenth-century textile in a beautiful
bright yellow brocade, edged in a *guêpière*,
or golden border. The thin organza sleeves
(which were not antique) were dipped in tea, to
match the antique look of her veil and apron.
The apron was tied in back with a big yellow

66 The choir
of the famous
'Choro Agordo'
sang traditional
regional songs
as Chiara
entered
and exited
the church99

In the Church of Castion in Belluno, Chiara's father, Count Giacomo Miari Fulcis, has just given his daughter away to her husband-to-be, Massimo Ferragamo.

organza bow. Her veil was set on a headband made of small flowers in ecru grosgrain.

Massimo's sister, the late Fiamma Ferragamo, designed Chiara's shoes as a wedding present. They were crafted from a deep yellow and white brocade from Fiamma's personal collection of antique textiles that matched the bodice of Chiara's dress. These were custom-made at the Ferragamo workshops according to the traditional nineteenth-century *scarpet* style of shoe, from the Veneto region of Italy.

THE CEREMONY

The wedding ceremony took place in the Church of Castion in Belluno on a sunny day in the beginning of September. The church was decorated with white lilies, baby's breath, and yellow daisies. The bride held a simple bouquet of pale pink roses mixed with white buttercups. The flower girls held long-handled baskets filled with rice and rose petals, and sat on the altar steps on beautiful green damask pillows with gold trim. In front of the marble altar, the choir of the famous "Choro Agordo" sang traditional regional songs as Chiara entered and exited the church. It was a wedding present from the bride's father's head employee, and a complete surprise for Chiara.

As the couple left the church, guests threw white

❝The giant raspberry, strawberry, and blueberry fruit tart wedding cake was 79 inches in diameter. Chiara could not even reach the center to cut the first piece.❞

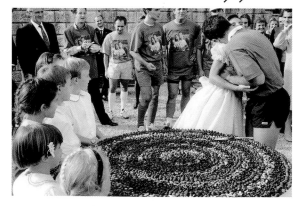

rose petals and rice to wish them a prosperous and happy life together, covering the whole length of the church in a sea of white confetti. Outside the church, the honor guard, comprising several members of the Italian National Ski Team, made an arch of skis for the newlyweds to walk under. Chiara's brother, Andrea, had been given the skis from her sponsors in Austria just before the wedding—they were the same skis that the Italian team would use in the next Olympics.

Massimo and Chiara departed in her brother Andrea's wedding present to the couple: a spiffy red Fiat 500 convertible.

THE RECEPTION

After the ceremony, guests arrived at Villa Modolo, which was built in 1644 and has belonged to the Miari Fulchis family since 1818, for a buffet lunch in the villa's courtyard and gardens, featuring a wide selection of Belluno culinary specialties. The menu was accompanied by wines from the bride's family vineyards in the Tuscan and Veneto regions. The wines called "le Corti" came from the Principe Corsini Vineyards in Tuscany, which belongs to cousins of the bride. There was also a Vin Santo (a sweet dessert wine) from Titignano, the bride's aunt's estate, and a spumante (sparkling white wine from the Veneto region) called Cartizze. After lunch, four waiters brought out a "wedding cake," which was more like a giant fruit tart, made of raspberries, strawberries, and blueberries. Seventy-nine inches in diameter, the cake was so large that Chiara couldn't even get to the center of it to cut the first piece! After dessert, guests were invited to participate in a soccer match, with teams divided up by Belluno (bride's side) and Florence (groom's side). Chiara had T-shirts specially made with a photo of Massimo and her printed on the front, she in a typically defiant pose—sticking her tongue out at the photographer. Unfortunately, Chiara's expression turned out to be an appropriate gesture: the groom's team was the victor.

THE FLOWER GIRLS

The flower girls were dressed in the same traditional style as the bride. They wore tiny yellow-and-ecru print dresses with fabric buttons in front, and ruffled collars edged in lace. They also had lace-edged sleeves and skirts with bright yellow aprons tied with bows in the back. In their hair, they wore a single white silk headband. The pageboys wore vests in the same yellow-and-ecru, with bright yellow pants and white long-sleeved shirts, white tights, and blue velvet shoes. Both flower girls and pageboys wore traditional scarpet shoes.

THE VILLA DI MAIANO

Looking sexy and stunning in a short red strapless dress and pearl and sapphire necklace and earrings, Chiara charmed all her guests at the reception in Florence with her poise and style. Little did they know that she took a 20-minute break between the 1,500 hellos and goodbyes, hiding in the kitchen, eating pasta to regain her strength. The evening included three lavish buffet tables and entertainment provided by the Gipsy Kings, who drummed out the rhythms of the night with vocalist Donna Noel singing "Bamboleo," "Ben, Ben, Maria," and "Djobi, Djoba."

THE MENU

FIRST COURSE
Funghi e zucchini fritti con polenta
(Fried mushrooms, zucchini, and polenta)
Risotto con raddichio rosso
(Risotto with red radish)
*Gnochi alla zucca con semi
de papaveri e ricotta*
(Pumpkin gnochi with poppy seeds
and smoked ricotta)

MAIN COURSE
Coniglio in latte profumato con anice
(Rabbit in milk perfumed with anise)
Daino al ginepro di montagna
(Venison with wild mushrooms)
Fagioli al flasco
(Beans prepared in a flask)

DESSERT
Wedding Cake

THE RED "FERRARI"

Massimo's friends, knowing of his passion for collecting vintage red Ferraris, were expecting him to depart in one of them. Confounding their expectation, Massimo and Chiara instead departed in a zippy red Fiat 500 convertible with the yellow rearing horse insignia of a Ferrari on the front, a wedding gift from Chiara's brother Andrea.

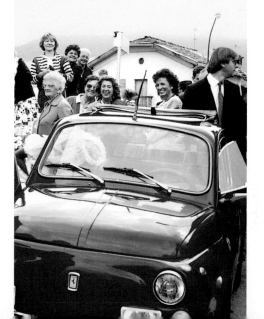

THE FAVORS

Besides the soccer shirts, the guests also received a watercolor by Florentine artist Luciano Guarnieri, depicting the bride in her dress "flying away from home" at Villa Modolo. This was a family tradition, since Guarnieri's master, Pietro Annigoni, also a famous portraitist, had similarly sketched Chiara's mother and aunts at their weddings. Commemorative wedding pictures, taken with the bride and groom on the stone steps of the villa, were also given as favors. With a view of the majestic Dolomite mountains in the background, it was the perfect memento to honor this idyllic country wedding.

PARADISE ISLAND
BAHAMAS

INES DE RIVERO & JORGE MORA MARQUES DE PELAYO

APRIL 27, 2002

THE ROMANCE

Theirs was a Latino romance that blossomed from the deepest of friendships. They were a perfect match: she, a gorgeous tall Argentine Victoria's Secret model; he, an even taller, handsome Cuban investment banker. They met in New York through mutual friends. Before long they realized, with slight apprehension, that they were deeply in love. During a weekend visit to the island of Santo Domingo, after what Inés describes as one of the most old-fashioned of courtships you can imagine, they decided to spend the rest of their lives together. Several months later, in April 2001, they had a quiet wedding in Miami. Soon thereafter, their daughter Maia was born.

THE PLANNING

Despite the civil ceremony in Miami, they both wanted to receive a blessing that would include their daughter. They envisioned an informal ceremony, with only close friends and family witnessing the religious consummation of their happiness. In their vision, this intimate ceremony would take place amidst the lush, tropical

ABOVE: *Scenic view of the ocean from the grounds of the Ocean Club.*

OPPOSITE: *Inés and Jorge holding little Maia in their arms on their way to the ceremony in Paradise Island.*

landscape of Paradise Island in the Bahamas, where they could bask in an idyllic setting and in the total luxury and pampering offered by the Ocean Club. A most-trusted friend, Greg Calejo, assured them that this weekend celebration would exceed their expectations. As the head of Entertainment and Special Events of Kerzner International, he divides his time between New York and the rest of the Kerzner Hotels, including the Ocean Club. But Calejo couldn't control the whims of Mother Nature. On November 5, 2002, a few days before the originally scheduled wedding, the dreaded Hurricane Michelle reared her ugly head in the Bahamas, and destroyed parts of the Ocean Club. Unfazed, Inés mustered up all the sangfroid she could and called each of her wedding guests to announce that due to a natural disaster, the wedding would be postponed until further notice. That day was set for Saturday, April 27th. "Finally" was written on the second set of wedding invitations that the guests received. And despite some unforeseen events—Jorge having a deep gash on his foot after a dive in the ocean—according to Inés, "at the end, it was absolute perfection."

THE DRESS

Jorge insisted that Inés keep her wedding dress simple because a big gown wouldn't look right at a beach ceremony. Inés envisioned a corset on top of a long layered chiffon skirt, something very feminine and flirtatious. She had a vision of her dress in mind when she walked into Oscar de la Renta's bridal studio, but when she saw the swatches from his Summer 2002 collection, there was one dress that stood out. It consisted of a knee-length white cotton lace skirt with a matching bustier all gathered with ruffles. "I saw this beautiful dress, and thought of incorporating Maia by

LEFT: *Inés having a last look before departing for the altar.*
RIGHT: *Guests in all white making their way to Dune.*

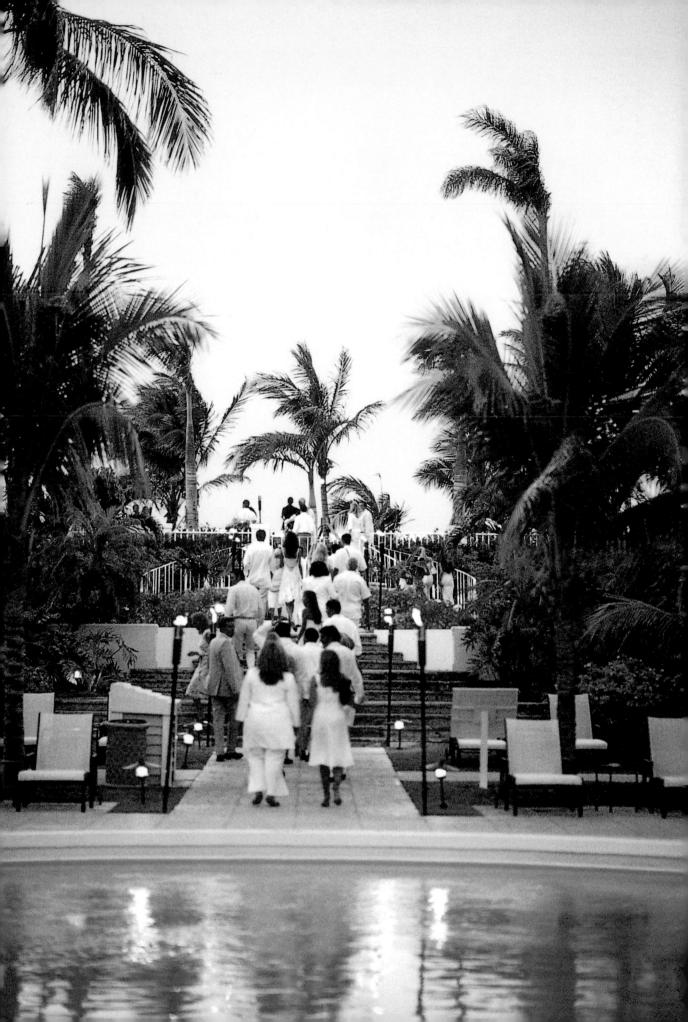

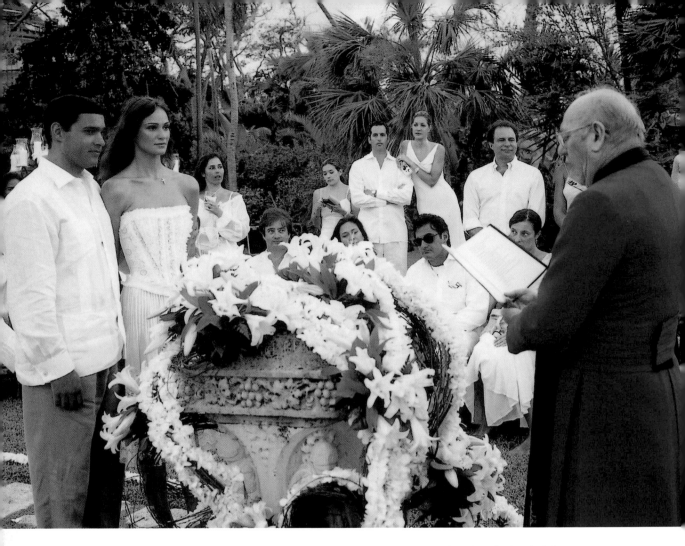

Jorge and Inés about to take their vows in front of the "sundial" altar as the guests, who were dressed in all white, looked on.

making her dress an extension of mine by using the same fabric."

The wedding was canceled in November due to the hurricane, but by April Maia had outgrown her dress. Also, Inés's dress had been in her closet for six months and she was beginning to second-guess her original impulse. So she went to the designer Alberta Ferretti for more options, where she picked three possible dresses. Throwing superstition to the wind (since her wedding was unconventional in all other ways anyway), Inés modeled her four choices for Jorge, who opted for the original Oscar de la Renta dress.

THE DRESS CODE

Inés was adamant about keeping her wedding loose and fun, a point that she made clear in the dress code for the guests. She requested white cocktail dresses for the ladies and white *guayaberas* (Cuban dress shirts) for the gentlemen. (Jorge wore one as well.) Ties were absolutely forbidden: Inés threatened to cut them into pieces and burn them on sight!

"LA PARILLADA"

The eagerly anticipated celebrations started on Friday night, with a bonfire on the beach. The dinner itself would take place around the pool area. In honor of the bride, the evening had an Argentine flavor. The fronts of the buffet tables were covered with burlap and faux cowhide, and the tabletops had *serapes* (colorful woolen shawls), gaucho hats, saddles, and leather riding whips as props. The two long dinner tables seating 60 each were covered with the same

The interior of Jean-Georges Vongerichten's seafront restaurant.

burlap fabric and faux cowhide. Black gaucho hats were placed on top of the tables, with colorful bandanas and old-fashioned kerosene lamps. Large lush cushions were scattered on the floor. There were also large decorated wooden buckets filled with beer to give an authentic Argentine *estancia* (ranch) feeling by the ocean.

The menu featured a cornucopia of Argentine specialties. For appetizers, there was barbecue pork on sugar cane, scallops in *kataifi* (a flaky phyllo crust), blue fin tuna tartar on a garlic plantain cup, and Sevruga caviar. The mouthwatering buffet dinner included split poussin lemon chickens, chorizo pork sausages, peppered ribeyes, split lobsters, and grouper filets. The bar overflowed with tropical drinks, Cuba

" Inés asked her guests to wear white dresses and *guayaberas*. Ties were forbidden. She threatened to cut them into pieces and burn them on sight."

Inés with her fellow models, dancing to the beat of salsa played by Luis Bofill.

Libres, and Mojitos, the weekend's signature drinks. The dessert table had cakes and pastries, including an overwhelming assortment of flans, coconut tapioca with banana, chilled rice pudding with platanos and cinnamon, and tropical fruits and berries.

THE CEREMONY

The "altar" in front of which their 120 guests had assembled was actually a sundial, swathed with garlands of white lilies and orchids. Jorge and Inés arrived in a white golf cart holding little Maia in their arms. The bride and groom, still holding Maia, then walked down the stone steps of the Ocean Club gardens. Their guests awaited them, sipping champagne from long flute glasses, or pale green mojitos from smaller—but no less lethal—glasses.

Maia wore a white organza frock dress embroidered with pale pink flowers, with a pink barrette in her hair. There were white rose petals in a straight line on either side of the aisle. A group of ten gospel singers, also in white, sang as the couple walked toward the altar.

The simple decoration consisted of a lily pond filled with hyacinths, surrounded by rustic iron candelabras and four stone columns. And—just in case—big hurricane shades with pillar candles were placed on the steps.

The blessing ceremony itself lasted only around 20 minutes, because, according to Inés, "we wanted it to be a pleasant experience for all of us and to start the celebration on time." (After such a long delay, who could blame them!)

> ❝ The event was perfectly timed so that guests could admire the golden sunset as they proceeded to the reception. ❞

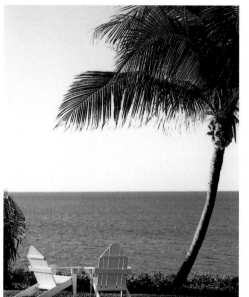

It was perfectly timed so that guests could admire the golden sunset as they proceeded to the reception, to celebrate with an evening of haute cuisine and hot salsa.

THE RECEPTION

At Dune, Jean-Georges Vongerichten's famous seafront restaurant, guests were greeted by exotic floral arrangements. There were orchid garlands hung provocatively from the chandeliers, and lying on top of the tables were clusters of lavender cattleya orchids in moss-wrapped vases. Stacks of pillar candles of varying sizes were placed all around, and little amber lamps emitted a soft, flattering light. Outside, on the deck, there were large garden pots arranged with exotic palms mixed in with cascading plants. Clustered around the bar were green and yellow coconuts with cymbidium orchids in the same colors "growing" from within them.

Luis Bofill's swinging Cuban salsa band had been flown in from Miami for the entertainment. They brought the whole wedding party onto their feet, as guests admired the expert shakes and undulations of Jorge and Inés. The rhythms kept on going long into the night, as DJ Joey Jam took over. After dinner, at around midnight, a tempura and sushi wrap station was set up.

THE HONEYMOON

The happy couple simply extended their stay at the Ocean Club for a few days after the wedding as a honeymoon.

THE TABLE

During the wedding reception at Jean-Georges Vongerichten's Dune restaurant, only orchids were used for decoration. The use of orchids evoked a feeling of Asian tranquility, which contrasted with the spicy menu created by his protégé, Josh Eden. One of the floral creations was made of rust orange cymbidium orchids that appeared to grow from within green and yellow coconuts placed in clusters on top of the bar.

THE CAKE

With their cake, Jorge and Inés flouted one more wedding tradition: It was not only black but also square. To contrast with the white theme of the rest of the evening, the bride had a black chocolate confection with a traditional Argentine dulce de leche filling. Even the most weight-conscious of guests could not resist this sweet temptation, some even succumbing to the unheard of—a second helping.

THE MENU

FIRST COURSE
"Black Plate": Cod fritters with mango chutney, crab rolls with tamarind sauce and crispy quail, tuna rice paper rolls and seafood satay
Papaya salad with mozzarella and prosciutto

MAIN COURSE
Rack of lamb with 7-spice crust and haricots verts or
Spiny lobster served with avocado, cucumbers, and tomatoes

DESSERT
Passion fruit pavlova
Wedding cake

THE ALTAR

The altar was swathed with purple and white orchids and white Casablanca lilies. The nearby lily pond was filled with white hyacinths and the whole area was illuminated by torches. Ten gospel singers added to the casually elegant feeling that Inés wanted to evoke for the blessing of her union with Jorge.

THE FAVORS

In a very thoughtful gesture, Inés assembled gift items for her male and female friends to take back with them as a memento of a fun-filled weekend at the Ocean Club. As Inés is one of the top Victoria's Secret models, sugar-free "VickiMints" were included in tote bags with assorted cosmetics and a CD of the wedding music. In order to protect the guests from the harmful Caribbean rays and to make walking around the beach more liberating, Inés made sure to include sunblock, lip balm, and flip-flops.

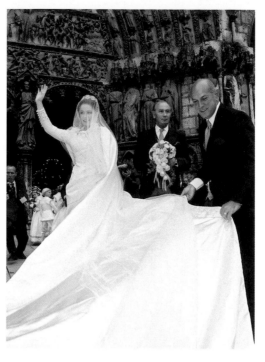

BOURGES &
VERSAILLES

SILVIA DE CASTELLANE & H.S.H. THE PRINCE
AND DUKE D'ARENBERG, OCTOBER 11, 1997

THE PLANNING

Theirs would be a fairytale wedding, full of tradition, opulence, and fanfare. The celebration would start at the legendary Château de Versailles, with a sumptuous dinner and concert for 440 guests—VIPs, close friends, and family members who had come from around the world.

Four days later, on Saturday, October 11, the actual wedding ceremony would take place, at the majestic Cathédrale de Bourges, which has been the site of several royal coronations and is classified as a world historical monument by UNESCO. This would be followed by a wedding breakfast for 1,200 at Château de Menetou-Salon, Prince d'Arenberg's country residence.

THE INVITATIONS

The first correspondence the guests received was a "save the date" card for the wedding ceremony and the breakfast that followed. The card had a representation of a Watteau painting called *La Signature du Contrat de la Noce de Village* (*Signature of the Marriage Contract of the Village Nuptials*) in a thin gold frame, dedicated to H.S.H.'s ancestor, the Duke of Arenberg, Chevalier

ABOVE: H.S.H. *The Princess Silvia d'Arenberg wih her father and Oscar de la Renta, the designer of her Balmain dress, holding her train before entering the cathedral.*

OPPOSITE: T.S.H. (*Their Serene Highnesses*) *The Prince and The Princess d'Arenberg sitting on their prie-dieux.*

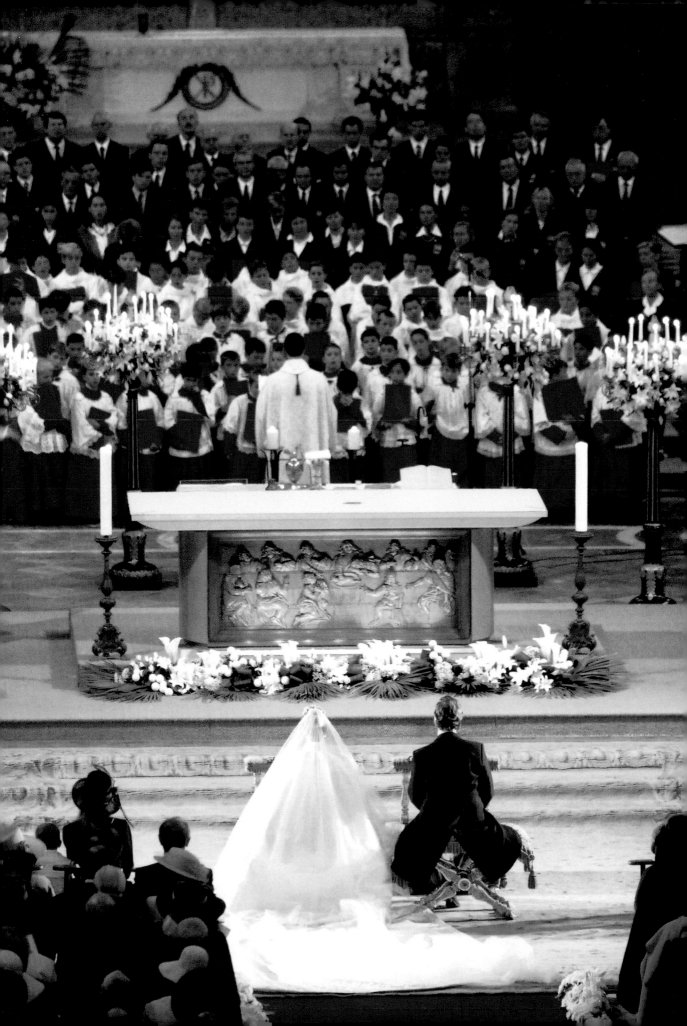

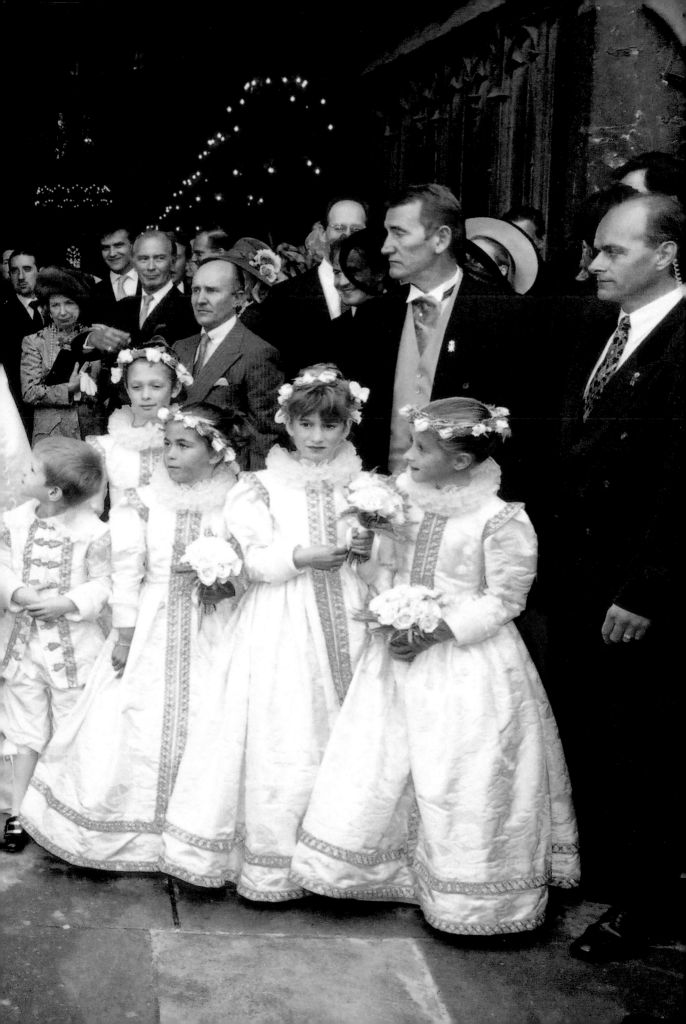

de la Toison d'Or. Included were two pages of helpful information on transportation and hotels in the vicinity.

Next was the invitation for the actual ceremony. A smaller invitation for the bridal breakfast with the prince's gold crest on it was included inside. There were also two special "access cards" for security purposes: a special red card to be placed on the windshields of the cars would allow guests to be dropped off at the entrance to the cathedral, and a yellow card for access to the cathedral itself.

Another set of invitations was sent to 440 guests for the concert and dinner at Versailles to take place four days before the wedding. These were on thick white paper with gold borders, with H.S.H.'s coat of arms embossed on the top in gold, as well as on the back of the envelope.

Last but not least, guests received an amusing watercolor inviting them to an after-party on Saturday night after the wedding breakfast, hosted by a friend in Paris. The invitation for this red-and-gold themed party depicted a colorful carousel made of animals such as lions, kangaroos, zebras, camels, and horses.

THE DRESS

H.S.H. Princess Silvia looked truly elegant in her couture Balmain gown. It was designed for the house by Oscar de la Renta in honor of H.S.H.'s late mother, the stylish Peggy Bedford, then Princess d'Arenberg. The gown paid tribute to this greatly admired American beauty and her loyalty to the couture house. It was ecru satin, embroidered with a golden thread, and featured a tall collar and a 20-foot train.

In her hair, H.S.H. Princess Silvia wore an exquisite tiara created by Chaumet in 1805 that was made of white gold and encrusted

LEFT: *The flower girls and pageboys were dressed in the seventeenth-century style inspired by Van Dyke paintings.*

141

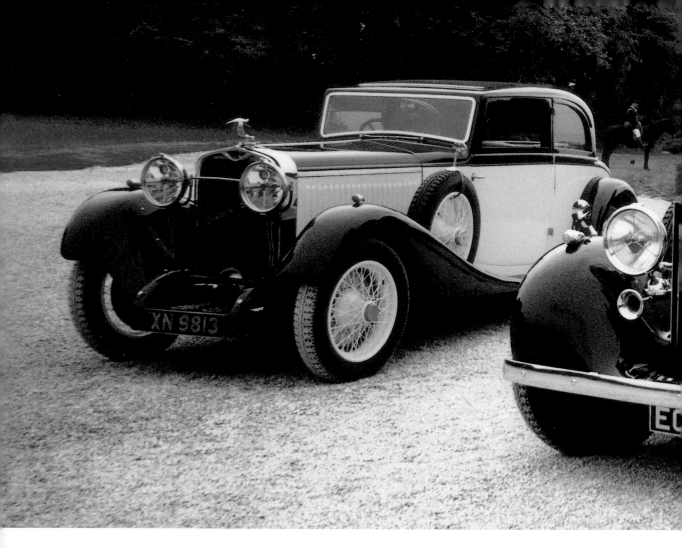

Vintage Rolls Royces from the prince's private collection ferried the guests to and from Château de Menetou-Salon and the parking lot.

with diamonds. The tiara was shaped in the princely heraldic medlar flowers. Each flower had a yellow sapphire in the center. Her long tulle veil was attached to the back of her chignon. She carried a simple bouquet of white roses, which she offered to the statue of the Virgin of the cathedral.

THE ATTENDANTS

The five pageboys and five flower girls that preceded the couple were attired in the same regal style as the bride. Their outfits, also by de la Renta, were inspired by Van Dyck's paintings of the seventeenth-century Prince D'Arenberg. The girls wore embossed ecru satin dresses, with one-half-inch thick gold trim, ruffled organza collars, and puffed sleeves. The boys were dressed in authentic seventeenth-century pageboy costumes, consisting of white damask jackets with gold trim at the shoulders, and organza and lace-trimmed sleeves. They had traditional gold Brandenbourg braids in the front.

THE VERSAILLES DINNER

There could be no more fitting a setting for this fairytale wedding than the magnificent Château de Versailles. The romantic evening began with a classical piano and violin concerto in the Royal Chapel in memory of the prince's parents, after which guests ascended the majestic marble staircase to the legendary Hall of Mirrors, where hors d'oeuvres and drinks were offered. As the guests proceeded along the intricately patterned parquet floors, they were

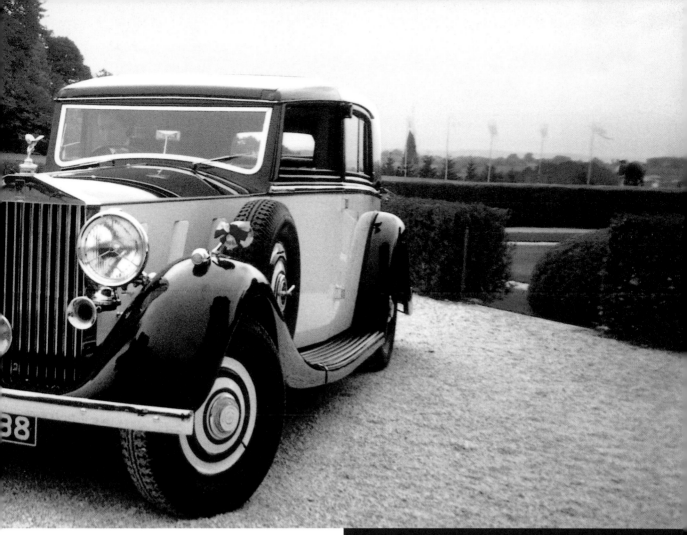

serenaded by a group of Hungarian gypsy musicians, wearing fuschia, yellow, and green silk shirts with embroidered vests.

The main dining room, the Hall of the Battles, where dinner was served, was a breathtaking sight. The longest table the guests had ever seen was surrounded by old master paintings, gilded chandeliers, and damask-covered walls. In fact, never in the history of Versailles had there been a table this long in the château. The golden damask tablecloth had been specially woven in Paris (it took over two months), and at 100 meters (328 feet) long, it had required four people to carry it in. The flower arrangements by Naturel Décor featured huge bouquets of white Casablanca lilies, white freesias, white roses, and gladiolis. On the table were silver bowls filled with red

dahlias and yellow roses, with tall, eight-arm candelabras with votive candles rising out of them. The candelabra were swathed in moss, with tiny yellow and red roses surging amidst the intense green of the leaves. At the base, the candelabra had arrangements of freesias and red and yellow roses. Ivy was strewn all along the table and gently crept up the centerpieces. Together, the flower arrangements created the illusion of a gold and red carpet on the damask tabletop.

The 200 *maître d'* on hand wore red livery with gold buttons embossed with the prince's crest of arms on them. One *maître d'* for every two guests allowed for a diligent res-ponse to every request. Princess Silvia wore a striking black-and-white creation by Paris-based designer Alexandre Narakas. Under the creative supervision of the prince, Narakas created an off-white *robe en fourreau* (bustle), with a long train starting from the top of the shoulders and a high Elizabethan collar. The dress had black-and-white vertical stripes on the front, and embroidered black leaves on the rest of it.

THE ENTERTAINMENT

After dinner, guests were escorted to the Hall

> 66 A show of falconry greeted the guests upon arrival at Château de Menetou-Salon. 99

Attached to the château was an intricately designed pavilion, where the wedding breakfast was held.

of Mirrors where there was colorful, exuberant display of fireworks outside the open windows. The effect was dramatized by the fact that the sparkling light and exploding colors of gold and silver were reflected in the mirrored walls and on the large crystal chandeliers above, creating the impression of riding a roller coaster through a brightly colored kaleidoscope.

THE CEREMONY

Guests staying in Paris arrived at the ceremony four days later in decorated first-class train wagons that had been reserved for the event, complete with maître d's serving drinks and breakfast during the two-hour journey.

For the wedding, the majestic Cathédrale de Bourges had been decorated for a sensational effect. Special permission was granted for the eighteen chandeliers to be lowered so that they could be draped with cascading white lilies and roses in the design of a crown. Every column had The Prince d'Arenberg's crest of arms on white panels of flowing silk. The altar was flanked by four huge gilt candelabra, wrapped with white roses and lilies. All along the aisle, at the edge of each pew, were bouquets of yellow and white roses. T.S.H.'s *prie-dieux* was carved by the finest craftsmen and gilded for the occasion, and had their initials engraved in gold. After the ceremony, the bride and groom left the cathedral in a convertible electric car, waving at the crowds of admirers from the local town and vicinity.

THE BREAKFAST

In light drizzle, livery men dressed in red and gold tunics and white and gold gloves greeted the 1200 guests, and escorted them into the breakfast pavilion. The first meal the bride and groom host after a morning ceremony is traditionally called a wedding breakfast. T.S.H. The Prince and The Princess d'Arenberg held theirs at a pavilion adjoining the groom's family's country home, Château de Menetou-Salon, in the French countryside.

THE CAKE

The wedding cake was an exact replica of Château de Menetou-Salon. At 5 feet high and 4 feet wide, it required four waiters to carry. It was white and gold, with yellow and red decorations all around. When the bride and groom cut their first piece, twenty-four white doves were released from inside.

THE MUSIC

The romantic evening at Château de Versailles began with a classical piano and violin concerto in the Royal Chapel in memory of the prince's parents, after which guests ascended the majestic marble staircase to the legendary Hall of Mirrors, where hors d'oeuvres and drinks were served. After dinner a colorful ensemble of Hungarian gypsy violin, cello, and accordion players wearing fuchsia, yellow, and green silk shirts with embroidered vests serenaded the guests.

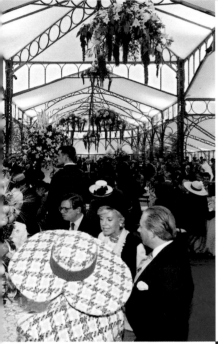

THE MENU

FIRST COURSE
Bisque d'Ecrevisses Valençay à la Truffe
(Shrimp bisque with truffles in honor of the Duchess of Valençay, the bride's great-grandmother)

MAIN COURSE
Caille Braisée Grillée
Prince de Bénévent
(Grilled Quail)

DESSERT
Parfait de la Belle au Bois Dormant
(Sleeping Beauty Parfait)
Wedding Cake

THE BREAKFAST

Attached to the château was an intricately designed pavilion, where the lunch was held. It was made of green metal and glass, with arches, glass windows, wall-to-wall green carpeting, and white fabric at the sides. The columns supporting it were covered with creepers and baskets hanging from the ceiling, filled with white, yellow, and red flowers, giving the impression of being in a lush tropical garden. Twenty-four Medici vases on stone pedestals were placed throughout the pavilion.

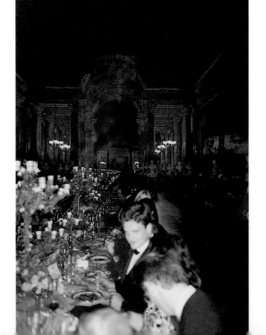

THE DECOR

It was a magnificent and rare occasion to be able to have a sit-down dinner for 450 in the dining room adjacent to the legendary Hall of Mirrors, called Gallerie des Batailles (called Hall of the Battles because of all the paintings depicting famous battles) at the Château de Versailles. The length of the custom-made table (which had to be assembled in place) and its 328-foot-long specially woven golden damask tablecloth added to the grandeur of the wedding. The guests felt transported back to the time of Louis XIV, the Sun King, who conceived Versailles for his courtly entertainment.

ROME
ITALY
DRUSIANA SFORZA CESARINI & CHARLES PRICE, MAY 26, 2001

THE ROMANCE

This is a wedding *à la Dolce Vita*. Drusiana, a native of Rome, was visiting friends in Gstaad, Switzerland, for a weekend of skiing in February. One hour away in Geneva, Charles Price, who everyone calls Chaz, had just finished a business meeting, which prompted him to accept a dinner invitation to join a group of his friends in Gstaad that night. On his way up the narrow mountain roads that Friday night, fate intervened, unleashing a terrible snowstorm, which slowed Chaz down so much that he missed his dinner date. Arriving in Gstaad safely but hungry and exhausted from the treacherous drive, he called his friend Karina de Brabant, who invited him over for a quiet dinner at the chalet where Drusiana was also staying. During dinner, he and Drusiana were seated at opposite ends of the dinner table and hardly spoke. But after dinner, at the nightclub—inspired either by the musical melodies or by Drusiana's artful dancing—Chaz initiated what would become a weekend-long flirtation before flying back to New York.

Drusiana didn't make much of the encounter—Rome and New York are not exactly next door, so anything further with Chaz seemed "too remote and way too difficult." Chaz thought otherwise.

ABOVE: *The Monsignor dressed in traditional Roman colors, on his way to perform the wedding.*

OPPOSITE: *The bride in a Cinderella-like four-horse carriage, about to arrive at the open-air wedding chapel on the grounds of Villa Porto.*

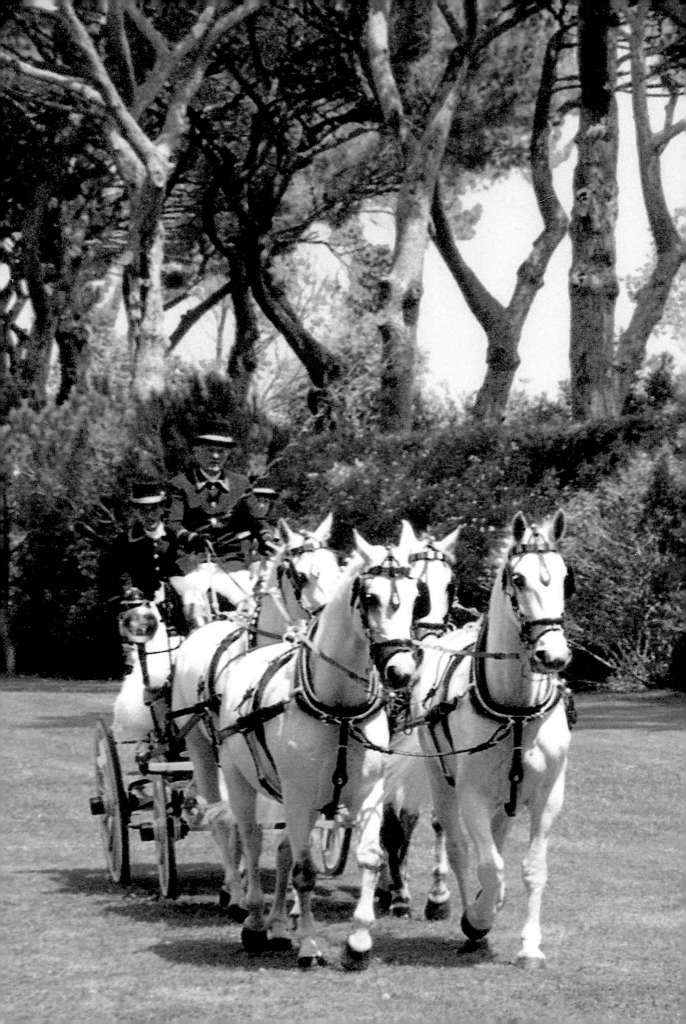

A few weeks after they met, at the end of March, he flew to Rome to spend a weekend with her. But instead of Drusiana showing her hometown to him, Chaz, who studied architecture there, showed her "his" Rome. "It was then that I realized that he was the man of my life," Drusiana says. In April, they met again in Careyes, Mexico, at Karina's wedding. By May, Chaz decided to reconsider a business offer to move to London, and took it.

THE PROPOSAL

At the Careyes wedding, Chaz gave Drusiana a beautiful Buccellati platinum ring, intricately laced with tiny little flowers, as a symbol of his conviction that he had found his soulmate. After that, says Drusiana, "he never mentioned marriage again!" Their actual engagement wouldn't take place for another year and a half. One evening in November of 2000, Chaz, in his unconventional way, decided to present Drusiana with her engagement ring in a most unobtrusive manner—by placing a blue velvet pouch on her bedside table while they were preparing to go out for dinner. He chose a ring with one large diamond in the middle flanked by two smaller heart-shaped ones to symbolize their two years together. She fortunately noticed it in time (even though she doubts he would have let her leave the room without it).

THE SETTING

The wedding was to take place in May, two days after Drusiana's birthday, at her family's estate in the Roman countryside called "Villa Porto." The town of Porto had served as the Roman harbor of Emperor Trajan in the third century B.C., and the main port of Rome. The vessels entered from the sea into the river Tevere and from there traveled on to Lago di Porto, which is part of the Sforza family estate. In keeping with Porto's rich

LEFT: *Mr. Charles Price, the groom, before the ceremony.*
RIGHT: *Drusiana with her father Don Askanio in the horse-drawn carriage, on her way to the altar.*

The reconstructed oratorio, which was used as the altar for the ceremony.

historic and cultural legacy, Drusiana chose a traditional Roman theme for the affair.

THE DRESS

Prince Egon Von Furstenberg, a friend of the family who has known Drusiana's mother, the Duchess Sforza Cesarini, since their schooldays, offered to design the wedding dress. Drusiana had dreamed of a Cinderella-like dress, with a huge puffy skirt and lots of embellishments, but Egon persuaded her that such a dress would look out of place at an outdoor country wedding. Instead, he conceived a dress to match the veil—which had been worn by her mother at her wedding in the 1960s—made by Capucci, and was approximately 10 feet in length. The veil had tiny little white flowers of varying sizes applied in thicker clusters around the head and face, and randomly strewn

tiny leaves and butterflies throughout the back. Egon recreated the Capucci design on the dress. The bodice was sleeveless mousseline, edged with a thin silk border around her neck. It had a tapered waist and a full skirt, with the same white flowers as the veil in thick clusters on the bodice, and more randomly on the skirt. The embroidered part ended at mid-length. She wore her hair in a chignon, with tiny white flowers inserted in the braid and simple white pearl earrings. She carried a bouquet of white peonies.

THE WEEKEND

Just being in Rome in springtime was treat enough for the guests. However, the official social engagements began with a cocktail party on Thursday night for family and close friends, at Drusiana's house in the Roman hills. The

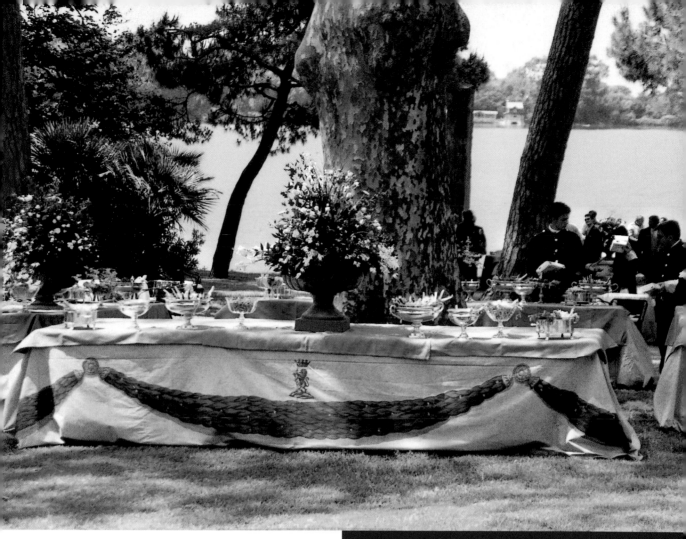

The buffet tables, with the Sforza coat of arms painted on the tablecloth, awaiting the guests.

buffet tables on the tri-level terrace were covered in green leaves from top to bottom, and a musician played the electric piano as background music on the higher terrace, which had an expansive view of Rome. Glass bowls with floating roses and gardenias alternated with votive candles on the balustrade. Downstairs, there was another buffet where desserts were set out for when the time came to sing "Happy Birthday" to the bride!

THE DECOR

Don Askanio, the bride's father, who takes great pride in his landscaping skills, suggested they reconstruct the ancient Roman oratory that was originally on the grounds. Using the ruins that were part of the *capela* (praying

The lakeside Villa Porto has been in the Sforza family's possession since the 1800s. It is in the typical Roman colors of rosso bruciato and rosso Romano.

chapel), they created the altar under which Drusiana and Chaz were married. All the marble and stone columns near the altar were also of Roman provenance.

For the luncheon afterward, a pavilion was erected on the lawn, incorporating an existing gazebo, on which the bridal table was situated. Conceived and designed by the Duke and Duchess, the tent took the form of a Roman military encampment. The canvas structure was in the traditional Roman colors of *rosso Romano* and *rosso bruciato* (Roman red and burnt red). The white canvas drapes covering the poles at the sides were attached to metal lances in the traditional Roman army manner with triple-thick silk cords.

THE CEREMONY

The flowers at the altar were all white—roses, lilies, peonies, and gardenias. The ceremony, which was both in English and Italian, was performed by the Bishop of Porto and by two other priests. There was a choir from the Roman singing academy of Santa Cecilia, which sang the "Ave Maria" as Drusiana walked to the altar and the "Halleluia" as she exited. Drusiana arrived at the outdoor *capela* in a dark blue open-air *carozza* (carriage) with the Sforza's crest in gold on the side. This carriage was drawn by four identical white stallions and impeccably dressed coachmen in traditional uniforms. Three carriages followed with the flower girls and boys and family members. The beautiful bride, arriving enveloped in a cloud of white tulle, was a most convincing version of a contemporary Cinderella.

> " The flower girls had cream silk dresses with a light green taffeta sash at the waist and wore garlands of yellow freesias and orange roses mixed with baby's breath. "

THE RECEPTION

Four large rectangular tables, placed around an old oak tree, offered drinks and delicious hors d'oeuvres. The tables were draped with white canvas, on which was hand-painted the golden coat of arms of the Sforzas (which depicts one rearing lion with a ducal crown in gold resting on top of his head) and undulating thick green garlands of laurel leaves with gold medallions at each side. On top of these tables were green linen tablecloths of the same color as the garlands. Similar tables were scattered along the edges of the lake, some offering only drinks. Large terra cotta urns were overflowing with arrangements in the Sforza family colors of blue and yellow, providing a colorful backdrop to the greens of the tablecloths and the lawn. The columns on either side of the house were covered with white climbing roses.

THE DIVERSION

After lunch, the same horse-drawn carriages belonging to the Duke took guests to another open field for a show of falconry. According to the nineteenth century custom, this show is presented as a gift in honor of a bride and groom of aristocratic background, and prized for the extremely difficult and challenging nature of the sport. Back at the pavilion, a jazz group performed for the guests who were too lazy or too full with all the Roman and Neapolitan culinary delicacies.

THE CAKE

The four-tier wedding cake was very traditional in look with white lace icing with vanilla and pandespagna. Each layer was standing on its own tray, with the edges decorated in white tulle, with little silk bows and pale champagne pink roses all around. A small bouquet of champagne pink roses rested at the very top of this sculptural arrangement. Beside the cake, on an antique lace tablecloth there were "confetti"—sugar-coated almonds—in silver baskets for good luck. Silk orchids with pearls in the center embellished the corners of each basket.

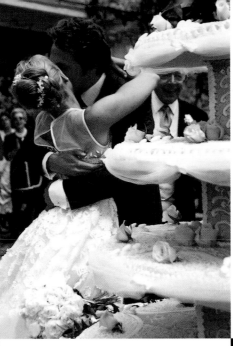

THE TABLE SETTING

At the rehearsal dinner at Palazzo Taverna, the tables were laid with burgundy red damask tablecloths and white porcelain plates, with red and green roses painted on them. A huge buffet filled with desserts was placed in front of an eighteenth-century gilt console, with blue and white Chinese vases on top. That evening, there were speeches from close friends and family—and of course, the best man's toast drew the most laughs.

THE MENU

FIRST COURSE
Mousse di gorgonzola con verdure stagionali
(Gorgonzola mousse with seasoned vegetables)
Crostata alla zingara tartufata agli asparagi con quennelles di pollo
(Gyspy tart stuffed with truffles and asparagus, with quennelles of chicken)

MAIN COURSE
Faraona farcita con giardiniera pomodorini gratinati paratatine, fagiolini e cipolline
(Stuffed pheasant with tomatoes, au gratin, small potatoes, beans, and tiny onions)

DESSERTS
Meringate di caffe con chicchi di cioccolato
(Coffee meringue with chocolate beans)
Parfait alla vaniglia con frutti di bosco
(Vanilla parfait with mixed berries)
Wedding Cake

THE AFTER-PARTY

On Saturday evening after the wedding, there was a "ball" at the eighteenth-century Palazzo Lancellotti. A wedding gift from one of Drusiana's best friends, it was mainly for the "young and the restless," who had enough energy to party after the afternoon's festivities. Guests enjoyed a lavish buffet dinner amongst the antique furniture, tapestries, and paintings; they floated from room to room admiring the details of such opulence and grandeur.

THE ENTERTAINMENT

The guests enjoyed the expert handling of the falcons by their master falconieri. This relationship between the falcons and their handlers takes years to achieve since it requires a bond of trust and respect from the birds, who are free-spirited predators by nature.

LONDON
ENGLAND

MARIE-CHANTAL MILLER *&* H.R.H. THE CROWN PRINCE
PAVLOS OF GREECE, JULY 1, 1995

THE ROMANCE

When Marie-Chantal Miller was in her early twenties and living in Paris, her Greek godfather started to praise the handsome looks and winning personality of a certain young Greek. A charming young man in his late twenties, who was pursuing a political science degree at Georgetown University. He was none other than H.R.H. The Crown Prince Pavlos of Greece.

Yet despite her godfather's persistent efforts to introduce them, they didn't actually meet for another two years, at a friend's birthday in New Orleans. Nonetheless, Cupid's arrow had hit its target. Their romance flourished, and two years later—during a ski trip with their families in Gstaad, Switzerland—he proposed. One clear sunny morning while riding up the slopes in a cable car, H.R.H. The Crown Prince Pavlos fell to his knees and asked Marie-Chantal to share the rest of her life with him. He presented her with a magnificent blue sapphire engagement ring from his pocket and waited breathlessly for her answer. (He had chosen a blue stone to represent his country, Greece, which is surrounded by blue skies and the deep blue of the Aegean, Mediterranean, and Ionic Seas.) She accepted.

ABOVE: *The invitation designed by Florine Asch for the dinner party at Wrotham Park, two nights before the wedding.*

OPPOSITE: *Wedding portrait of Prince Pavlos and Princess Marie-Chantal of Greece, 1995.*

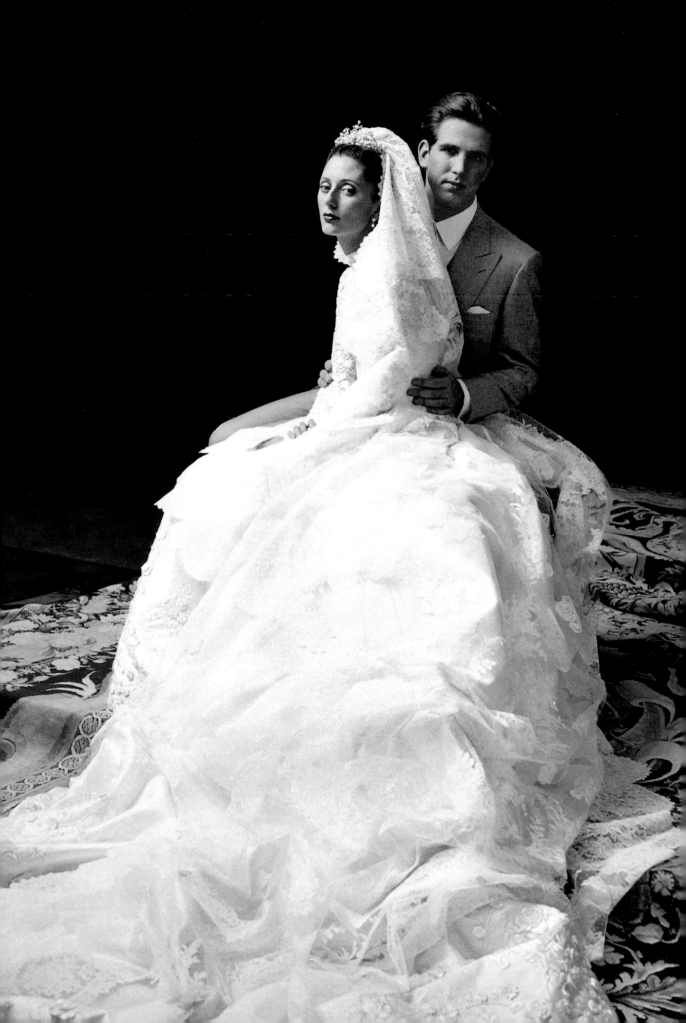

THE PLANNING

After the official announcement, Princess Marie-Chantal started preparations for the July wedding, just six months away. "As a little girl, I always dreamed of having a thousand people at my wedding!" As it turned out, she really did have a thousand people at her wedding, and added another 184 to that number!

The first event would be a dinner dance for 900 at Wrotham Park in Hertfordshire (on the outskirts of London), two days before the wedding.

The day after the dance, H.R.H. The Crown Prince Pavlos's aunt, Her Majesty the Queen of Denmark, would host an intimate lunch for fifty family and friends on her beautiful yacht called "Danenbrau," which sailed up the Thames for the occasion.

The wedding ceremony itself would be a comparatively small affair, for 400 close family, friends, royals, and other VIPs, at the Greek Orthodox Cathedral of Saint Sophia in London. A live broadcast of the ceremony would be shown to the remaining 800 guests from TV monitors located in a marquee at Hampton Court Palace, where a wedding breakfast would take place following the ceremony.

Although the wedding was not to take place in Greece, Princess Marie-Chantal wanted to come up with a fitting alternative. She envisioned "a lovely ancient Greek temple in a beautiful garden setting—very, very romantic, with lots of ivy and lots of white flowers and white tablecloths and Greek motifs all around." To execute her vision at the eleventh hour, she called on Robert Isabel in New York, the only person she felt who could actually do it artistically and tastefully enough so as to be beautiful without being "over the top." All in all, 3,000 people were involved in creating both events.

LEFT: *The wedding dress designed by Valentino Haute Couture for the royal occasion.*
RIGHT: *Princess Marie-Chantal, enjoying her "surprise" at Wrotham Park, in an evening gown by Valentino Haute Couture.*

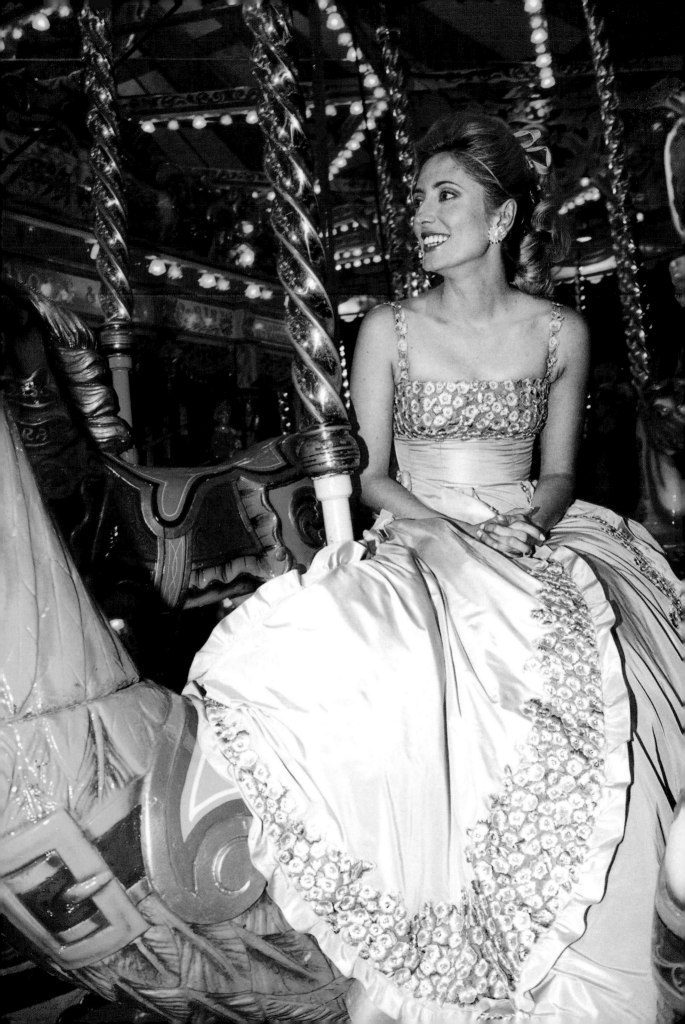

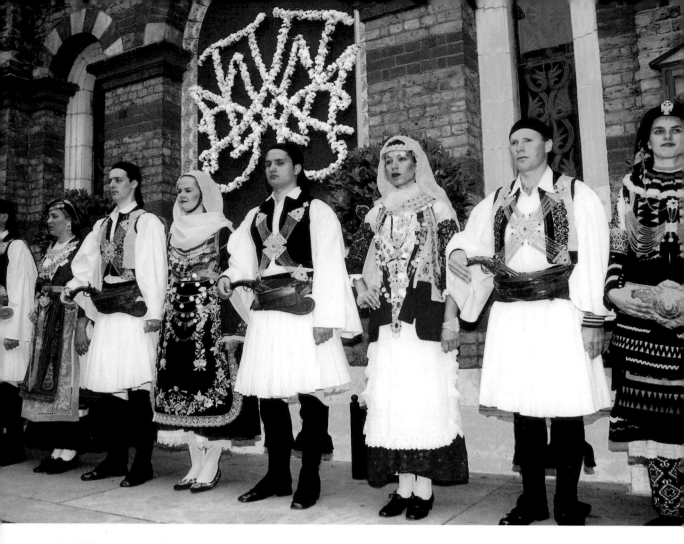

Greek folk dancers in traditional costumes greeted guests upon their arrival at the Greek Orthodox Cathedral of Saint Sophia in London.

THE INVITATIONS

The invitation for the June 29th dinner dance was a beautiful watercolor by French artist Florine Asch, depicting Wrotham Park with its columns swathed in ivy and the initials MC and P at the top of the colonnade, with chandeliers hanging on either side. A red ribbon tied in a bow on top and bottom framed this image, and fruit and flowers were draped all around. Inside were directions to Wrotham Park, and information on coaches leaving Claridge's to get there. These chic buses were each equipped with two butlers serving Pol Roger champagne, orange juice, and water.

The wedding invitation was printed on ecru paper, with the royal Greek coat of arms and the motto "My power—the love of the people" was printed in red, gold, and blue with two crowns, one on top of the other.

THE SETTING

The dinner dance was held under an immense pavilion that comprised the whole front of the house at Wrotham Park, going almost as high as the roof. It was divided into two parts, with massive curtains separating them. One part was the cocktail tent, where the receiving line would be, and the other was the dining and dancing area. There were also kitchens at either end of the main tent, each serving 500 guests. Four toastmasters were responsible for announcing the guests upon entering and for announcing the events during the course of the evening.

All of the flowers in the dining room were white, while the cocktail and after-dinner area had columns, urns, and tall candelabra-like structures swathed in laurel leaves (flown in from Greece), with a wide, round container

Pageboys enjoying a free moment after the wedding ceremony at Hampton Court Palace.

resting on the top filled with yellow and orange roses. These were displayed in the shape of the Greek flame. For that evening alone, 30,000 roses were imported from Ecuador, the bride's mother's country of origin. The centerpieces on the tables in the main tent were made of gardenias (flown in from California), with tall metal candlesticks. The golden tablecloths had black Greek friezes on the edge.

THE ENTERTAINMENT

While walking with her mother in London, Princess Marie-Chantal had admired a very beautiful, colorfully painted old Victorian-style carousel. Mrs. Chantal Miller had tracked down the owner of this carousel in order to

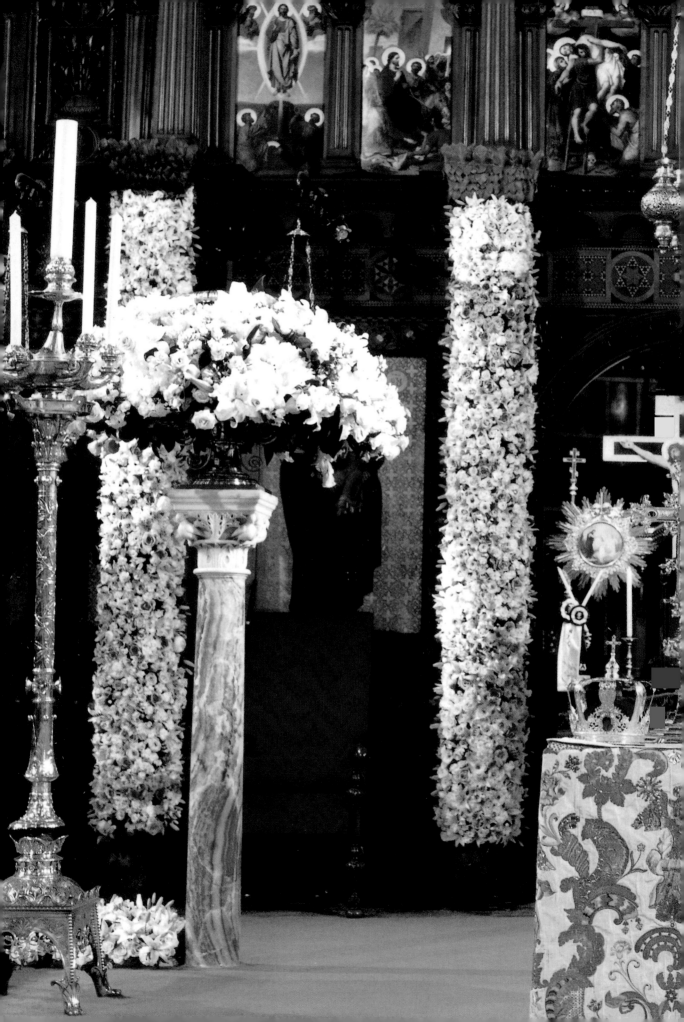

The altar of Saint Sophia Cathedral in London, where the royal nuptials of T.R.H. The Crown Prince and The Crown Princess Pavlos of Greece would be held. The crowns to be placed on their heads awaited the start of the Greek Orthodox ceremony.

surprise her daughter on her wedding day. It was indeed one of the best surprises of her life!

In addition to the carousel, there was a fabulous show of fireworks, and a special performance by the singer Taylor Dayne of her hit song, "Tell It to My Heart." Afterward, DJ Tom Finn continued the party till six in the morning.

THE DRESS

"I was looking for a conservative dress, in lace, to make it look more traditional," says the bride.

"It had to be 'timeless,' so that fifty years later I could look back at my wedding photographs and still say 'I had a beautiful dress.' I wanted something that was classic, rather than modern and trendy."

To realize this vision, she looked to Valentino, who created a couture dress of beautiful white silk shantung with a long train. The bodice and sleeves were made of lace with tiny white flowers applied on top of a crisscross pattern underneath. Exquisitely embroidered flowers hemmed the dress in an intricate pattern. Her veil took four months to make.

She wore a pearl and diamond tiara lent by Her Majesty, Queen Anne-Marie of the Hellenes, her mother-in-law, and little diamond drops from Harry Winston.

Her bouquet was a "giant rose" made from individual rose petals.

THE ATTENDANTS

The four flower girls wore a pale grayish blue organza full-length dress, with white flowers appliquéd on the sleeves, which tied with a blue organza ribbon. They each held one large pink rose, and wore white rose wreaths on their heads. They had white lace-edged cotton gloves and silk velvet ballerina shoes in gray-blue.

The four pageboys wore silk shantung pants with cummerbunds in a deeper shade than the girls' blue-gray dresses, and white silk shirts with ruffled cuffs, with pleats in the front. A blue silk ribbon was tied in a bow under their collars in lieu of a necktie. They wore black patent leather shoes.

> **At the start, have as distinct an idea as possible. And then find a person to fully understand and execute it.**

H.S.H. The Princess Alexandra Von Furstenberg, the bride's sister, was her one bridesmaid.

THE CEREMONY

The church was decorated in pink and white flowers, mainly Casablanca and calla lilies and roses. In front of the altar, on a ceremonial table draped in elaborate gold embroidery, rested a gold cross by which were two twin nuptial crowns. The crowns, made of gold and lined with crimson velvet, were held by the groom's six witnesses during the ceremony on top of the bride and groom's head.

The ceremony was filled with all the pomp and circumstance befitting such a royal union. Presiding over the ceremony were seven patriarchs of the Greek Orthodox church, headed by the ecumenical patriarch Bartholomew from Constantinople. Upon pronouncing them husband and wife, 4,000 rose petals poured gently down from the ceiling of the cathedral. Outside, at the church entrance, a group of eight traditionally costumed Greek singers greeted the guests as they exited.

THE DRESS

Valentino was chosen to be the creator of Princess Marie-Chantal's couture wedding dress. The dress was of beautiful white silk shantung with a long train. The bodice and sleeves were of lace with tiny white flowers applied on top of a crisscross pattern underneath. Exquisitely embroidered flowers hemmed the dress in an intricate pattern.

THE BREAKFAST

For the reception an expansive marquee was set up on the elegant grounds of Hampton Court Palace, consisting of three separate tents. The air-conditioned main dining tent was all white, and full of ivy and pastel colored flowers. On each table was a three-tiered glass container overflowing with fruits (topped by a pineapple), with tiny white flowers resembling jasmine strewn throughout. Ivy was hung from the ceiling, and all of the tent's supporting columns were draped in white, pink, and yellow flowers. The tablecloths and chairs were white, while the carpeting and chair cushions were beige.

THE MENU

FIRST COURSE
Cornish Lobster Salad

MAIN COURSE
Chicken with Morels and Champagne
Jersey Royal Potatoes
Asparagus and Baby Carrots

DESSERT
Nougatine with Orange Ice Cream and Red Currants

Clos de Mazeray Meursault 1993
Château Giscours 1990
Dom Ruinart Rosé Champagne 1986

THE FAVORS

Each guest received a silk scarf with H.M. King Constantine's coat of arms on it. During the wedding breakfast at Hampton Court, each guest also received a white monogrammed Royal Copenhagen cup and saucer full of sugar-coated almonds, with the initials of the bride and groom in gold. These were distributed by Greek dancers in folkloric costumes.

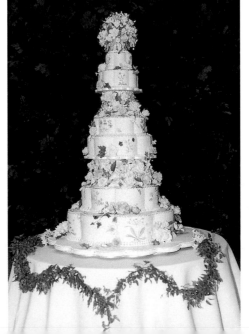

THE CAKE

Marie-Chantal designed the eight-tiered cake herself, in honor of her mother-in-law, H.M. Queen Anne-Marie of the Hellenes, who is Danish by origin and the sister of the Queen of Denmark. Inspired by the delicate Flora Danica porcelain set that she had received as a wedding present, she conceived an intricate design of tiny flowers and lace. Colette Peters, of Colette Cakes in New York, was the only person who could actually execute this extremely intricate and very tall cake. It had to be prepared in such a way that it could be assembled and disassembled for transport. The cake was flown over to London aboard Mr. Barry Diller's private jet, apparently filling the plane up completely.

SOURCES

CHAPTER 1
PHOTOGRAPHER: Kalliope Karella, kalliopekarella@yahoo.com Laurence Vetu, laurencevetu@wanadoo.fr,

DRESS: Tom Ford for YSL Rive Gauche BONPOINT, 811 Madison Avenue, New York NY 10021 Tel: 212 879 0900/ 1269 Madison Ave., New York, NY 10128 Tel. 212 722 7720

JEWELRY DESIGNER
Francesca Visconti di Modrone
345 East 57th St., New York , NY 10022
Tel. 212 593 6106, francescavm@aol.com

PARTY PLANNER: Juliet Barclay, Havana, Cuba, Tel. Office 53 7 669 016
For hotel bookings within Old Havana, special venues, applications to City Historian, juliet@cultural.ohch.cu

CATERER: Restaurante El Patio
Cathedral Square, Tel. 53 7 867 1034
Contact Maria Elena

FLORIST: Floreria Wagner
Havana, Cuba, Tel. 53 7 866 4178

INVITATIONS: Wren Press
15 Lots Road Chelsea Wharf, London SW10
Tel. 207 351 5887 Fax 207 352 7063

CALLIGRAPHER: Karen Levy
370 E. 76th St., New York , NY 10021
Tel. 212 472 1669 Fax 212 628 7470

TRAVEL AGENT: Protravel for guests from USA: Anita Sternberg
Tel. 212 409 9542 Fax 212 755 7612

Travel agent for European guests:
The Holiday Place (in London)
Tel. 207 431 0670 Fax 207 431 3657

Le Comptoir des Caraïbes for hotel bookings and other on-island services outside Old Havana, Tel. 53 7 868 4178

HOTEL HABANA RIVIERA
Tel. 53 7 334 051, Contact Liliana Pita

ENTERTAINMENT: Camerata Romeo Orchestra arranged through Juliet Barclay Cuban Band – Groupo Maguey
Obra Pia - arranged through Juliet Barclay

TRANSPORTATION: Classic Cars, Gran Car, Tel. 53 7 935 647

CHAPTER 2
PHOTOGRAPHER: Robert Fairer, London Tel. 207 207 9000 robertfairer@hotmail.com
Mary Hilliard, New York

DRESS: Carolina Herrera, 501 7th Ave., 17th Fl., New York, NY 10018, Tel. 212 944 5757

PARTY COORDINATOR: Chloe Black Florida Crystals Corporation
Tel. 561 366 5129 Fax 561 651 1317

CATERER: Le Cirque
455 Madison Avenue, New York, NY 10022
Tel. 212 303 7788, Contact: Benito

ENTERTAINMENT:
Topspin Entertainment, Tom Finn, DJ
Tel. 212 595 4499

LIGHTING: Winterling Lighting
George Winterling, New York: 516 793 5350,
Stuart, Florida 772 283 3339
www.winlite, george@winlite.com

FAVORS: Bibi Leon bibileon@hotmail.com
CASA DE CAMPO, La Romana, Dominican
Republic 809 523 3333 ext.5220

CHAPTER 3
PHOTOGRAPHER: Mauricio Donelli
Tel. 58 414 327 0493, www.mauriciodonelli.com

DRESS: Angel Sanchez, 526 Seventh Ave., New York, NY 10018, Tel. 212 921 9827
angelsanchezusa.com

BRIDESMAIDS DRESSES: Monica Noel
Contact: Marisa Noel Brown
MarisaBrown@earthlink.net

WEDDING PLANNER: Simone Martel
Tavern on the Green, Private dining: Brian
Calman, Tel. 212 873 4111

ENTERTAINMENT: Starlight Orchestra,
Valerie Romanoff, 180 West 80th St., Suite 217
New York, NY 10024, Tel. 212 595 0999
DJ – Christopher Ford, Tel. 212 755 4459
forddo@aol.com

FLORIST: Remco Van Vliet,
158 West 28th St., New York, NY 10001
remco@vanvlietandtrap.com

CHAPTER 4
PHOTOGRAPHER: Mauricio Donelli,
Tel. 58 414 327 0493, www.mauriciodonelli.com

DRESS: John Galliano for Christian Dior Haute
Couture 30, Avenue Montaigne, Paris
Tel. 331 4073 5444 Angel Sanchez, 526 Seventh
Avenue 212 921 9827 angelsanchezusa.com

MAKEUP: Ernesto Lopez
Tel. (58212) 265 2879 / (58414) 322 7930

CATERING: Festejos Mar (Frank Rodriguez)
Tel. (58212) 953 0022 festejosmar@cantv.net

ENTERTAINMENT
DJ Compota (José Antonio Diaz)
Tel. (58212) 284 6575 Fax (58212) 284 4341
compota31@hotmail.com

FLORIST: Estilo y Arte Martinez
(José Martinez), Centro Comercial
San Ignacio, Nivel Jardin, Local J23,
La Castellana, Venezuela
Tel. (58212) 267 7579 Fax. (58212) 265 9369

CHAPTER 5
PHOTOGRAPHER: Julie Skarratt
www.julieskarratt.com

DRESS: Vera Wang, Madison Ave.,
New York, Tel: 212 628 3400

PARTY PLANNER:
Monica Nielson (friend of the bride)
Bulldog Productions, Technical matters,
tent, stage, food for rehearsal dinner
Tel. 0476 131 11 - Fax 0476 711 71
Contact: Björn Bengtsson, Gunnar Ström
bulldog@mail.databasen.se

FLOWERS: Almhult Flowers
Sweden, Tel. 0476 711 35

SVANEHOLM CASTLE
Sweden, Tel. 46 411 40012

CHAPTER 6
New York Wedding:
PHOTOGRAPHER: Jasper Sky Photography
Contact: Stefanie Jasper or Paul Sky
Tel. 800 357 8011 jasper.sky@verizon.com,
Panoulis, Athens, Greece
Tel. (30 210) 3600 762 Fax (30 210) 3638 321

PARTY PLANNER: Saved by the Bell,
Contact: Susan Bell, Tel. 212 874 5457

CATERER: Cipriani 42nd St., Tel. 212 399 0599

HAIR & MAKEUP:
Rochelle Weithorn, Tel. 212 472 8668

LINENS & RENTALS
Tri-Serve Party Rental, Tel. 212 752 7661
Contact: Linda Lieberman

WEDDING CAKE
Cheryl Kleinman Cakes, Tel. 718 237 2271

ENTERTAINMENT: Starlight Orchestras,
Tel. 212 595 0999, Contact: Valerie Romanoff
DJ: Tom Finn, Topspin Entertainment
Tel. 212 595 4499

FLORIST: Avi Adler Flowers, Tel. 718 243 0804
Contact Avi Adler or David Stark

INVITATIONS: Judith Ness Calligraphy
and Design, Tel. 212 348 5863

LIGHTING: Bentley Meeker Lighting &
Staging, Tel. 212 722 3349

Wedding in Greece
PHOTOGRAPHER:Jasper Sky Photography
Contact: Stefanie Jasper or Paul Sky
Tel. 800 357 8011 jasper.sky@verizon.com,
Panoulis, Athens, Greece
Tel. (30 210) 3600 762 Fax (30 210) 3638 321
Kalliope Karella kalliopekarella@yahoo.com

DRESS: Gianfranco Ferré,
Via Pontaccio, 20121 Milano, Italy
Tel. 39 02 7213 8600 Fax 02 7213 4801
gianfrancoferre.com

CATERER: Platis, 15 Griva, Harandri, Athens,
Tel. 30 210 684 6300 Fax 30 210 684 6302,
saves@euresplatis.gr

WEDDING CAKE:
Dona Shalas, Tel. 30 6944 241 165

PARTY FAVORS: (Bonbonnières)
Kessaris, 7 Panepistimiou, 105 Athens
Tel. 30 210 3310 750 Fax 30 210 3214 806

TENTS: Con. Tent L.T.D., Mr. Papaspyrou
Kifissias Ave. 15231, Halandri, Athens
Tel. 30 210 075 4720, info@con.tent.gr

ENTERTAINMENT: DJ Kostas Berlis
Tel. 30 210 610 5255, sales@berco.gr

FLORIST: Petridis
314 Kifissias Ave., P. Psichiko
Tel. 30 210 672 8370 Fax 30 210 674 7080

DECORATION: Meli Interiors
Contact: Mrs. Mitsopoulos
41, Voukourestiou St., Athens
Tel. 30 210 362 7943 Fax 30 210 363 8996
enad@otenet.gr

CHAPTER 7
PHOTOGRAPHER: Kaija Braus
Tel. 212 226 3661, www.kaija.com

DRESS: Velasco Anderson:
Greg Mills 212 391 0050

FLOWER GIRLS DRESSES: Spring Flowers,
1050 Third Avenue Contact: Maria or Arsenia,
Tel. 212 758 2669

PARTY PLANNER: Lauren Short

CATERER: The Regent in-house caterer,
Contact: John O'Mahoney
Tel. 212 699 5697 Fax 212 809 0303
jomahoney@regenthotels.com

CAKE: Cipriani 781 Fifth Avenue, New York
NY 10021 212 753 5566 cipriani.com

ENTERTAINMENT: DJ for reception
Pat Caramel, Tel. 212 691 9122

Bagpipes outside church
Daniel Sprague Tel. 800 990 3601
Tel. 516 551 4806, Tel. 718 966 1936

FLORIST: Ron Wendt Floral & Event Design,
Partner: Philip MacGregor
245 West 29th St., New York, NY 10001
Tel. 212 290 2428

INVITATIONS:
Design: Bernard Maisner
Tel. 212 477 6776 www.bernardmaisner.com
Printing: Ted Harrington
Stationers' Engravers Co., Inc.
5 East 17th St., 2nd Fl. *or* 42 E. 20th St., 2nd Fl.
New York, NY 10003, Tel. 212 260 6787
Table Stationery: Glorie Austern
151 Sandpiper Key, Seacaucus, NJ 07094
Tel. 201 866 1985 Fax 201 392 1749

TRANSPORTATION
Cars: Lincoln Town Car 212 988 9700
Guest transportation: Campus Coach
Contact: Anne, Tel. 212 682 1050

LIGHTING: Bentley Meeker
341 E. 109th St., New York, NY 10029
Tel. 212 722 3349 Fax 212 722 8803

CHAPTER 8

PHOTOGRAPHER: Bernd Obermann
Washington Jefferson Hotel
318 W. 51st St., New York, NY 10019
Tel. 212 246 7550 Fax 212 246 7662

DRESS: Morgane Le Fay, 746 Madison Ave., NY,
NY 10021, Tel. 212 879 9700

PARTY PLANNERS: Bettina Hakko, Istanbul
Metin & Zeynep Fadillioglu, Istanbul
Tel. (90 212) 265 6181
Birgül Özden, c/o Kempinski Hotel, Istanbul

CATERER: Catering for Yildiz Palace
Swisshotel, Bosphorous, Istanbul
Tel. (90 2121) 269 0101 Fax (90 212) 253 2247

ENTERTAINMENT: DJ –Claude Challe, Paris,
France, Tel. (331) 4342 3048

INVITATION GRAPHICS: Alec Cobbe & David
Mees Design Partnership Tel. 44 1483 222 787.
44 737 7471 2176

HOTELS: Swissotel Bosphorus
(overlooking Istanbul & the Bosphorus)
Tel. (90 212) 259 0101 Fax (90 212) 253 2247
Çiragan Palace Kempinski (on the Bosphorus)
Tel. (90 212) 258 3377 Fax (90 212) 259 6687
The Four Seasons Hotel
(next to Hagia Sophia and Topkapi Palace)
Tel. (90 212) 638 8200 Fax (90 212) 638 8210

CHAPTER 9

PHOTOGRAPHER: Dora Franco,
Madrid, Spain, Tel. 34 914 353 727
dorafranophoto@yahoo.com
Kalliope Karella, kalliopekarella@yahoo.com

DRESS: Valentino Boutique,
New York, New York, Tel. 212 997 8111

PARTY PLANNER:
Organizzazione Venezia Privata
Tel. 39 041 520 8292 Fax 041 277 8051
veneziaprivata@libero.it

DECORATION SUPERVISOR
Matteo Corvino, Tel. 39 041 522 2725

CATERER: Harry's Bar, Venice
Tel. 39 041 528 5777

ENTERTAINMENT: Fabio Reggio
Tel. 39 041 524 0627

FLORIST: Marco Munaretto, Tel. 39 041 276 0366

INVITATIONS: Fernando Botero

PALAZZO: Pisani Moretta, Tel. 39 041 520 5226

CHAPTER 10

PHOTOGRAPHER: Luc Castel;
Kalliope Karella, kalliopekarella@yahoo.com

DRESS: Oscar de la Renta Bridal
New Jersey, Tel. 973 471 7444

JEWLERY: Asprey, 725 Fifth Avenue, New York
NY 10022 Tel. 212 688 1811, asprey.com

CATERER: St. Clair, Paris 331 4602 8888

DECOR/LIGHTING/EFFECTS/ORCHES-
TRATION: Guy Morin, Gerard Gasquet
Marrakech, Morocco
Tel. 212 4 443 3745 Fax. 212 4 443 5006

FLORIST: Christian Tortu, Paris
Tel. 331 4326 0256

GRAPHICS FOR ORIENTAL INVITATION:
Mohammed el Mkramer, Morocco

EQUESTRIAN SHOW IN CHANTILLY:

Mr. Mario Luraschi

CHAPTER 11

PHOTOGRAPHER: Fabrice Trombert
Contact Paul or Marie,
Tel. 212 935 0200 Cell 917 854 7851
fabricetrombert@earthlink.net

DRESS, John Galliano for Christian Dior
Haute Couture, 30, Avenue Montaigne, Paris
Tel. 331 4073 5444 Tel. 212 247 7540

PARTY PLANNER: Andres Yanome
Tel. 52 315 351 0241 Fax 52 315 351 0240
takeshimibu@prodigy.net

INVITATIONS: Florine Asch, Paris
florineasch@hotmail.com

HOTEL: Careyes Villas, contact: Mr. Giorgio
Brignone, www.careyes.com.mx

CHAPTER 12

PHOTOGRAPHER: Agenzia Fotografica
Zanfron, Belluno, Tel. (39) 4371 940 096

DRESS: Mrs. Paola Quadretti, Alta Moda,
Via del Sole 17/r, 50123 Firenze, Italia
Tel. 39 055 289 057

VILLA: www.contemiarifulcis.it

CHAPTER 13

PHOTOGRAPHER: Meg Smith
Fax 707 486 8019
info@megsmith.com

DRESS: Oscar de la Renta, Tel. 973 471 7444

PARTY PLANNER: gregcalejo@kerzner.com,
Tel. 212 659 5200

CATERER: Dune Restaurant at the Ocean
Club, Paradise Island, Bahamas

ENTERTAINMENT: DJ Joey Jam
Tel. 242 324 3683, Louis Bofill
Cuban Band, bofill18@aol.com

FLORIST: Michelle White, Tel. 242 325 3581

HOTEL: The Ocean Club,
Paradise Island, Bahamas, Contact Greg Calejo,
Tel. 212 659 5200

CHAPTER 14
Wedding at Menetou-Salon:

PHOTOGRAPHER: Luc Castel & Kalliope
Karrella, kalliopekarella@yahoo.com

ORGANIZER: Pierre Celeyron,
1, avenue Théophile Gautier, 75016 Paris,
Tel. 331 5574 8585

CATERER: Lenôtre – Mr Rémi Raymond
40, rue Pierre Curie 78370 Plaisir
Tel. 01.30.81.46.46

LIGHTING AND SOUND
C.I.E.L. – Mr Gérard Gillet, 28, rue Charles
Bassée, 94120 Fontenay sous Bois
Tel 01.41.95.02.22, ciel2@wanadoo.fr

FLORIST: Linard Fleurs
Madame Linard, 17, rue Sarrebourg,
18000 Bourgees, Tel. 02.48.67.55.33
contact@linardfleurs.com

INVITATIONS: Calligrapher, Anne-Laure
Sénard, 27, rue Rémilly, 78000 Versailles
Tel. 01.39.51.36.19, alsenard@wanadoo.fr

Dinner at Versailles:

PHOTOGRAPHER: Luc Castel
Kalliope Karella, kalliopekarella@yahoo.com

ORGANIZER: Pierre Celeyron
1, avenue Théophile Gautier, 75016 Paris
Tel. 331 5574 8585

CATERER: Lenôtre – Mr Rémi Raymond
40, rue Pierre Curie, 78370 Plaisir
Tel. 01.30.81.46.46

ENTERTAINMENT: Music – Tziganes.
Paul Toscano Tel. 331 30 416206

LIGHTING AND SOUND:
C.I.E.L. – Mr Gérard Gillet, 28, rue Charles
Bassée, 94120 Fontenay sous Bois
Tel. 01.41.95.02.22 ciel2@wanadoo.fr

FIREWORKS: Ougier Fêtes et Feux
Monsieur Emmanuel Celeyron
312, avenue Emile Zola, 75015 Paris
Tel. 01.45.79.40.88

FLORIST: Naturel Décor – Monsieur Dominque
Barbier, Z.I. du Val de Seine
8, rue Denis papin, 92230 Gennevilliers
Tel. 01 41 47 21 90, natureldecor@wanadoo.fr

INVITATIONS: Anne-Laure Sénard
27, rue Rémilly, 78000 Versailles
Tel. 01.39.51.36.19, alsenard@wanadoo.fr

CHAPTER 15

PHOTOGRAPHER: Kalliope Karella,
kalliopekarella@yahoo.com

DRESS: Prince Egon Von Furstenberg,
Via A. Pacinotti 73, Rome 00146
Tel. 39 06 557 6220 Fax. 39 06 553 00303
egonvonfurstenberg.com

CATERER: Roberto Ottaviani
Hotel Lord Byron, Tel. 39 06 322 0404

PARTY PLANNER: Jean Paul Troili
Tel. 39 06 678 1486 Cell: 39 337 774 548

FLORIST: Cecotti, Tel. 39 06 3611 414

PALAZZOS: Palazzo Taverna (rehearsal dinner),
Via Monte Giordano 36, 00186 Roma
Tel. 39 06 6813 4499, www.alddobrandini.it
Princess Stefanina Aldobrandini (caterer)
Palazzo Lancellotti (ball after the wedding)
www.cittadelfare.com/palazzi/casalnuovo.html

CHAPTER 16

PHOTOGRAPHER: David Seidner
and Sir Geoffrey Shakerley, London
Tel. 44 208 960 3199 Fax 44 208 964 0052
gs@photographicrecords.com

DRESS: Valentino Haute Couture
Rome, Italy. Contact: Mrs. Violante Valdettaro
Tel. 39 06 67391, violante.valdettaro@hotmail.com

PARTY PLANNERS: Lady Elisabeth Anson
Tel. 44 207 229 9666 Fax 44 207 727 6001
Contact: Ana Parkinson
Robert Isabel, New York, Tel. 212 645 7767,
robertisabel@robertisabel.com

CATERERS: *Wrotham Park*:
Alison Price Catering, Tel. 207 371 5133
Contact: Alison Price or Terry Shaw
Hampton Court Palace: Lorna Wing limited Tel.
207 731 5101, Contact: Lorna Wing

CAKE: Colette Peters, New York
Tel. 212 366 6530, www.colettecakes.com

ENTERTAINMENT: Lester Lanin Orchestras
(music at wedding breakfast), Tel. 0707 873324

Wrotham Park:

Beryl Diamond Quartet, Tom Finn, D.J. Doc
Scantlin, Taylor Dayne (music at ball)
Band Equipment: Robert Isabel
Pepper's Marquees, Tel. 405 860 249 Contact:
Stuart Pepper

FIREWORKS & LIGHTING: Starlight
John Kellett & Michael Lakin
Tel. 208 960 6078

CAROUSEL: Bob Wilson & Sons Leisure Ltd.,
Tel. 0121 772 0180

FLORISTS: *Hampton Court:*
The Flower People, Tel. 207 498 9407
David Jones, Tel. 208 870 4394
Steve Woodham, Tel. 207 243 9689

Wrotham Park:

Rob Van Helden, Tel. 207 371 5788

INVITATIONS: Grahics: Florine Asch
Paris, France florineasch@hotmail.com
Printing: Austen Kopley/Barnard & Westwood

WROTHAM PARK
Robert Byng, Tel. 208 441 0755

HAMPTON COURT PALACE
Dennis McGuninnes, Tel. 208 781 9501

ACKNOWLEDGEMENTS

I am very grateful:

To Prosper and Martine Assouline, for having believed in me and for enabling me to realize my dream weddings book.

To Brooke de Ocampo, for introducing me to the Assoulines.

To my heroic, tireless, and perfectionist editor, Karen Lehrman, for ensuring that all the weddings sounded as stylish as they looked. Thanks for countless hours of meticulous editing and creative supervision—and for her constant reassurance.

To all of Karen's supportive team, Sarah in particular, for spending so much time in front of the computer inserting captions and devising poetic words to describe "nuptial bliss." And a special *merci* to Assouline's design team headed by Mathilde Dupuy d'Angeac and Nelly Riedel, for their tireless efforts to make the book so chic and elegant.

To Rebecca McArtor, for deciphering my long handwritten manuscripts and for her insightful suggestions (and for putting up with such exotic names, menus, and flowers). I couldn't have written this book without her!

To my husband, Michael Rena, for tolerating my jet-setting around the globe during the golden era of the '90s to attend yet another fabulous four-day wedding at some exotic location! I hope that this book has partially justified my escapades and exonerated my guilt for abandoning spouse and hearth in pursuit of fun.

To all the talented photographers who very kindly contributed to the visual success of this book: Laurence Vetu, Mary Hilliard, Robert Fairer, Mauricio Donelli, Julie Skarratt, Jasper Sky, Panoulis, Kaija Braus, Bernd Obermann, Dora Franco, Fabrice Trombert, Luc Castel, Zanfron, Meg Smith, David Seidner, and Sir Geoffrey Shakerley. Thank you for your valuable assistance and generosity.

Last, but not least, this book would not have been possible without my incredible friends, the brides who have given me all of their support and enthusiasm. I thank them, not only for entrusting me with their most intimate memories and recollections, but also with their precious wedding albums, contact sheets, negatives, and invitations from their most memorable day. They were available at all times and never ceased to cooperate. This book is truly about them, their fabulous weddings, and their unique style.

With enormous thanks and appreciation to the Countess of Albemarle, Emilia Pfeifler, Marisa Brown, Claudia Macaya, Ulrica Lanaro, Natasha Kneiss, Rolla Gordon, Joana Schliemann, Lina Sanchez y Vals, Valesca Guerrand-Hermès, Karina Brignone, Chiara Ferragamo, Inés Mora Marchessa de Pelayo, H.S.H. The Princess Silvia d'Arenberg, Drusiana Price, and H.R.H. The Crown Princess Marie-Chantal of Greece.

PHOTOGRAPHIC CREDITS

p. 8-9: © Laurence Vetu; p. 10-11: © Kalliope Karella; p. 12: © Laurence Vetu; p. 13: © Kalliope Karella; p. 14-15: © Laurence Vetu; p. 16: © Kalliope Karella; p. 17 top: © Tom Ford for YSL; right & bottom: © Laurence Vetu; p. 18-19: © Robert Fairer; p. 20: © Mary Hilliard; p. 21-26: © Robert Fairer; p. 27 top, left & bottom: © Mary Hilliard; right: © Robert Fairer; p. 28-45: © Mauricio Donelli; p. 46-55: © Julie Skarratt; p. 56: © Kalliope Karella; p. 57: © Panoulis; p. 58: © Kalliope Karella; p. 59-61: © Panoulis; p. 62-63: © Jasper Sky; p. 64: © Panoulis; p. 65 top & left: © Jasper Sky; right & bottom: © Panoulis; p. 66-74: © Kaija Braus; p. 75 left graphics: © Bernard Maisner; top, right & bottom: © Kaija Braus; p. 76 graphics: © Alec Cobbe & David Meers Design Partnership; p. 77: © Berndt Obermann; p. 78: © Von Rohr; p. 79: © Bart Homan; p. 80-83: © Berndt Obermann; p. 84: © Von Rohr; p. 85: © Berndt Obermann; p. 86: © Kalliope Karella; p. 87: © Dora Franco; p. 88: © Kalliope Karella; p. 89 graphics: © Fernando Botero; p. 90-94: © Dora Franco; p. 95 top, right & left: © Kalliope Karella; bottom: © Dora Franco; p. 96-103: © Luc Castel; p. 104 graphics: © Mohammed el Mkramer; p. 105 top & left: © Kalliope Karella; right & bottom: © Luc Castel; p. 106 graphics: © Florine Asch; p. 107: © Fabrice Trombert; p. 108: © John Galliano; p. 109-115: © Fabrice Trombert; p. 116-117: © Studio Zanfron; p. 118: © Mrs. Paola Quadretti; p. 119-125: © Studio Zanfron; p. 126-135: © Meg Smith; p. 136-140: © Luc Castel; p. 142 -144: © Private Collection; p. 145 top, right & bottom: © Kalliope Karella; left: © Luc Castel; p. 146-155: © Kalliope Karella; p. 156 graphics: © Florine Asch; p. 157: Wedding Portrait of Prince Pavlos and Princesse Marie-Chantal of Greece, 1955 Chromogenic print © International Center of Photography, David Seidner Archive; p. 158: © Valentino Haute Couture; p. 159: © Sir Geoffrey Shakerley, Photographic Records.